Becoming clerical workers

Critical Social Thought

Series editor: Michael W. Apple
Professor of Curriculum and Instruction and of Educational
Policy Studies, University of Wisconsin-Madison

Already published

Critical Social Psychology Philip Wexler
Reading, Writing and Resistance Robert B. Everhart
Arguing for Socialism Andrew Levine

BECOMING CLERICAL WORKERS

Linda Valli

Assistant Professor, Department of Education
The Catholic University of America, Washington DC

Routledge & Kegan Paul
Boston, London, and Henley

First published in 1986
by Routledge & Kegan Paul plc

9 Park Street, Boston, Mass. 02108, USA

14 Leicester Square, London WC2H 7PH, England and

Broadway House, Newtown Road,
Henley on Thames, Oxon RG9 1EN, England

Phototypeset in Linotron 202 Times, 10 on 12pt
by Input Typesetting Ltd, London
and printed and bound in Great Britain
by Billing and Son Ltd, Worcester

Library of Congress Cataloging in Publication Data

Valli, Linda, 1947–
 Becoming clerical workers.

 (Critical social thought)
 Bibliography: p.
 Includes index.
 1. Women clerks—United States. 2. Women clerks—
Training of—United States. I. Title. II. Series.
HD6073.M392U58 1985 305.4'3651 85–2499

British Library CIP data also available

ISBN 0–7102–0336–5

Contents

Series editor's introduction

In our kind of society, women have a double relation to wage labor. They are both paid and unpaid workers. Unpaid domestic labor, relations of consumption, and their connections to paid work are all critically important in illuminating the 'shaping' of women's consciousness.[1] This consciousness and these relations have a long history, of course, for women's ties to wage labor have changed markedly over time. We need to remember, for instance, that at the end of the eighteenth and the beginning of the nineteenth centuries, the lack of an 'adequate supply of workers' and the continuing need for cheap labor created conditions that made *women* the first industrial proletariat in the United States.[2] Thus, current concerns about the ideological, political, and economic status of women's work have roots in the very first phase of America's industrial project.

Historically, we know that the belief that woman's 'proper place' was in the home has often enabled employers to pay considerably less to women. After all, such wages were 'merely supplemental.'[3] Ideologies of domesticity and exploitative economic arrangements have not been inconsequential in the way women's work has been constructed over time. They have had an immense impact on the kind of labor that is the topic of this book, clerical work and how young women learn to become such workers.

It is hard to fully understand why clerical work looks the way it does without having a sense of its history. Office work in the latter part of the last century was predominantly male work. Many businessmen had personal secretaries and clerks who themselves often saw such employment as a step on the path to upward mobility. Office work had certain managerial responsibilities

associated with it. Yet with the growth of industrial capitalism, new patterns of office organization stressing rationalization and efficiency also grew. Centralized decision-making, 'more complex arrangements for providing and using capital,' the expansion of marketing programs, and so forth, all this called for an extension of bureaucratic control and a veritable explosion of record-keeping tasks and paper work. The nature of office jobs changed markedly, as did the technology of office work. These jobs were more and more filled by women. 'Unlike the men they replaced, women did not work primarily as personal secretaries.' The tasks of office work had now lost their managerial content and were 'subdivided to produce maximal efficiency with minimal training.'[4]

In her excellent history of women's paid labor, Alice Kessler-Harris describes the situation in the following way.

> The developing bureaucracy required people who were fluent
> in English, educated enough to respond to a variety of
> commands efficiently, and without the need for large incomes.
> Initially reluctant to hire women, employers succumbed to the
> lure of higher profits – for the jobs offered to women paid
> about half of what a comparable man might get. Explaining
> his preference for women workers, one businessman said that
> young men wanted to be promoted and to get higher salaries
> as they courted girls and then began to raise families. . . .
> 'Girls do not have these demands made upon them.'[5]

Yet this does not totally explain what was happening, for women themselves chose such work as a solution to very real economic and ideological dilemmas. Once again Kessler-Harris is helpful on showing both parts of this dynamic.

> . . . Women moved quickly into most clerical positions. Their
> place was assured when the typewriter came into general use
> in the 1890s. The machine required nimble fingers –
> presumably an attribute of women. Its operators exercized
> no initiative. They were expected simply to copy. And the
> work was clean. Attracted by the new jobs, large numbers
> of women not previously employed began to look for work.
> These were native-born daughters of native parents, who had

consistently refused jobs next to immigrant women in factories. For them, office work brought only minimal loss of dignity and offered the chance to earn decent incomes.[6]

Thus, clerical work did help capital in its search for ways to reduce wages and increase efficiency. Yet it also enabled women to experience a greater sense of financial independence and provided a partial solution to the tensions created by the growth of employment of immigrant women in factories by offering 'more dignified work' to other women. Further, it helped solve the problems caused by the ideology of domesticity. 'Propriety' and a particular middle class ideology seemingly demanded that the jobs in which (white) women worked for wages outside the home should be organized around the idealized values of future home life. Gentility, morality, neatness, and cleanliness, these would be stressed against the values of ambition, competition, aggression, and ever-increasing income that dominated the idealized man's world of work. The fact that these solutions 'confirmed women's place in the home' at the same time that they enabled waged work to seem more legitimate is but one of the contradictions emerging here.[7]

This tension between the world of the home and the world of waged labor does not die. It is transformed as the economy and gender relations are themselves altered. One thing is certain, though, these ideological tensions and contradictions still need to be worked through by new generations of women (and men, of course). The women in *Becoming Clerical Workers* are clearly living out this history, both in their paid and unpaid labor and in their secondary school experience. It is the connections between the two that Valli uncovers.

So much has been written about the connections between the school and the labor process that it is now hard not to think about schooling in class terms. From the early functionalist work of Bowles and Gintis to the later analyses of myself and others that focus on the contradictory relations between schools and the larger social formation, there has been a clearer recognition that our educational system can only be fully understood 'relationally.'[8] Its meaning, what it does culturally, politically, and economically, is missed if our analysis does not situate the school back into the nexus of dominant social relations that help shape our society.

The recognition that schools need to be understood in this way has had its benefits to be sure. But it has also led to a number of problems as well. Class has most often been the fundamental category of one's investigation. Less attention has been paid to the other constitutive dynamics around which our society is organized. Here I am talking about gender and race. While future books in this series will take the issue of the specificities of race as their problematic, the current volume deals directly with the intersection of class and gender.

Patriarchal structures and class structures are both subtle, complex, and wide-reaching. They have their own dynamics, however, and are not reducible to one another, though unfortunately those scholars on the left who stress class as the fundamental category of analysis tend to want to merge feminist issues back into the 'real' problem of class relations. As Heidi Hartmann has put it in arguing against such reductive tendencies, 'The marriage of marxism and feminism has been like the marriage of husband and wife depicted in English common law: Marxism and feminism are one, and that one is marxism.'[9] Such a position has, of course, been challenged conceptually and politically. These criticisms have caused a particular set of questions to come to the forefront of our analyses in a number of fields. What is the relationship between gender and class? How are these relationships produced and reproduced in particular sites such as the home, the paid work place, and the school? Are these dominant relationships contested by real women and men as they go about their daily lives or are they largely accepted as the way the world is?[10]

These are complicated issues as you would imagine. But the attempt to deal with both class and gender together, without slighting either, is one of the most serious agendas we face. However, these attempts face other difficulties if they are to do justice to the actual people who are in these sets of relations.

For example, the problem is not only how we might fruitfully examine both class and gender together, but also how we combine structuralist insights about the relationship between the school and the social and sexual divisions of labor with a culturalist perspective that places human agency and the concrete experiences of people at the center. How do we show the role of the educational system in the production of these divisions without at

the same time falling into the many traps that bedevilled earlier attempts at doing this?[11] Can we get inside the school and illuminate what actually happens, how teachers and students act within the conditions set by the institution and the larger society, *and* point out the possibilities that exist for altering dominant relations?

In the past, only a relative handful of books have been able to successfully combine a structuralist focus on the objective conditions within a social formation and the culturalist insistence on seeing these conditions as ongoingly built, and contested, in our daily lives. All too often, authors choose between seeing culture as a mere reflex of economic relations or else tend to fall into a naive romanticism about the power of 'resistance' by women and men on the shop floor, the home, the office, or the school. Yet, over the past decade a literature has been built within sociology and education that has taken these issues seriously both empirically and theoretically.

Though not specifically school related, Michael Burawoy's ethnographic work on the labor process provides one example.[12] Within the cultural studies tradition in England, and closer to the concerns of the sociology of education, Paul Willis's volume *Learning to Labour* stands as something of a turning point.[13] It created a foundation upon which a generation of further work has stood. Also of major import here was Angela McRobbie's study of working-class girls and the culture of femininity.[14] In the United States, the research of Robert Everhart on the ways working-class youth creatively use their school experience in ways that both help and hurt them,[15] and that of Lois Weis on the elements of 'good' and 'bad' sense – the cultural and ideological contradictions – existing in the actions of black students in an urban community college,[16] have extended our ability to deal with these questions considerably. All enable us to more clearly see how culture and economy work in our society at the level of the concrete practices of people in places like schools.

The idea that schools have a close relationship to the 'external' society is not a new one in the sociology of education by any means. Mainstream work in social stratification and status attainment has taken this connection quite seriously, often in a technically sophisticated manner. As has been argued elsewhere, however, such work has an underconceptualized model of how

capitalist economies operate and has been more concerned with individuals and less concerned with class relations than it might have been.[17] This does not mean that such investigations have not made a real contribution. To the contrary, their methodological advances have had a lasting impact, as have a good deal of their data. Yet, the above questions still remain, as do others relating to their treatment of the paid and unpaid status of women.

Within the status attainment tradition in the sociology of education, the majority of work has been done on men. For a variety of reasons, for a long time it was as if women simply existed as shadowy figures behind the scenes, so to speak. This lack was a problem empirically, of course; but theoretically, as well, it left an immense gap. How could one talk about mobility, income level, achievement, and so on, even on an individual level, and ignore the experience of 51% of the population? The empirical problems have now been recognized and a number of individuals within the status attainment tradition have paid much closer attention to issues of gender. Yet while these gains have occurred, they have been largely made simply by including girls and women in data collection and analysis. Like the questions concerning class and the economy in general, the theoretical issues surrounding women's experience of schooling and work remain.

Linda Valli's volume goes a long way toward helping us answer these questions. It offers both a theoretical and empirical critique of the ways status attainment research has looked at what schooling does. This is not all. It provides new avenues for approaching major issues within the larger labor process literature, especially those dealing with the deskilling and reskilling of work. *Becoming Clerical Workers* also paints a detailed portrait of both the structural conditions of women's paid work and the subjective experiences of being on the job. Finally, by examining the relationship between school and office for a group of students training to become clerical workers, it uncovers the lived reality of both, showing the contradictory ideological and cultural forms at work in each site.

Valli does this by going considerably further than other politically informed ethnographic accounts of schooling. Most other studies that have sought to show what students learn in school, and the connections of that learning to the unequal sets of social relations in the larger society, have relied on the school experience

itself to support their claims. Even some of the more theoretically elegant ones have not usually followed the students from the school into the paid labor force. Because Valli does do this, she is much better able to demonstrate the contradictions, mediations, and struggles female students live out as they make their way among home, school, and office.

In so doing, the volume provides an empirical test of a number of debates. Let me note just a few of the more significant ones. Valli's analysis helps us solve the controversy between what can be called the embourgeoisement and proletarianization positions in social theory. Is our labor force becoming more skilled, more 'middle class'? Or is it becoming deskilled and its labor intensified so that even white-collar labor is becoming more like the rationalized labor found on the shopfloor? These questions are strikingly important not just theoretically, but for the development of political strategies as well. Answers to them require a close reading of the actual work experiences of people who are different by class, gender, and race. And a close reading of what is happening at the level of the concrete reality of clerical work is what Valli gives us.

Another example concerns Bowles and Gintis's structuralist arguments that schools function to reproduce the social division of labor through the hidden curriculum that students learn. This 'correspondence theory' has been challenged by many within a more culturalist tradition who have supported a position based on a belief in the relative autonomy of cultural form and content. These differing positions, however, are often argued out on an abstract level.[18] I do not mean to denigrate such theoretical work since it is essential that it continues. However, the question is also empirical. Do schools and students function as correspondence theories would have it? What happens as students (who are themselves classed, raced, and gendered actors) go about their daily lives in these institutions? Valli's analysis illuminates this exceptionally well without losing the complexity of what is going on.

The volume is not limited to description and critique, however, even though that alone would be significant. What sets it apart from other books is its insistence on the possibility that conditions in schools and offices can be different. Toward this end, Valli elaborates a number of ways in which the formal education of clerical workers could be changed politically and pedagogically,

many of which could be instituted by teachers and others *now*.

All of this makes *Becoming Clerical Workers* one of those rare books that is essential reading for people in a wide array of fields. It advances major theoretical and empirical contributions to areas within sociology involving work on status attainment, the labor process, and class and gender relations. Its integration of the school and work experiences of women clerical workers makes it important reading for feminists. And within education, its sensitive ethnographic account of educational programs that seek to link the school and the paid workplace, its suggestions for reform, and its extension of previous work on the relationship among culture, economy and schooling, these too make it a book that cannot help but have us rethink many of the presuppositions we have about women's work in the home, the school, and the office.

Michael W. Apple
The University of Wisconsin-Madison

Acknowledgments

I understand now why so many authors say, 'Without the help of
. . . this book never would have been written.'

My debt to the subjects in this study (students, teachers, super-
visors, and union reps) and to the scholars upon whose own
creative labor I so heavily rely will become evident to the reader.
Although I cannot name those women and men here, I would
like publicly to thank them.

Michael Apple, Herbert Kliebard, Nancy Lesko, Mary
Haywood Metz, Michael Olneck, and Mary Lou Watkins can and
should be named. They have been wonderful mentors and friends
who made *my* workplace humane, supportive, and intellectually
enriching.

I would particularly like to thank Michael Apple and Michael
Olneck for insights, questions and critiques they shared with me
over the years.

PART ONE
Introduction

1
Theoretical overview

This book is about the choice senior high school girls make to obtain training in office work, the actual preparation they receive for that work, and their emergent work cultures and identities. My decision to study vocational preparation for office work was influenced by the realization that typical workers in the United States are clerks, the vast majority of whom are women, and that clerks rank among the most dissatisfied of workers in this country (*Work in America*, 1973; Blaxall and Reagan, 1976).

Over a decade ago, a special task force commissioned by the federal government to examine issues of health, education and welfare from the perspective of work asserted that

> what is striking is the extent to which the dissatisfaction of the
> assembly-line and blue-collar worker is mirrored in white
> collar and even managerial positions. The office today, where
> work is segmented and authoritarian, is often a factory. For a
> growing number of jobs, there is little to distinguish them but
> the color of the worker's collar: computer keypunch
> operations and typing pools share much in common with the
> automobile assembly line (*Work in America*, 1973: 38).

Why, then, would students consciously prepare themselves to become office workers? That question became the starting point of an inquiry into the lives of a specific group of high school students, into the type of education or training they receive for office jobs, and into the nature of those jobs themselves.

The logical site from which to begin such an investigation seemed to be an office preparation program in a public high school; there I would find students training to be office workers. From research I had previously conducted I became aware of

3

cooperative office education programs at the secondary level. Since students in these programs actually work in a real office situation for both pay and academic credit as well as attend regular classes within the school building, a cooperative education program, often referred to by the acronym COOP (pronounced co-op), seemed to be the ideal choice for studying the way in which young women make the transition from school to work, the way in which they learn what it means to be office workers.[1]

Data were collected during the 1980–81 school year. The site was a comprehensive, urban high school, which I will call Woodrow High, in a mid-western city.[2] I was present at Woodrow from September through June on approximately half the school days, scattered throughout the year. Three related techniques were utilized to collect the data: participant observation in the school and at work (fourteen sites in all); formal and informal interviewing of significant subjects throughout the year (e.g. teachers, students, supervisors, alumnae and co-workers); and analysis of curricular materials and other related documents.

Since my theoretical orientation was toward culture and actual curriculum practices rather than toward attitudes and formal or official curriculum, ethnography was the natural methodological choice. As Willis (1977) has argued, ethnography is particularly well suited to an understanding of cultural transmission and change. Only an ethnographic approach can render thick, contextualized descriptions that provide the substance of cultural analysis, that can unlock 'the informal logic of actual life' (Geertz, 1973: 17). Only ethnography can place the researcher 'in a position both to observe behavior in its natural setting and to elicit from the people observed the structures of meaning which inform and texture behavior' (Wilcox, 1982: 458). This immersion in the field encourages the ethnographer to put aside 'preconceptions or stereotypes about what is going on and to explore the setting as it is viewed and constructed by its participants' (Wilcox, 1982: 458).

A structured totality

The basic theoretical perspective underlying this analysis is one of social and cultural reproduction, one in which people actively

engage their institutional and cultural surroundings to make choices, create meaning and, ultimately, give shape to their everyday lives. These surroundings are envisioned as Althusser's structured totality, in which various domains are in 'relative autonomy' to one another and in which 'reciprocal action' is possible (Althusser 1971: 135). In Burawoy's words, 'the defining features of a structured totality . . . are the "relative autonomy" of its parts and their mutual determination through the conditions of each other's reproduction. . . .' (1978: 308).

Given the assumption of society as a structured totality, a task of this analysis becomes a specification of the nature of and linkages between such domains as the educational, cultural, ideological and economic that set limits upon the ways in which, and within which, young people make the transition from school to work. But by using terms like educational, cultural, ideological and economic domains, I am neither suggesting that these are the only structures or domains in society, nor that they are discrete or monolithic entities. Indeed, as the ensuing analysis demonstrates, the cultural and ideological, for instance, permeate virtually every aspect of school and work life, each of which are characterized by variation and a complex structuring of their own.

Nor am I positing the functionalist equivalent of a smoothly functioning social system wherein each part and each person serves the needs of the whole. 'Rather than a functional coherence where all things work relatively smoothly to maintain a basically unchanging social order . . . where order is assumed and deviance from that order is problematic' (Apple, 1982: 14), this version of a structured totality envisions contradictions, conflicts and changes within and between levels so that the production of, say, a new generation of workers is never merely a question of teaching the appropriate skills and norms, as it is, for instance, in the work of Parsons (1959).

Focusing on the transition to work makes the economic domain central to the analysis. A further specification of the concept 'mode of economic production' will serve to illuminate some of the underlying assumptions in the following chapters.

Mode of economic production can be defined as the 'social relations into which men and women enter as they transform nature.' A capitalist mode of economic production is characterized, as are all class societies, by social relations wherein some

directly 'produce the necessities of life' and others expropriate the surplus (Burawoy, 1979: 14–15). Under capitalism, this expropriation takes place through the selling of one's labor power to those who own the means of economic production in exchange for a wage.

Within the capitalist labor process itself, two sets of relations can be found: technical relations in production and social relations in production. Technical relations refer to the machines, technology, skills, division of labor and scientific knowledge utilized in the transformation of raw materials into finished products. Wright (1978) refers to these relations as the social forces of production in an attempt to emphasize the socially determined, non-neutral aspects and effects of technology. But since the mere use of the word *forces* seems to undermine Wright's claim that social relations are primary, I will follow Burawoy's distinction between technical and social relations in production. Social relations, then, refer to the ways in which the labor process is organized to secure the appropriation of surplus value. They refer to the relations of workers to each other and to management.

Since raw labor power, or the potential for work, must be translated into real labor, and since workers do not necessarily want to produce 'the amount of labor that the capitalist desires to extract from the labor power they have sold' the labor process must be controlled for surplus value to be extracted and profit to be made (Edwards, 1979: 12).³ Control of the labor process is, thus, at the heart of the social relations in production as they are discussed throughout this study. But, as Edwards points out:

> Control is rendered problematic because, unlike the other commodities involved in production, labor power is always embodied in people, who have their own interests and needs and who retain the power to resist being treated like a commodity (1979: 12).⁴

If control of the labor process is the essence of the social relations of economic production, efficiency is the essence of the technical relations. Machines in capitalist societies are enlisted in this production process not primarily to ease the burden of work, but 'to increase the productivity of labor' (Braverman, 1974: 206). Work will, thus, not necessarily become any easier or more interesting. In fact, if one of the ways machines increase productivity

is by cheapening labor power, work might well become more rote, mindless, boring and dissatisfying.

While Braverman argues that control and efficiency are separate dynamics, Burawoy (1978) and Edwards claim they are united, that the design of machines and the technical organization of work are mechanisms for both efficiency and control. Although that particular debate is beyond the scope of this analysis, concerns voiced recently by women's and labor groups about the changing conditions of office work highlight the adverse effects these dynamics can have on the lives of workers. Most of the concerns center on the use of technology to permanently displace workers, to isolate workers, and to simultaneously devalue, routinize and intensify their work.

Though the overall picture is by no means clear and office work is still one of the expanding labor market sectors, some general trends and some specific cases have raised serious questions about the future of office jobs. In the early 1950s, only 1,000 computers were in use in the United States and microcomputers had not yet been developed. By 1980, ten million microcomputers had been sold and predictions are that by 1987, 41 million word processors and microcomputers will be in use (*Race Against Time*, 1980; Serrin, 1984). The case of Citibank illustrates why office workers so often associate job loss with automation. As the National Association of Office Workers reports:

> In June, 1975, it took Citibank three days to process a letter of credit request, and required over thirty processing steps, involving at least fourteen people acting on papers in six files. Today it takes only one individual with a video display terminal on line to a minicomputer-based system, working from a complete 'cockpit like' workstation with records filed electronically. The request is answered the same day. . . . Citibank reduced the department workforce from 142 to 100 employees (*Race Against Time*, 1980: 3).

Such changes obviously increase fears workers have about their ability to find and keep jobs, especially in a time when computer costs have drastically declined and office workers are beginning to organize.

For those office workers who retain their jobs, lack of control over the changing quality of work life is of real concern. Many

7

experience their 'social office' transformed into electronic work cubicles which isolate them from co-workers (and potentially weaken worker solidarity). As one word processing operator described her experience:

> I work at a terminal all day. . . . There are panels six feet high around all the operators. We're divided into workgroups of 4 to 6 with a supervisor for each workgroup. In many cases, we don't see another person all day except for a ten minute coffee break and lunch time. All we see is the walls around us and sometimes the supervisor. The isolation is terrible (*Race Against Time*, 1980: 9).

Technological control, through machine monitoring and pacing, is, of course, another possibility in the electronic office. And, although, as indicated in Chapter 5, I saw little evidence of its use, in a recent survey by the National Association of Office Workers 35 per cent of the word processing operators who responded said their work was electronically monitored. This potential is of obvious concern to workers who fear a machine-controlled, dehumanized sweatshop 'where speed is at a premium,' where virtually every movement can be recorded:

> The computer opens vistas of ultra-accuracy in dissecting the work process. Efficiency experts measure employees movements in TMU's (time-measurement units) that can compute, for instance, how long it takes a typist's brain to refocus her moving eyes on a page: approximately 7.6 TMU's. One TMU equals 0.00001 hour, or 0.036 second (Perl, 1984).

And although the productivity of word processing operators is 25–150 per cent higher than the traditional clerk/typist, their pay is often less, justified, it would seem, on the basis of their more limited job scope (*Race Against Time*, 1980).

The capitalist mode of economic production, with its needs for control and efficiency, is not, however, the only structure of relations to determine the job market and the nature of jobs. Capitalist relations do not fully account for the sexual division of labor, a division in which women by and large have not merely different but inferior positions to men. While capital determines that most workers will have subordinate positions in a hierarchical division of labor, it does not necessarily determine that that

division be sexual or that women will be disproportionately allocated to those positions. For an adequate explanation of this phenomenon, the concept of patriarchy must be utilized.

Defined as male domination of women through control of their labor power (Hartmann, 1981: 18), patriarchy interfaces with capital's interests in ways that seriously affect working women's lives. The impact can be vividly seen in the extent to which jobs continue to be segregated on the basis of sex, in the wage consequences of that segregation for women, and in women's unchanged domestic labor.

Often lost in the rhetoric of women's progress in obtaining economic equality is the fact that certain indices of occupational and job segregation by gender are higher today than they were thirty years ago, and that many women are worse off financially.

Women are still concentrated within a few of the lowest-paying occupational categories, with 35% of all working women employed in clerical positions. In 1950, only 62% of clerical workers were women; by 1980, that representation increased to 80% (*Race Against Time*, 1980). Within that broad occupational category is an even higher incidence of gender segregation: 98% of all secretaries, stenographers and typists, and 91% of all bookkeepers, accounting and auditing clerks are women (Keyserling, 1984).

These are distressful trends for women workers since economists have shown that 'the more an occupation is dominated by women the less it pays' (Treiman and Hartmann, 1981: 28), and since 'of all the new jobs expected through 1995, the majority are in heavily segregated, mostly female occupations' (Reskin, 1984: 8). The trends are not, of course, distressful to owners and managers who often deliberately redesign jobs such as insurance adjusters and examiners through technological 'advances' as a means of displacing male workers. Females can then be hired at lower wages (Reskin, 1984).

As is widely known, full-time women workers today earn only 59% of the wages of male workers. What is not so commonly known is that 'the wage gap between men and women is now greater than it was 30 years ago even though women now receive larger proportions of higher education degrees' (Keyserling, 1984: 16), and that full-time women workers have lost ground not only in relation to men, but in relation to their past earning power as

well. Despite the fact that the majority of women work to support themselves and their dependants, that 'in 1983, 45% of all women in the labor force were single, separated, widowed or divorced,' their purchasing power is actually lower than it was twenty years ago (Keyserling, 1984: 7–8). Fully 27% of full-time working women have earnings below the poverty line (Barrett, 1984: 16).

In contrast to men, women's position in wage labor must be viewed in relation to domestic labor. Even though time and labor-saving devices have supposedly alleviated the long hours and drudgery of household work, women who work outside the home still find that they must spend between 25–40 hours a week on housework. Husbands, on the other hand, do only a small fraction of domestic labor, and that fraction does not increase when their wives take jobs outside the home: 'between one-quarter and two-thirds of husbands reportedly do no housework at all, and those who do average between 6 and 11 hours per week' (Barrett, 1984: 23). Since the average twenty-year-old woman today can expect to be employed for thirty years of her life, she will apparently have to learn how to cope with a double work day (Keyserling, 1984: 17). Men, in the meantime, have seemed able to avoid double work. The most they have to cope with is 'losing the convenience of a full-time homemaker' (Barrett, 1984: 24).

While the exact relationship between patriarchy and capital and the extent to which they reinforce or undermine one another are still intensely debated, the contrast between men's and women's participation in wage and domestic labor is a fundamental charactistic of the 'structured totality' in which young women and men shape their lives.[5] The sexual division of labor, the technical relations in production, and the social relations in production are essential features of the 'terrain' that young workers contest and reproduce as they prepare to leave school. These reproductive processes are intensively explored in the following chapters.

Reproduction as a theoretical construct

But what exactly does it mean to reproduce the social structure? As Bills (1981: 15) so clearly states, although the concept of reproduction

sounds threatening enough, there is no need . . . to make it any more complex than necessary. Its referent is really quite simple. Essentially, it refers to the processes or mechanisms by which society maintains itself over time. It directs us to the ways in which societies remake or reproduce patterned social relationships from one generation to the next.

Although debates abound regarding both reproductive processes and the nature of the social relationships that are reproduced, two preliminary problems with the concept of reproduction must first of all be addressed.

The first problem with the reproduction metaphor, as alluded to earlier, is that it tends to connote a mechanistic, non-problematic, one-directional process. The analyses of Althusser, Bowles and Gintis, and Bourdieu, as will be discussed shortly, are particularly prone to this problem. All of them neglect processes of change, human activity, subjectivity and consciousness, even though Althusser explicitly introduces the last two concepts into his theory. Yet, such need not be the case. As Giddens (1979: 114) states:

All social reproduction is grounded in the knowledgeable application and reapplication of rules and resources by actors in situated social contexts: all interaction thus has, in every circumstance, to be contingently 'brought off' by those who are party to it. Change is in principle involved with social reproduction . . . social systems are chronically produced and reproduced by their constituent participants. *Change, or its potentiality, is thus inherent in all moments of social reproduction.* (Emphasis in the original)

The second problem with the concept of reproduction is its unspecified use, resulting in the conflation of several levels of analysis. These levels or types need to be consciously distinguished in order for a clear and coherent analysis to be possible. Yet, there is little agreement on primary categories.

Barrett (1980), following Edholm, Harris and Young, distinguishes three types of reproduction: biological reproduction, reproduction of the labor force and social reproduction, which she basically defines, for capitalist societies, as the reproduction of class relations (p. 29). Althusser, on the other hand, pays little

or no attention to biological reproduction, focusing instead on the 'reproduction of the conditions of production,' which include productive forces and 'the existing relations of production' (p. 128). Productive forces in turn include both the means or material conditions of production (raw materials, buildings, machines, etc.) and labor power. Production relations, in capitalist societies, he would say, are fundamentally relations of exploitation.

Table I: Althusser's model of the economic infrastructure

conditions of production = productive forces
(raw materials + labor power)
+
relations of production
(relations of exploitation)

For both Bourdieu (1977) and Willis (1981), the primary categories seem to be cultural reproduction and social reproduction, with Bourdieu and Passeron (1977) criticizing classical theorists and Willis (1981) criticizing structuralist Marxists (Althusser among them) for severing 'cultural reproduction from its function of social reproduction' (Bourdieu and Passeron, 1977: 10). For both Bourdieu and Willis, the concept of social reproduction is the more inclusive of the concepts, dealing with the perpetuation of power relations in class societies, and for both, the reproduction of cultural forms is a key element in the on-going relationship between classes.

Willis, however, is quite right in claiming that Bourdieu's work suffers from an imbalanced attention to cultural forms and practices. By focusing so exclusively on 'the cultural arbitrary' and 'symbolic violence,' of the culture of dominating classes, Bourdieu appears to claim by default that working or dominated classes have no culture, or at least, that their culture has no efficacy. Working class culture appears as a void, as a mere absence of dominant culture; it is defined and analyzed only through its negation. In Willis's words:

> . . . whilst Bourdieu offers a very important set of arguments
> concerning dominant culture, its relative independence,
> mode of transmission, constitution of the nature of a class,

and how all this helps to constitute the nature of a social relationship necessary to capital, he gives us no real help toward understanding what may be similar processes in the culture of the dominated. . . . Their 'culture' apparently, is only the medium of the transmission *backwards* of their objective chances in life. They disqualify themselves because they have never had a chance . . . (their) culture *is* the same as their structured location in society. . . . The dominated have no relatively independent culture and consciousness (1981: 55–6).

In contrast to this mode of analysis, Willis explicitly focuses on the reproduction of class relations through the (re)production of working-class consciousness, practices and cultural forms. Claiming that an investigation of social reproduction should start with 'the cultural milieu, in material practices and productions, in lives in their historical context in the everyday span of existence and practical consciousness' (1981: 49), Willis draws heavily upon everyday cultural productions to explain not only how class relations are reproduced but how they are (potentially) contested and transformed as well.

This mode of investigation, this focus on the relation between cultural and social reproduction most informs the analysis offered in the ethnographic account. Using Barrett's category of the reproduction of the labor force (more specified in Althusser's model as the reproduction of labor power and the relations of production as elements in the reproduction of conditions of production), I focus upon that aspect of social reproduction that has to do with the transition and integration of a new generation into the labor force, noting in particular the significance of cultural productions.

Cultural vs oversocialized theories of reproduction

The concept of culture, then, becomes central to this analysis since, in Willis's terms, it gives flesh to some of the primary processes through which social reproduction occurs. The reproduction of the labor force, of the technical and social relations in production, could not occur without the reproduction of cultural forms that makes possible the incorporation of certain groups into

specific locations in the division of labor, particularly into areas that are 'dead-end' or low-paying.

This focus on culture, cultural forms and practices utilizes a model of the social world with active participants, in constant interaction with others and with external structures, who are engaged in the on-going creation of their own identities. As such it is in theoretical opposition to traditional socialization models of reproduction processes.

Socialization models often assume, except for the case of deviants, the non-problematic internalization of societal norms. As Wrong (1961) so well stated the shortcomings of this body of literature, much of it renders an 'oversocialized' view of persons and an 'overintegrated' view of society (p. 184). The internalization of a social norm comes to mean that the person 'both affirms it and conforms to it in his conduct . . . the degree to which conformity is frequently the result of coercion rather than conviction is minimized' (Wrong, 1961: 188).

These socialization models tend to assume a static society, operating on the basis of shared norms and consensus which passive recipients mechanically internalize. They conflate varying dispositions, behaviors and motivations into a single construct (socialized) and conflate individual biography, group culture, and social structure into one harmonious unity. Nowhere is this more evident than in Parsons' telling phrase 'role-personality' (1959: 308), wherein the person becomes little more than the functions s/he performs for society, little more than a machine acting in correspondence to the needs of society. And although Wrong's benchmark article on the 'oversocialized conception of man,' written in explicit opposition to Parsonian functionalism, was published in 1961, the same theoretical problems Wrong attacked pervade much of the more recent socialization literature.

Most socialization writers follow Brim's basic definition of socialization as 'the process' by which individuals acquire the knowledge, skills, and dispositions that enable them to participate as more or less effective members of groups and the society (Goldstein and Oldham, 1979; Goslin, 1969; Kerckhoff, 1972; Schwartz, 1975). In the course of their analyses, however, they generally fail to explicate process and fall into an unquestioning acceptance of individuals learning or internalizing what they are taught from their experiences in family, school and peer groups.

In fact, the language employed in these analyses often contradicts the stated focus on process. Goldstein and Oldham, for instance, speak of the 'socialized "product" ' (p. 81). Inkeles regards the individual as the successful or unsuccessful outcome or product of a series of socializing inputs (1966: 617). Dreeben (1968), claims to begin with the assumption that by acting in situations individuals learn how to cope with their constraints. But by focusing on the school as 'an agency of socialization whose task is to effect psychological changes that enable persons to make transitions among other institutions,' (p. 3) he actually renders the activities and consciousness of individuals immaterial to his analysis, creating models of people who are little more than robots.

Some authors, despite Homans' cautions about the 'social mold theory' of human nature (Wrong, 1961: 191) even persist in describing socialization as the process in which the person is molded or shaped into an adult or effective member of society (Dager, 1971: x; Schwartz, 1975: xi; Smith and Orlosky, 1975: 2). Process, in these contexts, becomes little more than work upon the raw, inanimate materials of nature; people are objects transformed by processes to which they fall prey.

And although, in the adolescent socialization literature especially, phrases like choice and decision, reacting to meaning, and learning how to cope with situational constraints are used, these processes are little more than predictable reflexes to prior socializing experiences (Dreeben, 1968: Kerckhoff, 1972; Schwartz, 1975). People as subjects are absent from the analysis; they do little more than adapt to pre-established roles and expectations (Kerckhoff, 1972); they 'develop capacities necessary for appropriate conduct in social settings' (Dreeben, 1968; 3); they 'comply voluntarily with the demands their society makes upon them' (Schwartz, 1975: xv).

The primary image one is left with after a perusal of this literature is that of a well-oiled system (when socialization properly occurs) in which none-too-conscious beings are content enough to fit into the social slots that need to be filled. Fortunately, in this view of the social world, the different skills and qualities necessary for the proper functioning of inter-related roles in a stratified or complex society can be distributed in the population at large in their necessary proportions. All that has to be done is to provide

different socializing experiences for different adult roles (Kerck-hoff, 1972).

Surprisingly, this view of the relation between individuals and society pervades not only the traditional socialization literature, but feminist literature regarding sex-role socialization and various strains on Marxist thought as well, with concepts like habitus and ideology coming dangerously close to that which is weakest in the socialization tradition. By failing to confront problems with the concept of socialization head on, feminists often fall into the position of implying that women are 'irrational' for accepting the limitations of traditional sex-role models. The literature leaves the impression that women must indeed be the inferior or second sex to accept so easily and complacently the subordinate position they have in society, to fail to recognize and overcome the sex-role socialization they received in childhood.

Bem and Bem (1974: 20), for instance, use language which suggests that women are consigned, through socialization processes, to the role of homemaker. They claim 'it is a mark of how well the woman has been kept in her place,' of what a 'smashing success' society has achieved in socializing women to accept their traditional roles in the sexual division of labor. Jo Freeman's analysis of sex-role socialization carries the same implication of female passivity:

> (women's) motivation is controlled through the socialization
> process. Women are raised to want to fill the social roles in
> which society needs them. They are trained to model
> themselves after the accepted image and to meet as
> individuals the expectations that are held for women as a
> group (1974: 24).

And Bonnie Freeman draws upon colonization imagery to analyze women's subordinate position in society. She talks about the 'colonization of the female's identity' and of women having 'a male culture foisted on them' (pp. 208–9). These frames of reference leave no room for subjectivity to emerge, without which domination must continue in an unbroken pattern.

The term 'habitus,' associated with the work of Bourdieu and colleagues often carries the same overly determined qualities as functionalist uses of socialization and feminist notions of sex-role socialization. Although, in *Outline of a Theory of Practice*,

Bourdieu claims to develop a non-mechanistic theory of repro-
duction, since his real argument appears to be against the creative
free will approach of subjectivist voluntarism, he comes very close
to emulating the mechanistic orientation of the culture-personality
school of American anthropology he so explicitly denounces. In
this school of thought, Bourdieu argues, personality is defined 'as
a miniature replica (obtained by "moulding") of the "culture" '
(1977: 84). But by defining habitus as

> systems of durable, transposable dispositions, structured
> structures predisposed to function as structuring structures,
> that is, as principles of the generation and structuring of
> practices and representations which can be objectively
> 'regulated' and 'regular' (1977: 72)

Bourdieu establishes the same homology he attempts to argue
against. Subjects do little more than internalize social structural
requirements determined by their structural positions in society.
Habitus becomes merely 'the product of internalization of the
principles of a cultural arbitrary . . .' (1977: 31).

Similar problems exist with Marxist uses of the concept of
ideology. My contention is that by using ideology as synonymous
with culture or in place of culture, the individual (or group)
becomes little more than the personification of social role, one
aspect of a social structure in which the only change mechanism
is that of external forces since the person has so perfectly internal-
ized social expectations and needs.

Althusser (1971), for instance, in an attempt to argue the
material base of ideology, proposes that the term 'ideas' be
removed from the definition of ideology and replaced by the terms
'practices, rituals and ideological apparatus.' In this formulation,
the consciousness, beliefs and actions of subjects are interpellated
not by ideology in the form of ideas, but by the ideological appar-
atuses (church, school, family, etc.) in which practices and rituals
are embedded. In Althusser's words:

> The individual in question behaves in such and such a way,
> adopts such and such a practical attitude, and, what is more,
> participates in certain regular practices which are those of the
> ideological apparatus . . . (1971: 167).

In a later formulation Althusser (1973: 37) retracts this position

17

somewhat by stating there are actually two types of ideologies, theoretical and practical, but that the theoretical are merely 'detachments' of practical ideologies. My argument is that Althusser's description of practical ideologies is identical to commonly accepted definitions of culture and that by collapsing the entire realm of culture(s) into a construct of ideology or ideological state apparatuses, the area of human freedom, thought, conflict, ambiguity, and contradiction is lost. In Althusser's own words, 'there are no subjects except by and for their subjection. That is why they "work all by themselves" ' (1971: 182). Subjects here become the same mindless automatons they are in the functionalist socialization studies referred to earlier. Whether the concept is ideology or socialization, it functions as 'social cement.' Only system maintenance and reproduction are possible in these formulations.

Therborn and Johnson both criticize Althusser on similar grounds. According to Therborn, Althusser 'omits the question of how classes are constituted as struggling forces, resisting exploitation or actively engaged in it' (1980: 9). Johnson elaborates:

> What is correctly understood as a condition or a contingency becomes, in the course of the argument, a continuously achieved outcome. Dominant ideology, organized especially through apparatuses like schools, works with all the certainty usually ascribed to natural or biological processes. We are returned to a very familiar model of one dimensional control in which all sense of struggles or contradiction is lost. Althusser's account resembles nothing more than those (unrealized) bourgeois visions of the perfect worker which reoccur across the capitalist epoch, whether images of the sober and prudent aristocrat of labour or those soon-to-be employed young men and women, complete with aptitudes, 'employability' and 'social and life skills' who are the subject of the Manpower Services Commission (1979: 230)

This same image of perfectly socialized or ideologically determined workers also undermines the analysis of Bowles and Gintis. Although they begin *Schooling in Capitalist America* (1976: 10) with the claim that 'workers are neither machines nor commodities but, rather, active human beings who participate in production with the aim of satisfying their personal and social needs' their

formulation of the role of schooling creating differential worker characteristics ignores their own best advice. As Apple (1982: 8) states the critique, *Schooling in Capitalist America*

> tends to assume that students are fully 'determined,' that they passively accept what the school teaches them – hegemonic teaching that prepares them ideologically for life in an unequal labor market. In this way, it seriously undertheorizes the complex issues surrounding class culture and the dynamics of working-class and gender resistances in and out of schools. . . . The correspondence between the needs of the social division of labor and the real meanings that students act on in schools is not all that clear . . . one cannot assume that institutions are always successful in reproduction.

Bernstein (1977: 187–8) generally agrees with this position, claiming that while schooling 'may well *legitimize* values and attitudes relevant to the mode of production . . . this does not mean that these are so internalized as to constitute *specific personalities*.'

What I propose in this analysis is that whereas the concepts of socialization, habitus and ideology tend to be used in a deterministic manner, the concept of culture is well suited to avoid this analytic pitfall, providing room for the expression of human power and subjectivity while not falling victim to what Bourdieu refers to as the problem of social psychology, interactionism and ethnomethodology, the tendency to ignore social structure and reduce interpersonal relations to individual relations (1977: 81).

What, then, is culture and how are we to conceptualize its significance in regards to the transition from school to work? Without elaborating on the full range of anthropological debates (Geertz, 1973; White, 1972) on the nature and function of culture (whether it is primarily learned behavior, mental phenomenon or underlying structures; whether it has efficacy of its own or is primarily symbolic context), I will merely state, as should by now be apparent, that I employ a broader notion of culture than that used by Goodenough's school of thought. I do not regard culture as primarily residing in the head: as 'concepts, beliefs, and principles of action' (Wolcott, 1982: 84), as 'standards for deciding what is. . . .' (Singleton, 1974: 27), as 'a patterned system of tradition-derived norms influencing behavior' (Spindler, 1963: 6). This view is more cognitive and more coherent than are people's

lived experiences. Rather, I take the broader view that culture is 'the common sense or way of life of a particular class, group or social category, the complex of ideologies that are actually *adopted* as moral preferences or principles of life' (Johnson, 1979: 234). I take Johnson's stress on adopted to signify the lived, experiential, practical nature of the concept. That is what basically distinguishes cultural from ideological or socialization processes. Culture signifies an active participation in and creation of one's on-going way of life, not a passive reception of prescribed norms.[6]

Social actors, however, need not (and perhaps cannot) be fully aware of the elements of their culture. Common sense is not always coherent and is seldom a systematic attempt to consciously understand the meaning of one's life.[7] Culture is not primarily cognitive; it is found more in symbolic and behavioral than in verbal forms.

This distinction I am drawing between culture and ideology is quite similar to the Althusserian notions of practical and theoretical ideologies (Johnson, 1979: 233).[8] Culture, here, is predominantly material while ideology, even though it has material consequences and is embedded in material relations, is basically a mental production. Throughout this study, then, I apply the concept of culture to the common-sense utterances and the everyday behaviors of the relevant social actors. Following the example of Willis (1977: 160–70), I reserve the concept of ideology to stand for more formal systems of thought, or, as Gramsci would express it, for those ideas produced by intellectuals (Gramsci, 1971: 5–23). In the specific context of this study, ideology refers to those ideas about work and work identity put forth by the formal agenda or practices of the school and the workplace.

Since culture, like ideology, is not a 'free-floating configuration,' but is given shape by the material conditions from which it arises (McRobbie, 1978: 97), one of the aims of this study is to discover those material conditions as well as the nature of the culture(s).[9] Informed by the sub-culture literature, I will assume that the primary material conditions, structures or institutions which give rise to cultural orientations are those of work, education, family, peer-group and gender-relations (McRobbie, 1978; Willis, 1977; Hall and Jefferson, 1975).

Just as there are likely to be contradictions and differences in the ideologies these structures or institutions convey, so too are

there likely to be differences in the cultures of the students preparing themselves for office work.[10] These differences are the result not only of the situationally specific location of the students within these structures, but also of their personal biographies: the way in which each young woman constructs her identity and life-history, the way in which she makes sense of her experiences and copes with her life circumstances (Clarke et al., 1975: 49–60; Critcher, 1975: 167–73).

In the process of the identity construction, which can also be thought of more broadly as cultural production and reproduction, individuals and groups use various cultural forms to handle the situation and relationships they are confronted with. Cultural theorists classify these forms in different ways. Clarke et al. (1975), Anyon (1982), Genovese (1974) and Apple (1980, 1981) speak of a mix of resistance and accommodation, with Genovese perhaps most eloquently explaining the terms in his description of the relation of slaves to slaveholders in the anti-bellum south: 'Accommodation and resistance developed as two forms of a single process by which the slaves accepted what could not be avoided and simultaneously fought individually and as a people for moral as well as physical survival' (p. 658)[11] Willis (1977) utilizes language of differentiation and integration. The dynamic of differentiation is that of opposition to institutions and rein-terpretation of dominant ideologies in light of class or group interests and feelings; integration is 'the process whereby class oppositions and intentions are redefined, truncated and deposited within sets of apparently legitimate institutional relationships and exchanges' (p. 63). Resistance/accommodation and dif-ferentiation/integration can be seen as rough equivalents of each other. In fact, Willis goes on to speak of processes of cultural accommodation and resistance being 'riveted tight' since they are products of causes outside themselves (pp. 185–6).

Drawing upon Goffman's contrast of front and back regions in *The Presentation of Self in Everyday Life*, Giddens (1979: 208) captures the sense of accommodation/resistance in his concept of ' "pragmatic acceptance" (grudging, semi-cynical, distanced through humour).' As in the two prior couplets, pragmatic accept-ance joins together two apparently oppositional modes of relating. It is, at one and the same time, a way of conforming and a way of controlling.

This generally unarticulated strategy has its articulated counterpart in the concept of negotiation. This concept is most thoroughly explored by Strauss (1978) who argues that any notion of social order without some form of negotiation is inconceivable even though other modes of interaction (manipulation, coercion, persuasion, etc.) are often chosen, depending on the structural context (pp. 235–8). Strauss defines negotiation as a 'means of "getting things accomplished" when parties need to deal with each other to get those things done' (p. 2).

Negotiation adds a crucial dimension missing from the preceding concepts. For the first time one gets a sense of face-to-face, although not necessarily equal, confrontation or bargaining.[12] Perhaps because the previous analyses were extrapolated from extreme and overt oppositional sub-cultures, sub-cultures which did not tend to bargain with dominant cultures and institutional forms, this sense of negotiation is necessarily absent. But in most situations, certainly in the ones I observed, it was a daily occurrence.

The concept of social strategy provides yet another way of conceiving the individual's or group's interactions with their social context that is not constrained by the determinism implied in the concept socialization. Strategy suggests a purpose guiding ideas and behavior, with choices constrained by social forces. Lacey (1977: 67–73) outlines three basic types of social strategies that are pertinent to this discussion. The first is that of internalized adjustment and closely approximates the traditional definition of socialization, with the exception that Lacey works from an overly conscious and rational model of human behavior. Here 'the individual complies with (social) constraints and believes that the constraints of the situation are for the best.' The second strategy Lacey calls strategic compliance; it looks like internalized adjustment, but the individual retains 'private reservations' about such matters as another's definition and control of the situation. The third choice is that of strategic redefinition of the situation. This term 'suggests that change is brought about by individuals who do not possess the formal power to do so' (p. 73) and most closely approximates the concept of negotiation. These redefinitions can be brought about by either privatizing or collectivizing strategies (p. 89). Behavioral choices would be determined by the interac-

tions between personal biography, cultural orientations, and the constraints of a particular situation.

And, finally, three categories developed by Clarke and Jefferson (1976: 144), dominant, negotiated and oppositional, can be added to this schema. Although the authors use these categories to describe forms of consciousness in subordinate groups, I believe they can be used equally well to describe cultural forms. The authors identify two types of dominant culture for subordinate groups: deferential and aspirational. Those who embody a deferential culture accept the social world as it is and their place in it. Those who embody an aspirational culture accept the social world as it is, but *not* their particular social position. These individuals or groups generally become or attempt to become socially mobile. Those with a negotiated form of culture or consciousness recognize their subordination, view the world in terms of 'us' and 'them,' and try to compromise with that world, try to make minor gains. In the end, however, they do come to terms with domination. This is not true of those with a basically oppositional orientation to society. These groups, contend Clarke and Jefferson, do not accept the legitimacy of the social formation, but actively challenge and seek to transform it.

Although these concepts emerge from different and in some ways competing paradigms, and although there is an essential unity in such couplets as accommodation/resistance, a chart showing the rough equivalences of the concepts will help clarify them and will also demonstrate the richness of practices that a term like socialization either glosses over or denies.

Table II: The range of concepts used to replace the notion of socialization

acceptance	accommodation	negotiation	resistance
integration	strategic compliance	strategic redefinition	differentiation
dominated	pragmatic acceptance		contestation
internalized adjustment			opposition

Introduction

Where a socialization approach to the transition from school to work would ask questions like, 'how are students socialized into their work roles, what skills and attitudes do they need to learn for those roles, how do they acquire the role-personality necessary to do their jobs, and how do they adjust to work?' the cultural perspective utilized in this analysis leads to questions that do not assume adjustment. Instead, it would ask questions like, 'how do students construct identities and work orientations within particular structures of relationships, how do they account for the social and sexual divisions of labor and their place within it, how do cultures/ideologies of family, school and work interact with student cultures?' But before these questions are answered, I will briefly outline the role the school plays in the transition from school to work within this cultural perspective.

The school as a site of social reproduction

In *Learning to Labour*, Willis specifies three levels at which social institutions should be analyzed: the official, the pragmatic, and the cultural (1977: 176–9). The official level includes the formal purpose and goals of the institution and closely embodies Althusser's notion of theoretical ideology. This official ideological level of an institution should never be mistaken for its real life, which is a combination of the pragmatic and the cultural.

By the pragmatic level Willis means the everyday practice (Althusser's practical ideologies) of institutional functionaries or, in this particular context, school personnel. These practitioners are 'mainly interested in their own face to face problems of control and direction and the day to day pressures of their own survival within the inherited institution. They run a practical eye over "official" ideology' (p. 127). The pragmatic level would include the in-use curriculum, pedagogical styles, systems of evaluation, disciplinary measures and practices, and the like.

At the cultural level are the clients (in this case students) of the institution, who bring to the institutional goals and practices their own understandings and experiences of the social world, their own expectations and ways of coping.[13] This cultural level is more likely than not composed of sub-groups (often based on class, ethnic and gender divisions) and, like the pragmatic level, will not

necessarily be in line with the official ideology of the organization. An adequate understanding of the school's role in preparing students for the world of work, of allocating them to specific occupational slots or levels, and of reproducing the social and technical relations in production, would have to take these three discrete but related levels into consideration, offering explanations of continuities and discrepancies among them, as well as an analysis of the continuities and discrepancies between the educational and economic domains in general.

This type of analysis is essential if one assumes, as I have, that the social formation is a structured, rather than an expressive, totality composed of relatively autonomous parts.[14] No tight correspondence, like that envisioned by Bowles and Gintis, is possible in this type of structure. Although characteristics of the economic sector might impinge upon or influence the official, pragmatic and/or cultural levels of the school there are no direct mechanisms to ensure, as Bowles and Gintis (1976: 130) claim that students will be trained to be 'properly subordinate' workers rendered 'sufficiently fragmented in consciousness to preclude their getting together to shape their material existence.' Although there might be some general homologies, the theory that a 'correspondence principle' exists between the structures of schools and workplaces, and that structural correspondence is the primary way in which the school prepares students to be workers is doubtful (Bills, 1981).

More adequate accounts of the school as a site of social reproduction are offered by Bernstein (1977), Clarke et al. (1975), and Wolpe (1978), who work within a structured totality problematic. Bernstein, for instance, claims that although 'education is a class-allocating device, socially creating, maintaining and reproducing non-specialized and specialized skills, and specialized dispositions,' it has only an '*approximate* relevance to the mode of production' (1977: 185). He specifically mentions contradictions and discrepancies between the categories of workers produced by the schools and those expected by the mode of production (1975: 186). While Wolpe (1978: 314–16) points to the inability of schools to keep pace with a changing labor process, Bernstein basically accounts for these contradictions by claiming that the 'agents of symbolic control,' those with control over educational and ideological productions, have an ambiguous class location and are

different from those who dominate economic production (1977: 191–2).

Wolpe extends this argument by claiming disjunctures not only between those with symbolic and those with economic power, but among those with symbolic power as well, which renders 'homogeneous ideological discourse' within schools a highly unlikely situation (Wolpe, 1978: 318). Clarke et al. look beyond those with direct power in the schools, to those who are served by the schools for their analysis of contradictions between educational and economic sectors, claiming that the school is 'a classic, negotiated, or mediated class institution' doubly-bound to families and neighborhoods on the one hand, and to 'kinds of learning, types of discipline and authority relations' functional to economic production on the other (1975: 44).

An adequate analysis of the reproduction of labor power, of the transition of students into workers, needs to consider all these levels of relative autonomy and potential contradiction. Most of all, it needs to consider the cultural milieu, since

> it is from the resources of this level that decisions are made which lead to uncoerced outcomes which have the function of maintaining the structure of society. . . . To quote the larger factors is really no form of explanation at all. It does not identify a chain or set of causalities which indicate particular outcomes from many possible ones. It simply further outlines the situation which is still in need of explanation; *how* and *why* young people take the restricted and often meaningless available jobs in ways which seem sensible to their familiar world as it is actually lived (Willis, 1977: 172).

Conclusion

This chapter has outlined the theoretical framework which has informed the research and analysis presented in the following chapters. I have suggested that an analysis of the reproduction of the labor force or, in other words, of the transition from school to work needs to be situated within a social formation envisioned as a structured totality with relative autonomy and mutual determination among domains. I have argued that within this process

of social reproduction, cultural forms and orientations play a significant role in shaping work identity and must be analyzed in relation to economic factors, formal ideologies (such as are presented in schools programs), family and peer group life, and other relevant contexts. The school itself must be viewed as a multi-level site for an adequate understanding of its role in reproduction, and discontinuities as well as continuities within and between domains must be taken into account. The next chapter offers an ethnographic description of the school, the cooperative program, the teacher and the students, information which serves as a necessary prologue to the ensuing analysis.

2
Ethnographic overview

Woodrow is one of four comprehensive public high schools in Macomb, a midwest city of somewhat fewer than 200,000 people. Each of these schools draws its student body from geographic areas designated by the Board of Education; each of the schools has a population of approximately 2,000 students, with Woodrow having the oldest and largest school structure. Although an elite sub-division is within its catchment area, Woodrow is one of the two high schools considered basically 'working class.' The two high schools on the other side of town, Dewey and Bailey, are regarded as the middle-class schools. Most of the city's industry is located in Woodrow's district, and, according to the 1979–80 school profile compiled by the guidance department, it has the highest percentage (8%) of minority students.

Possibly because of the influence of a major state university and a community college within the city, Woodrow's college-going rate is higher than would be expected from such a dominant working-class area. But even though the value of higher education seems to have permeated the city, there is a marked difference between the college-going rates of students on the working-class side of town from those on the middle-class side. The future plans of the 1979 graduating classes from the four schools are shown on Table III. The table shows two distinct patterns: one for the working-class schools; one for the middle-class schools. Dewey's and Bailey's graduates are almost twice as likely to attend four-year colleges as are Humphrey's and Woodrow's, whose graduates are, in turn, twice as likely to go to work or to junior colleges upon high school completion. The category 'other' primarily includes students who are undecided about their futures. Again, there is marked contrast between the two types of schools.

Table III: Graduation plans of Macomb's Seniors by school

Graduation plans	Working-class schools		Middle-class schools	
	Humphrey 1979	Woodrow 1979	Dewey 1979	Bailey 1978*
College/university	34%	40%	70%	76%
Junior college	26%	21%	13%	8%
Work	26%	24%	13%	9%
Military	2%	3%	1%	1%
Other	12%	12%	3%	2%

* Bailey's 1979 data were not available. Other data indicate there would
be no major change among the 1978–81 patterns.

Woodrow also prided itself in having ACT scores above the
national average (although they are equal to the state's and below
the city's) and in servicing a widely diverse student population.
The student course description handbook states that

> two hundred and thirty subjects are offered including
> vocational cooperative employment programs in Business
> Education, Distributive Education and Home Economics.
> Extensive programs are in effect for students with learning
> disabilities (mental retardation, emotional problems, school
> avoidance, drop-outs, slow learners, handicapped students).
> Alternative education in the form of night school for drop-
> outs, 'free-school,' RSVP (academic and work based
> community education) and independent study is available.

On a four point scale, 25% of the 1979 class graduated with at
least a 3.0 average, 50% with at least a 2.5 average. According
to one of the assistant principals, the drop-out rate was close to
the national average. Approximately 20% of each freshman class
did not complete their senior year.

To graduate from Woodrow a student needed 20 credits,
including 2 in English, 3 in Social Studies, 1 in Mathematics, 1 in
Science and 2 in Physical Education. Data from Dewey High
showed a similar pattern, with the exceptions that 3 English credits
and only 1½ Physical Education credits were required. Although
there were some specifically required courses, a wide range of

options was open to the students within a basically untracked curriculum. Little effort was made to group students according to ability apart from the grouping which occurred due to future plans (e.g. work or college) and preferences. The only exceptions to this policy seemed to be the limited number of students alluded to in the course description handbook as 'learning disabled.' But even these categories of students were mainstreamed wherever possible, as confirmed by the experiences of three of the students in my sample.

Although the school employed hall monitors, the atmosphere in the building was generally one of uncoerced calm, of students going about the business of school. A few students tended to spend most of their day hanging outside the school doors smoking, pranks were occasionally planned, outbursts in the halls were occasionally heard, and during my year of observation one glass door was smashed in. Other than that, expressions of overt hostility and discipline problems seemed minimal. This was so even though (or perhaps because) student freedoms had been recently curtailed. During their free time students were allowed to use the cafeteria, go outdoors to smoke, or leave the school grounds. The main restriction seemed to be that students could not be in the lobby except during 1st, 4th and 7th hours or in the corridors except during the 5 minute passing time between each class.

Woodrow High School's Cooperative Office Education Program

The Cooperative Office Education class I observed started in this particular school in 1968. It was the last of Macomb's high schools to have such a program. The chief obstacle to the implementation of the program appears to have been a former business department chairperson who was not in favor of it. Upon her retirement, the present teacher, Mrs Lewis, was successful in initiating COOP and had been the sole teacher responsible for the program for the past 12 years.

Not everyone in the school was in favor of cooperative education. One assistant principal believed it was too expensive a program to operate: the coordinating teacher received an extra free period each semester for every 15 students in the program.

One business teacher expressed doubts as to its value for students, seeing it primarily as a device students used to get out of school every afternoon.

Cooperative Office Education was organized the way traditional cooperative education is. During their senior year, students attended classes part-time and worked in their career-related area part-time. In this particular situation all the students attended classes in the morning and worked from 3 to 4½ hours in the afternoons. Some put in additional time, on occasion, on Saturdays or during school holidays. Most employers were flexible in letting students off work for special events like homecoming.

Students were supposed to carry three classes in addition to the 'related' office class. Some managed a lighter load, either officially or unofficially. The related class, the office class specifically designed to relate to the work experience of the students, was 40 minutes in length and was the last class most students had before lunch and their afternoon work time. Generally classes ran 55 minutes, but Mrs Lewis received permission from the administration to release the class early so they would have time for lunch before arriving at work. Students would sometimes miss class (excused or not) and show up for work that afternoon. Four times a year Mrs Lewis met with each supervisor for a student evaluation session during which students were sometimes present. Within a day or two Mrs Lewis would then meet with each student in her private office to go over the evaluation.

Students received two separate grades and two separate credits for the class: one for class time and one for work time. Both students and teacher believed that at least two credits should be given for work. It was, in their conversations with me, a far more salient aspect of the cooperative experience than what went on in the classroom.

The Cooperative Office Education Class had a one-semester junior level prerequisite, Office Procedures, which was intended to serve three basic functions: to orient students to office work, to recruit potential students into the cooperative class, and to acquaint the teacher with potential COOP students for later selection and placement purposes. Although the class was sometimes waived for COOP students, some ended up taking it their senior, rather than their junior, year. Since it was an integral part of the program, I will describe and analyze its curriculum as well as that

of the cooperative class, but emphasis will be primarily on the senior-level class.

The Office Procedures syllabus covered the following:

September:	On the Job Training Packets
October:	Resumes, Interviewing and Phone Techniques
November:	Filing
December:	Report Typing
January:	Invoicing, Data Processing, Phone Books

In addition, spelling tests were given on most Fridays (with a pretest the preceding Monday) and the students were quizzed (but not graded) on current events about five or six times during the year. Two field experiences were open to Office Procedures students: Legal Secretaries Day, which consisted of observing an in-session court room and talking to legal secretaries in their offices, and Junior Intern Day, in which juniors could choose to spend a whole or half day in a work area they might be considering for the future.

In the senior-level related class, the following topics were covered:

September:	Check Book Reconciliation Unit
October:	Office Related Articles, Typing, Vocabulary, Job Hunting
November:	
December:	Letter Styles, Dictaphone, Proofreading
January:	
February:	Payroll Project
March:	Tax Forms
April:	Typing/Communications
May:	Grammar Sheets

Other activities that took place in the class were: planning the Appreciation Banquet (a thank-you to supervisors which took place in May); organizing a candy sale to raise funds for the banquet; having lunch together; inventorying the room's equipment; and doing typing and related work for various clubs and organizations (sometimes for pay, which went towards banquet expenses). The latter activities were infrequent, but the candy sale occupied a part of each class throughout November and the

students, organized in various committees, worked on the banquet throughout much of April and May.

Many of the curriculum materials for both classes were prepackaged. Students could, thus, read instructions for themselves and proceed at their own rate, check answers in the answer book which was generally accessible to them, and help one another as they were inclined. The most teacher-directed unit was filing, taught in the Office Procedures class. Although the materials were prepackaged, simulating an actual filing system, they were relatively complex, involving 20 rules, 5 different types of filing, and requiring timings of rate of production. The only discussion-oriented unit was the Magazine Articles. The topics brought up in the class were: sexual harassment, office feedback, office furnishing, secretarial shortage, office manners, unfair pay, and office troublemakers.

While a full analysis of cultural reproduction mechanisms would have to take all aspects of the curriculum into consideration, in this particular context too much attention to the formal corpus of knowledge would distort rather than illuminate the ideological messages actually conveyed and received. The fact is that although most of the formal syllabus was organized around the teaching of particular skills, in actual practice little class time was devoted to concentrated work in these areas and the development of these skills was not the primary concern of either the teacher or the students. During interview sessions with the teacher, the students and the graduates, the same refrain was consistently repeated.

'I don't attempt to teach much in the class because, unlike the other city high schools, we have a junior pre-requisite. I'm also less demanding in this class than in my others because the students and I spend a long time together. I'm more relaxed in here because I want to build up personal relationships. I see myself as more in a counselor's role.'

Mrs Lewis

'The hour in school seemed wasted. We didn't discuss problems at work and what we were doing. That's what I thought it would be like – saying what problems we had at work and discussing what we could do about them.'

Kathryn 1980

Introduction

'I don't think I'd want the class part again. I don't think it taught that much. I don't think there needs to be a class part. It doesn't help that much in the jobs most of us are in. I don't see the point of having it.'

Dorothy 1981

'My parents thought I was skipping when I got home early. They didn't believe she was letting us out or that there was nothing to do.'

Jane 1980

The teacher

Mrs Lewis had been directing the program at Woodrow High for twelve years. She perceived herself and introduced herself as a feminist, as a person who believed in and worked towards women's equality with men, particularly in the business world. Having had parents who encouraged her to succeed just as much as they encouraged her brothers, Mrs Lewis belonged to numerous professional and women's organizations, and had a life history that was very much career oriented. She was married, the mother of two, and, at the time of the study, a recent grandmother. On the bulletin board in her office was the saying 'All discrimination against all women must be removed' and Erica Jong's poem 'Woman Enough.'

Mrs Lewis was also quite verbal about her feminism. When the principal distributed the faculty roster, she confronted him over the asterisks placed after the names of married women. A new roster was distributed the next day with the asterisks removed. During class time, she told the students she considered the term 'Gentlemen' to be an inappropriate salutation since the unknown addressees could be women and, during a filing unit, she also told the class the formulation 'Mrs John Smith' was incorrect, that a woman always kept her own first name. She indicated in private conversation with me that she wanted the girls in her COOP class to be more assertive and career oriented than they were, but expressed the unlikelihood of that happening because of the type of socialization they received from their families.

Having herself been very active in the local teacher's union,

Mrs Lewis expressed regret that many women had anti-union attitudes since, she believed, that was the only way teachers or secretaries would ever get anything. She related this anti-union attitude to 'terrible self images,' claiming that many female teachers and secretaries behaved like 'doormats,' like inferior persons or little girls when they were around men, thanking everyone for allowing them to have such 'wonderful jobs' rather than approaching men on an equal basis. She thought that she herself threatened men because she did come across as their equal.

Prior to obtaining her position at Woodrow High School, Mrs Lewis taught business courses on a part-time basis at the local community college. That was her first teaching experience and gave her confidence in her teaching ability. She also began work on a master's degree at that time. Before that Mrs Lewis had a head secretary's job with a 'top advertising agency on Madison Avenue . . . which hired only college graduates.' She had majored in secretarial skills and minored in marketing in the Business Education Department of a major east coast university and regretted that bachelor's degrees in the secretarial area had been pretty much eliminated.

The students

The seniors who elected Cooperative Office Education at Woodrow High School did not seem atypical of their female counterparts. Since a comprehensive account of the COOP students will be given in Chapter 4, at this point I will merely describe some of the fundamental cultural forms the students witnessed in their families and participated in at school.

The students' parents basically portrayed a traditional sexual division of labor pattern in the home as well as at the workplace. Many of the students had mothers, and sometimes older sisters, who had worked in offices. This work was often done on a part-time basis, or had been returned to once families had been raised. Mothers who did not work in offices tended to be employed as sales clerks or cafeteria workers. Fathers, on the other hand, generally had histories of full-time manual labor or civil service work; most of them were loading dock workers, mechanics, truck drivers, factory workers, or building custodians. A few students

had fathers who were mail carriers or police officers; one father was a high school teacher, and one was listed as an industrial engineer although he had never been to college.

In a similar manner traditional sex roles were enacted in the home. Although, for example, three students mentioned fathers who cooked for the family, in no instance did the activity flow out of a basic role identity. In one case, the mother had suffered a mental breakdown and had been institutionalized. The father, thereafter, assumed the role of housekeeper. In another instance, the father started sharing the responsibility for cooking with his high school daughters after his wife died. In the third instance, the father had been retired for some time because of disability. Gourmet cooking had become a hobby for him.

The usual pattern, however, was the mother-as-homemaker. Not even a working mother and retired father guaranteed that the father would partake in routine housekeeping chores. In these cases, the running of the vacuum cleaner once a week seemed to vindicate the father, in his own eyes at least.

But the fact that students came from homes with a traditional division of labor did not necessarily mean that these practices were automatically internalized. Some of the students had older sisters whose marriages did not follow the traditional pattern of their parents, and this raised the possibility of the students questioning some firmly held beliefs. One student, for instance, who tenaciously clung to a strict sexual division of wage-labor ideology, arguing that 'men are stronger than women and that's just the way it should be,' simultaneously argued that men should help with everything in the house, although her own father did not, because that was the way her mother said it should be and that was what her brother-in-law did.

The cultural productions of the students at school often mirrored the gender codes they observed at home. Many of the senior girls chose to take a child development class while the boys did not, even though the class was open to them and the teacher was a firm believer in the course for all would-be parents. Yet, although the choice of the class was made out of the acceptance of a traditional sex-role ideology, the content of the class had the potential of changing students' attitudes since it often presented viewpoints that departed from their own. The word 'parenting' rather than 'mothering' was, for example, consciously used in a

syllabus which contained sections on the father's role in child-rearing and on sex-role stereotyping.

In contrast to the female-dominated child development class was the male-dominated auto mechanics. Although a few girls enrolled in it each year, most chose to stay away or never even considered it. In explaining why she had not taken the course, Marion, a 1980 graduate, said to me:

'I would have liked an auto repair course even though I'm all thumbs. But it was all boys so I wouldn't have felt right. . . . Nobody would think you'd take mechanics unless you were loose. They don't look at it like you might need to know that stuff.'

Contrastingly, the few boys who took cooking or child development were never described as loose. The one senior boy who took child development the year of my observation, for instance, was merely considered the class clown.

This same reluctance to put themselves in a position of being labelled on criteria related to sexual activity (or perceived sexual activity) prevented some of the girls from taking the traditional senior spring vacation in Florida. When I asked one of the COOP students, for example, why she was going to the Bahamas and not Florida over the spring break she answered that it was not any more expensive and, besides, girls who went to Florida tended to come back to school with a 'rep,' whether they had earned it or not. Again, the innuendos of 'having a rep' or 'being loose' never applied to boys.

The students also enacted traditional cultural forms of gender relations in the manner in which they participated in what Bernstein calls the expressive order of the school. This expressive order, often conveyed in school rituals like assemblies and extracurricular activities, 'controls the transmission of the beliefs and moral system' and can be contrasted to the instrumental order of the school 'which controls the transmission of facts, procedures and judgments involved in the acquisition of specific skills' (1975: 54–5).

A number of the COOP students had been or were, at the time of the study, peppies, cheerleaders or pom-pom girls.[1] As far as I know, none of them participated in these roles for girls' sports; rather, they cheered for boys' basketball, swimming, wrestling,

football or hockey. Being a member of one of these groups meant that on days of a pep rally or important game, the girls wore their uniforms, which usually consisted of a letter sweater, short cheerleading skirt and matching briefs. Even in sub-zero weather the girls would show support for boys' sports by baring their legs on their behalf.

Two of the students in the COOP class, Janie and Dana (an ex-model), were the co-captains of the pom-pom squad, and Maureen, a former football peppie, was nominated for the esteemed position of homecoming queen. Janie, who had started her COOP job with the State the summer before her senior year, had to alter her work schedule once school began to accommodate her pom-pom practices.

An incident that occurred one day as I walked with Janie through the mall highlights the accepted patterns of relations between Woodrow's boys and girls. Janie had cheered for the boys' swim team her junior year and those boys were quite friendly with her. On this particular day, one of the team members sneaked up on Janie from behind, 'swept her off her feet' and ran through the mall with her. Janie screamed in surprise, then laughed, offering no sign of protest or displeasure.

This same supportive and submissive behavior was also present in out-of-school activities the students reported. Doris, for instance, light-heartedly complained to me about the 'ass-pinching' treatment girls were subjected to at a particular bar in town, but she, Nancy, Kris, and Josie continued to frequent it on a regular basis, never voicing objections to the 'offenders.' Terri admitted that she felt terrible if she scored higher than her boyfriend when they went bowling and sometimes deliberately threw the ball in the gutter. And Maureen said she often took her boyfriend's socks home to darn, although at the same time she was complaining about her mother's double standard regarding house chores for her and her brother.

The structure of gender relations at Woodrow can be clearly seen in two of the most important student assemblies that took place during the year. School assemblies are a form of ritual behavior which, as Bernstein says,

> involves a highly redundant form of communication in the
> sense that, given the social context, the messages are highly

predictable. The messages themselves contain meanings which are highly condensed. Thus the major meanings in ritual are extraverbal or indirect; for they are not made verbally explicit. Ritual is a form of restricted code (1975: 62).

Bernstein described rituals as a means of social control which prevent 'the questioning of the basis of the expressive culture and so are conditions for its effective transmission and reception' (1975: 56).

This interpretation is generally supported by both the phenomenological and anthropological literature. Working within the framework of Berger and Luckmann's social construction of reality, for example, Mechling (1981: 138) contends that 'out of the natural dimorphism of sex, culture constructs gender – whole symbolic orders of male/female that permeate everyday life.' One of the ways in which this arbitrary construction is made to appear natural is through ritual dramatization which (as Mechling quotes Frank Young) 'is the communication strategy typically employed by solidarity groups in order to maintain their highly organized, but all the more vulnerable, definition of the situation' (1981: 144).

Since the school assemblies reported here were prepared by students with little or no adult supervision, they should be regarded as representative of student culture rather than school ideology. These two assemblies were called TWIRP and SENIOR AUD. TWIRP, an acronym for The Woman is Required to Pay and a variation of the Sadie Hawkins theme, traditionally took place close to Valentine's Day. The SENIOR AUD (short for auditorium) was scheduled close to graduation and was one of the fun rituals enacted to celebrate graduation.

At the TWIRP AUD, a senior boy is traditionally crowned king in a conscious take-off of the homecoming queen crowning. This same type of role-reversal also occurred during the SENIOR AUD, which seemed to be structured on the Academy Awards format. Awards were presented for various forms of notorious behavior with songs and skits interspersed for variety. The two main skits were performed by senior boys dressed as girls.

The first skit, a parody of 'The Twelve Days of Christmas,' was called 'The Twelve Years of School.' As the curtain went up, twelve boys stood with their backs to the audience singing

Introduction

In my first year of school-ing
My father said to me,

'Don't. . . .

As they went through the twelve years, the boys turned around one by one, adding the specific line written for their year. Some of the don't were: pick your nose, suck your thumb, fight with boys, stuff your bra, lift your dress up, drink and drive, get pregnant. Audience laughter was loudest when the '7th grade girl' faced the audience stuffing tissues in his bra; when the '11th grade girl' turned, displaying balloons (not too originally) stuffed in his shirt to form voluptuous breasts; and when the '12th grade girl' revealed his pregnant appearance, created with the help of a pillow.

The second skit turned out to be an introduction to the 'Most Sexy Pair of Legs' Award. The stage curtain was raised just high enough to reveal four pairs of hairy, muscular legs obviously belonging to football player-like anatomies. Each nominee offered some sex-stereotyped movement, like leg stroking or crossing, as his number was called off for judgment. When the winner was announced he emerged from behind the curtain to accept his award in a tuxedo jacket and boxer shorts.

I would argue that a specific form of social control was exercised in these rituals. By enacting a traditional gender code which identifies women primarily on the basis of their sexuality at the very moment of high school graduation, at the time when academic achievement and accomplishment are foremost, the senior boys (in ways probably not realized by them) assert their superiority and dominance by dramatizing what they think the girls' identity really is.[2] The fact that the girls in the audience appeared to enjoy the humor in these skits as much as did the boys indicates that, although arbitrary and therefore always vulnerable, the dominant gender code still maintained a high degree of legitimacy among Woodrow's student population.

The language used during these events evinced the same stratified structure of gender relations. Just minutes prior to the start of the SENIOR AUD, when the planning committee was finishing last-minute details like microphone testing, a boy from the audience yelled to a girl on stage who could not be heard, 'Well speak up, woman!' The same type of language was used during the

assembly. One of the awards was called the Don Juan or 'Swinger' Award. In describing the award the male MC said, 'Most guys like to *keep* a steady girl, but some of us don't.' Somewhat surprisingly, this language, announcing ownership and possession, was not used solely by boys. Cindy, one of the COOP students, responded to a joking remark Mrs Lewis made about dating with the remark, 'I'm not interested. I'm *taken.*'

Other occurrences during these assemblies also revealed the same dominant gender code. Boys and girls, except for a few steady couples, chose to segregate themselves in the audience. The boys tended to cluster in the back from where they would direct cat calls and wolf whistles to various girls on stage. These clusters of boys would also hoot and snicker at the singing of such popular romantic songs as 'If' and 'Close to You.' The girls sitting in front of them would then turn around to shout 'Oh, shut up' or 'Grow up' and would show their appreciation to the duet on stage (and for a culture of romance) by giving them a long, loud, standing ovation.

Various ethnographers have commented on the young female's immersion in a culture of romance. Brake (1980: 140) notes how the theme of romantic attachment (and dependence on men) is emphasized in the media (songs, comics, pop stars) adolescent women are drawn to, and McRobbie (1978: 98) calls the culture of romance a factor that 'saves' girls from the otherwise 'unexciting future' they envision for themselves. Boys, on the other hand, at least in public, must preserve their independent, masculine images by scorning that which is so obviously feminine.

Conclusion

This brief description of Woodrow High School, of the Cooperative Office Education Program and the teacher who conducted it, and of a particular aspect of the cultural life of the students as enacted at home and at school provides the context in which the COOP students started to become clerical workers. In this chapter I have begun to explore the dominant gender code at Woodrow High School, a code that relegates women to positions subordinate to men and judges them on different criteria. This gender code is

critical to the forthcoming analysis since it helped structure the way COOP students constructed their work identities.

The three main parts of this analysis develop and relate the ways in which the student's culture interacts with the COOP program to shape their transition from school to work. Part Two analyses their choice of office training in the form of cooperative preparation and the way in which they obtain jobs; it focuses on allocation processes. Part Three focuses on the actual work the students do on their jobs, on the technical relations in production. It analyzes the skills needed for those jobs, the skills the students learn in school and their involvement in learning and production. Part Four focuses on social relations that structure the labor process, on exchange, authority and gender relations in particular, on the school's role in preparing the students for their roles in these relations, and how the students actually participate in these relations. And finally, Part Five draws out the implications and connections of these three aspects of the reproduction of the labor force and offers some suggestions for office education.

PART TWO
Reproducing the division of labour

3
The school's selection processes

In order to understand who the students were who enrolled in Cooperative Office Education at Woodrow High School, why they signed up for the program, how they obtained jobs, and what future directions they took upon graduation from the program, in order to understand (in other words and loosely speaking) the 'status attainment process' of this group of students, key elements of the official, pragmatic and cultural levels of the selection process must be examined. As I will explain, what have been called allocation theories of status attainment would locate selection mechanisms at the official and pragmatic levels; they would place the power of determining the educational and occupational trajectories of students in the hands of the school. Socialization theories, on the other hand, would locate the selection mechanisms at the cultural level; they would view the role of the school as merely implementing the choices and decisions of students and their parents. While both approaches help explain certain selection practices that occurred in the students' cooperative experience neither of them (singly or collectively) is capable of rendering an adequate account of the transition of these students from high school to either the world of work or to further education.

Allocation theories posit the intervention of school authorities and structures in determining who receives desirable school rewards, such as college preparatory track placements. They examine 'the mechanisms and criteria of control of the individual by social agencies' (Kerckhoff, 1976: 369) and although, technically speaking, can point to meritocratic selection criteria, they are generally used by school critics to reveal arbitrary or biased allocating procedures.

Allocation theories are specified in diverse ways. Erickson

(1975) posits a gatekeeping model wherein counselors and other monitoring officials make decisions regarding other people's lives and careers on the basis of ethnic or co-membership identification rather than on the basis of qualifications. Clark (1960) describes a cooling-out model of status deprivation wherein students thought to be unpromising are covertly 'sidetracked' from their pursuits by a variety of institutional practices. Karabel (1972) claims that this cooling-out function has a strong social-class basis.

Rosenbaum's tournament model of status attainment can be succinctly described by the phrase, 'when you win, you only win the right to go on to the next round; when you lose you lose forever' (1978: 252). In this allocation model, structural mechanisms like grade-weighting and lack of information or misinformation given by school personnel function to select students out of college tracks and into general or vocational tracks. Once screened out, attendance at a four-year college becomes a virtual impossibility.

In a tangential way, Bourdieu's notion of cultural capital can also be regarded as a type of allocation theory in that schools are seen to 'reproduce the structure of the distribution of cultural capital among . . . groups or classes, thereby contributing to the reproduction of the social structure' (Bourdieu and Passeron 1977: 11). They do this by sanctioning the cultural arbitrary of a particular class, by preventing dominated classes from recognizing the arbitrariness of that culture, and 'by enabling the possessors of the prerequisite cultural capital to continue to monopolize that capital' (p. 47).

At a more abstract or generalized level of analysis, many of these allocation models either imply or directly state that the school functions, not merely as a selection agency, but as a legitimating agency for a stratified or class society. It legitimates both the unequal structure of that society and who obtains what positions within it by making those who are not selected for the desirable positions believe they are not worthy of or qualified for them. Karabel (1972: 240), for instance, claims that one of the main features of the cooling out function of schools 'is that it causes people to blame themselves rather than the system for their "failure".' Bourdieu and Passeron (1977: 210) make a similar claim:

. . . in a society in which the obtaining of social privileges
depends more and more closely on possession of academic
credentials, the School . . . confers on the privileged the
supreme privilege of not seeing themselves as privileged
(and) manages the more easily to convince the disinherited
that they owe their scholastic and social destiny to their lack
of gifts or merits.

If applicable to the selection processes of the COOP program
at Woodrow High School, certain features of these allocation
models will be evident. School personnel will be actively involved
in directing students to the types and levels of programs they
regard as suitable. This should occur even if there is no formal
track structure. Since COOP is regarded as a mid-level program
(a non-academically oriented but a high-level business course),
students who exhibit strong academic ability would be discouraged
from enrolling in the program as would minimal achievers and,
in the words of Woodrow's course description handbook, learning
disabled students. Moreover, since allocation theorists posit
screening procedures on the basis of a range of ascriptive factors
and since office work is traditionally regarded as women's work,
gender could well be a factor in determining who is and who is
not encouraged to take the program.

Moreover, particularly if Rosenbaum's tournament model is
relevant to this context, structural mechanisms will be in place
that prevent students from compensating for lack of preparation in
particular areas. Academic and career information will be lacking,
misleading or unevenly distributed. Lastly, students not in college
tracks will believe in the 'natural superiority' of college-goers and
might blame themselves for their own failure.

Socialization theories of status attainment, on the other hand,
generally do not envision the school as a legitimating agency since
they view the school as merely implementing the expressed wishes
of its clientele. An individual's status attainment is seen as 'being
determined by what he chooses to do and how well he does it'
(Kerckhoff, 1976: 369). Choices are seen to vary on the basis of
social class, ability and other ascriptive criteria, but these choices
are viewed as free and uncoerced, arising from such psychological
and individual-level variables as ambition, aspiration, and role
identification. If students take unequal advantage of the resources

the school provides them it is because they choose to do so, because their motivations and life goals are different. If the school provides a range of courses and other resources to students, it does so in response to their range of requests, not in an attempt to manipulate their destinies. Thus, if minority students under-achieve or have lower status ambitions than whites, the cause is seen as a 'fatalistic life-orientation' because of early socializing experiences (Kerckhoff and Campbell, 1977). If women continue to choose classes that prepare them for traditional sex roles, the cause is a gender-based identification with role models or a social-ized interest in intrinsic rather than extrinsic rewards (Wolpe, 1978). In neither case, according to this perspective, does the school influence these decisions or orientations. It is a neutral institution established solely to serve its clients.

Applications of this model of status attainment to the COOP program are fairly apparent. If the socialization model applies, students will not have been, even covertly, deterred from their desired courses of action. They will be in the COOP program because it fits in with their life goals and offers them the type or level of status they are seeking. If gender-based tracking exists, for instance, school personnel will have had nothing to do with it, other than heeding the requests made to them.

Before analyzing the relation of these status attainment models to the context of cooperative office education at Woodrow High School, a brief statement of some of the limitations of allocation and socialization theories will be helpful in guiding the reader through the ethnographic material. These shortcomings, merely stated now, will be analyzed and further explained in the context of this section.

First of all, allocation theories are based on the premise of scarcity of desirable openings, a scarcity which implies competition for those openings. As the content of Chapter 3 will explain, although COOP officially meets the criteria for desirable place-ment, competition for admission into the program did not exist.

Secondly, as the forthcoming ethnographic material will demon-strate, allocation theories imply two things about social agents that were definitely not true of the cooperative office education students: that they are easily manipulated and deterred from their pursuits, and that their foremost occupational interest is upward mobility or the attainment of status.

48

Third, although allocation theories claim the importance of societal forces and structural limitations in the selection process, when operationalized, these structural forces are limited to such institutional variables as school resources or contextual characteristics, or the criteria school personnel use in advising, grading or tracking decisions. While characteristics of the labor market seem an obvious structural determinant, they are seldom mentioned as a significant factor in allocation models. Paradoxically, socialization theories of status attainment, which focus on the individual's skills and motivations, are better at including labor market factors. Their shortcoming, however, is in focusing solely on the 'perceived' opportunity structure. By failing to investigate the relationship between real and perceived structures, this approach is forced back into such social psychological explanations of status attainment as traditional sex-role socialization or fatalistic life-orientations (Garrison, 1979; Kerckhoff and Campbell, 1977).

And finally, in socialization theories, aspirations are often viewed as being stable, having unalterable consequences and changing prior to changes in the opportunity structure (Macke and Morgan, 1978; Garrison, 1979).[1] By implication, socialization models offer a view of the social world totally open to the movements individuals choose to make within it; aspirations have less to do with material conditions than with socializing practices and the perceptions they evoke.[2] My data question these assumptions, indicating the quite apparent impact of the real opportunity structure on these students' educational and occupational orientations.

By analyzing ideologies and practices at the official, practical and cultural levels, I indicate which aspects of allocation theory were relevant to the selection and stratification processes that occurred during the course of the cooperative program and why those aspects and not others were significant. In keeping with the alternative model of cultural reproduction outlined in Chapter I, I further demonstrate the inadequacy of socialization theories 'psychological variables' of ambition, aspiration, and sex-role identification.

Selection mechanisms: the official level

According to the official state guidelines for cooperative education, the teacher-coordinator is the person who selects

49

students into the program. So, at the official level at least, COOP is seen to function on an allocation model. The guidelines state that

> the teacher-coordinator should select the students who *want*, *need*, and *can benefit* most from the Cooperative Office Occupations Program. In order to maintain objectivity in selecting these students, a coordinator must strive to maintain standard criteria when evaluating applicants.

Selection criteria can vary on the basis of program objectives and/ or the business environment, but should not vary from student to student. They should be applied in an equitable, meritocratic, non-arbitrary manner.

To further assist teachers in selecting students for the program, the guidelines itemize two different types of criteria that should . be taken into consideration: fixed and variable. The fixed criteria 'are composed of requirements the students must meet to be eligible to COOP' and are threefold: vocational objective, skill requirements and senior status. With regard to vocational objective, the guidelines explicitly state that 'all students enrolled in the COOP must have a clearly defined career goal' that falls within the broad categories of office occupations (e.g. accounting, computing, data processing, general clerical, secretarial, typing). With regard to skill requirements, the guidelines list advanced typewriting, orientation to the various office machines, introduction to filing, office procedures, and job application and interview techniques. These are the basic skills students should have prior to their participation in COOP. The senior level course should then improve these skills, which students may have developed in a junior level introductory office course or elsewhere. With regard to the last criteria, senior standing, the guidelines state that since 'COOP is designed to prepare students for employment immediately upon graduation from high school,' the students who are selected should be ready to graduate upon completion of the program.

The official guidelines, then, make the same assumption as do many of the socialization approaches to status attainment: that high school students have a consciously developed life plan and have made well-thought-out occupational decisions. Since enrollment in the program is officially dependent on students having

acquired specific office skills, these students would have to make some preliminary career decisions when they are fifteen years of age. The guidelines also presume that these students envision employment in office work as a career.

Since the skill requirements are part of the fixed criteria the teacher-coordinator is to take into account when selecting students into the program, Rosenbaum's tournament model of status attainment should be applicable to COOP. If by the time they complete their junior year students did not take courses which taught them (or in some other way develop) advanced typing and other office skills, they should not be admitted to the COOP program.

In addition to these fixed criteria, the guidelines list a number of variable criteria which are suggested means of determining student performance and eligibility. The guidelines say that 'variable criteria measure student performance in several different areas and are used to provide the coordinator with the basis for student eligibility.' Variable criteria include attendance, faculty evaluations, coordinator interview, course work, employable skills, neatness of application, work experience and extra-curricular activities. The teacher-coordinator is encouraged to obtain data on these criteria by reviewing the students' application sheets and cumulative record, by conducting an interview with the student, by obtaining recommendations from other teachers, and by verifying the students' career objectives with their guidance counselors. These procedures should help the teacher assess the students' qualifications and interests, their communicative, mathematical and employable skills, and such personality traits as enthusiasm and courtesy.

The students' role in the selection process would be making known the fact that they 'want, need and can benefit' from participation in a COOP program. Indicators of this office career orientation and desire would apparently be such things as a history of enrollment in office-related courses, verbalizing this career interest to counselors and teachers, success in developing verbal, math and office-related skills, good attendance, neatness, and a courteous and enthusiastic personality. But ultimately it is up to the teacher-coordinator to decide who is best qualified for the program.

Nowhere do the guidelines suggest that there might be potential

problems in objectively applying these selection criteria. Nowhere, for instance, is it suggested that the students who are the most skilled or who express the strongest desire for participation in the program might not necessarily be the same students who can most benefit from it. But clearly this is a source of ambiguity, as is the manner in which the variable criteria are described. By calling criteria such as attendance, course work and work experience 'variable' and by neglecting to offer any definition of variable or any description of how or when these criteria should be brought into consideration, the guidelines encourage the exact arbitrary selection processes they supposedly were written to avoid. How, for example, is a teacher to weigh the applications of a student with some work experience against the application of a student with a perfect attendance record? How does a teacher regard the application of a student with a history of school avoidance but who gives strong evidence of being able to benefit from a job skills program? In matters such as these the guidelines are of no help to the teacher-coordinator.

Selection mechanisms: the pragmatic level

These last few paragraphs have indicated that although at the official level the selection process for cooperative office education seems relatively straightforward it contains assumptions and ambiguities that have the potential of making the application of the criteria relatively difficult. It should not be surprising, therefore, to find that the selection process at the pragmatic level, the level which must additionally accommodate institutional constraints and school personnel's perceptions and practical interests, does not exactly mirror the official guidelines.

In fact, little that occurred in the COOP program at Woodrow High School could actually be termed 'selection' since virtually any student who applied to the program was accepted. This open-admissions policy of sorts appeared to be the result of two factors: the low numbers of students who applied to the program, and Mrs Lewis's belief in the value of the program for a wide range of students.

The low number of students who enrolled in COOP seemed to have been caused by multiple factors. First, although COOP was

listed in Woodrow's annual course description booklet, and some
of the students knew about it through this official channel, many
students indicated they knew nothing about it until some chance
occurrence brought it to their attention.[3] This incident often
involved a conversation with a student who was already enrolled in
Cooperative Office Education. These descriptions of the 'decision-
making' process were typical:

'I didn't take COOP until second semester. I had a friend who
was in the program and she said she was enjoying it; she
liked working in an office situation. And she was making
money. It sounded interesting.'

'When I was in the 10th or 11th grade I was sitting in the
library with Gloria, who was in office education. I thought to
myself, "Gee, you get the whole afternoon off. You don't
have to stay in school for more classes." That sounded great.'

'I heard about COOP from a friend of mine who took it last
year. She would tell Doris and me about it and how nice it was
to leave school each day. We didn't really decide to take it
until the last minute.'

A few of the students, those whose circumstances or plans
tended to be quite unusual, were encouraged to take COOP by
a teacher or counselor who would not as a matter of routine be
recommending COOP to the students. One student, for instance,
had found a job at an insurance company the summer before her
senior year. She wanted to keep the job (which her parents had
been 'nagging' her to get) during her last year of high school and
her counselor suggested that was the right type of job for her to
receive COOP credit. She had not necessarily thought about
'going into' business prior to this. Another student, who also had
an office-type job at a small oil delivery company prior to her
senior year, was similarly encouraged by her counselor. Because
this student's mother had died, she needed to be enrolled as a
full-time student in order to be eligible for her social security. She
could not leave school at noon to go to work and still be
considered full-time unless her work also counted for school
credit. The counselor immediately suggested COOP as a means
of resolving the problem. The other student who fell into this
category was interested in trying for an accounting scholarship.

53

Her interests were known to a math teacher whose daughter, a CPA, had taken COOP. He recommended Kathryn do the same in order to obtain some accounting-related work experience before she graduated. Kathryn commented that she had never heard of COOP before this, adding, 'and I had taken accounting and typing in the business department.'

But these occasions of school staff encouragement to take COOP were definitely the exception. In fact, of the thirty-three students in my sample, only four received information about COOP from a counselor or teacher other than Mrs Lewis. From Mrs Lewis's point of view, the business department as a whole and the cooperative office education program in particular did not receive the type of support they needed and deserved from the rest of the school staff. In a conversation she had with the COOP students she told them that there were definitely factions among school personnel. 'Some people believe that schools should only teach academic subjects: English, history, things like that. They believe schools should not be in the vocational business at all.' And because COOP is an expensive program, it is frequently mentioned as a possible area to eliminate when budgets are tightened.

Lack of information regarding Cooperative Office Education clearly seems to have been a factor in the low numbers of students who applied to the program. So, while counselors actively sought to accommodate special student needs in recommending COOP to them, for the most part (even though they did not overtly function as gatekeepers) they can be viewed as having acted in that capacity in their failure to disseminate information. This failure, however, as Rosenbaum (1976) has indicated, may be more of a structural condition than a personal choice. At Woodrow, the ratio of students to counselors was something like 400 to 1. Given these conditions, counselors are obviously not in the best situation to do routine and thorough academic counseling.

But it is not clear how many more students would have applied to COOP had they known about it. I raise this question for two reasons. First of all, as Mrs Lewis and some of the students themselves mentioned, a decision to take COOP involved a major commitment. At minimum, it meant being gone from the school building from noon on for one's entire senior year (with the exception of the few students who took the program for one

semester only). For a student who wanted or needed a class that was only offered in the afternoon, taking COOP was almost automatically out of the question. Or, for someone who liked school and was involved in extracurricular activities, COOP was also a difficult choice. If a student wanted to remain active in sports, cheerleading and/or student government, she had to see if it were possible to arrange school and work schedules around that activity, which meant directly approaching teachers and supervisors to see if they would be amenable to such an arrangement.

The second reason why more students might not have signed up for COOP is because of their particular perception of the program. According to Mrs Lewis, this would include two types of students. The first type would be the students who already had part-time jobs and thought they did not need a school program to help them find one. They did not see any difference between a 'job' and a 'career' and so would not see value in enrolling in a vocational preparation program.

The second type, according to Mrs Lewis, would be the students who would consider office work undesirable. In Mrs Lewis's words, 'nobody wants to be a secretary.' This, she said, was more true now than it was ten years ago because the woman's movement had opened doors to professional occupations previously closed to them. The 'higher-level' woman now had more opportunity and more choice than she once had and so did not have to settle for office work, where women are generally not considered part of the managerial team and do not make much money.

This perception is supported by the literature and is commonly believed. The chairperson of Woodrow's Business Department gave me a magazine article entitled 'The Case of the Disappearing Secretary.' Referring to Department of Labor Statistics, the article states that although 3.6 million people are now employed as secretaries, '20% of the available jobs go unfilled.' The article claims that low pay and status and sometimes 'demeaning tasks' characterize office jobs and that there will be 'plenty of openings far into the future' (Seixas, 1981: 84). In a recent survey of members of the National Secretaries Association, respondents stated that lack of esteem, low salaries, lack of advancement opportunity, the secretarial shortage, and go-fer functions were among their

ten uppermost professional concerns (Riley, 1980: 20). These findings are corroborated by the scholarly literature.[4]

According to Mrs Lewis, this change at the societal level forced her to take students she would have rejected otherwise, although students were generally not aware of this. Referring to one of the COOP students, Mrs Lewis commented, 'If I had a lot to choose from, she would not be chosen.' Speaking at a more general level, she continued:

> 'I have taken many students I wished I could have turned away. . . . Students like this unfortunately find themselves in office jobs today, whereas say fifteen or twenty years ago nobody with her ability would even have been hired in an office. . . . She would have been in a factory, or, if there were a decent day-care system in the U.S. she would be working with children. She would be working in something that wasn't demanding and that didn't have a lot of deadlines. But because our world has changed and women's roles have changed, business unfortunately has had to absorb people it never would have looked at twice. . . . We have had to take students for office jobs who are not real good workers.'

Mrs Lewis believed, then, that her right or power to select students for COOP was severely curtailed by societal changes. During the year of my field work, only sixteen students registered for the class (one a week late), so it was apparent that Mrs Lewis did not have much leeway to screen students from the program.

From the information I was able to obtain, only one student was turned down for the program that year. Mrs Lewis said she screened her out because her record of school avoidance was so great she would simply be too high a risk in a work situation. When she went over the list of students with me who were interested in signing up for COOP the following year, the same two qualities of low-ability and poor attendance emerged as screening criteria. Again, however, Mrs Lewis's ability to use these criteria was mostly dependent on the numbers of students she had to choose from. She referred to one of the students as a 'poor attender,' adding 'I've had a conference with her counselor, but I'll have to take her if the class is small.' In these situations, Mrs Lewis did not have the structural freedom to function as a gatekeeper.

However, in the 1980–81 school year, twenty-seven students had taken the COOP class, the highest number in its twelve-year history.[5] Obviously, if Mrs Lewis were to have exercised her right to be selective, she would have done so with this group of students. But she did not. With twenty-six students in her class first semester, Mrs Lewis took on an additional student (one with medical school aspirations) second semester. She also accepted at least two students into that class who had accumulated such high levels of truancy that they had been placed in special school programs. One of those students had had a positive relationship in other classes with Mrs Lewis, who apparently felt that despite Debbie's school record, she would be a good risk. In a conversation about yet another student in that 1980 class of twenty-seven students, Mrs Lewis commented on how helpful COOP was to a young person who came from a 'poor background' and who would never be exposed to the office world without participation in such a program.

So even though the low number of students who enrolled in Cooperative Office Education was the main reason why screening procedures were so minimal, it was obviously not the only reason. It appeared to me that Mrs Lewis's belief in the value of the program for students disposed her to maintain a relatively open admissions policy, even though the extra numbers would result in a much heavier work load for her. Although she had often remarked on businesses not giving secretaries adequate pay, responsibility or decision-making power, she also told me that she had loved everything about being a secretary and that she often felt more affinity toward secretaries than toward many teachers.

It was also apparent that Mrs Lewis placed a high value on cooperative education as a specific form of vocational training. Before COOP was offered at Woodrow High, Mrs Lewis had encouraged its adoption. But the implementation of the program was blocked by the incumbent business department chairperson who saw no point in initiating a relatively expensive program into the department's curriculum. Upon that teacher's retirement, Mrs Lewis again put forth the proposal for Cooperative Office Education, this time successfully. Since COOP teachers must be specially certified, Mrs Lewis undertook the required training, and at the time of my field work, had been the sole teacher responsible for the program for the previous twelve years.

57

If admission to Woodrow High School's Cooperative Office Education Program had occurred in a highly competitive context, one in which the demand for classroom slots was greater than the supply of students, Mrs Lewis undoubtedly would have screened out more students than she did. But since she was faced with the constraint of meeting a yearly quota or running the risk of having the program eliminated from the school's curriculum, students found themselves in the position of being able to select themselves into the class. It was, so to speak, a buyer's market.

Probably because of this supply/demand relationship, I found nothing in this case study to approximate Rosenbaum's tournament model of selection. Although Rosenbaum (1978) was referring to a college preparatory program, the prerequisites for Cooperative Office Education mandated by the state make the selection mechanisms for the two case studies comparable. At Woodrow High School, these prerequisites were not rigidly enforced, but were waived on an individual basis according to the discretion of Mrs Lewis. Only in a very competitive environment of scarce openings, as this analysis and the work of Davis and Haller (1981) suggest, is a tournament model of selection likely to be found.

For the same reason, the selection process into the COOP program bore little resemblance to Clark's cooling-out metaphor. Seldom did enough students apply to the class for any of them to be cooled out; when they did (with the exception of the most truant or low-achieving student) they were still accepted into the program because job opportunities in offices were plentiful. As in the tournament and gatekeeping models, the cooling-out function is only needed in the face of excessive aspirations. In this context, what is in greater need of explanation is why more students were not cooled out of college preparation classes and into the COOP program. This chapter has accounted for that phenomenon by describing the lack of information available about the program, the enormous time investment COOP-ing required and Mrs Lewis's account of the perceptions students had of the program. Moreover, the last section of this chapter described how, in a basically untracked school like Woodrow High, it is possible for college-bound students to acquire adequate training in both academic and vocationally oriented classes. Before moving to the cultural level of analysis, however, COOP job selection processes

need to be examined, since they differed quite markedly from selection into the program itself.

Although Mrs Lewis did not have much control over the students who enrolled in Cooperative Office Education, she was able to exercise a certain amount of discretionary power regarding the jobs the students interviewed for as part of their cooperative experience. On occasion a student would find an office job herself and then decide to enroll in the COOP program. But for the most part the process worked the other way around, more in keeping with the official description of the program, wherein a student's competencies and interests were to be assessed by the teacher/coordinator in order to select an appropriate work situation for the student.

This job selection process pertained only to the interview stage, however. Mrs Lewis never had the power to actually place a student in a job. Rather, she would send specific students to interviews at specific job sites. Supervisors then interviewed students who were sent to them (sometimes from more than one school) and made the final hiring decisions. Some of the jobs were announced to all of the students in what might be called an open job-market competition model. Mrs Lewis would give the students a brief description of the job and let them decide whether or not they would apply for it. At other times, Mrs Lewis notified select students about the availability for certain jobs. Criteria for selection varied according to the situation.

Because Mrs Lewis had some of the students in previous classes and because she had them fill out application forms as soon as they informed her of their desire to enroll in COOP (sometimes as early as the first semester of their junior year), she had certain information available to her that she could use in deciding which students to notify about job openings. The application form asked such questions as

What subjects do you plan to take next year?

Do you plan to attend school after graduation? Where? What course of study?

What type of work do you think you will be doing five years from now?

If you were absent over five times last year, give reason.

How do you consider your record as a student? (Excellent,
 Above average, Average, Below Average).
Would you like to start your COOP job in the summer?
What type of COOP position would you be interested in?

Students were also requested to list their previous work experience
and the subjects they had taken and grades received over their
previous high school years.

One of the relatively straightforward questions from the appli-
cation to serve as a means of soliciting students for job interviews
was whether or not they wanted to start work in the summer.
Since few jobs opened up before the fall and since few students
chose to begin their COOP work during the summer (only three
of my thirty-three interviewees), the job selection process usually
involved more complex factors. The four primary criteria Mrs
Lewis seemed to use in suggesting certain jobs to select students
were: characteristics of the job or work site, student career
interest, student ability, and the student's mode of self-presen-
tation. These criteria were generally overlapping.

Mrs Lewis sometimes selected students for specific job inter-
views because of her knowledge about or feeling toward that
particular organization. At one work site, for example, COOP
students from other schools in the area were also sent to interview.
Because of this, Mrs Lewis said, 'We really want to send good
kids.' She would tell only those students she considered to be well
qualified about the jobs. Mrs Lewis would tell the students the
qualifications that were listed for the job and then ask the students
if they had those qualifications since, as she said, 'They often
have the better ability to judge what they can handle.' In other
words, Mrs Lewis did the first level of screening, the students
did the second level, and the job supervisor made the final
selection.

Mrs Lewis mentioned two other work sites that required very
capable students. Both of these places required the students to
take a written test, whereas most of the other employment
decisions were based solely on an interview. At one of these
places, the test was primarily one of grammar proficiency.
Students were given a business letter consisting of grammatical
errors and were asked to correct it, producing a perfect copy at
the typewriter. The year prior to my field work, this department

refused to take any of the students who applied for the job because of their lack of basic English knowledge.

The written test at the other work site was more mathematical. Mrs Lewis described the job as requiring a lot of common sense and the ability to cope with all kinds of situations and said the employers trusted her to send them capable students. Patti, whom at the start of the year Mrs Lewis described as 'fabulous,' and Evelyn, the highest ranking student in the class, were the two students sent to take the test. Both were hired.

There were also certain jobs which Mrs Lewis considered quite routine, and which could, therefore, absorb students who lacked a high level of skill or job aptitude. These jobs she would also point out to specific students. Kris was one such student. About her Mrs Lewis said,

> 'I've had to take too many like her; I don't feel that she's good material. . . . I used to call students like Kris in for a conference and say I felt their career choice was probably in other areas, that they'd be happier in a different kind of work. I try to let them down easy when I see that they aren't going to have a too successful experience. Kris will be okay in a highly supervised, routine job, like the one she has now.'

Kris spent most of her work day, along with about twenty other women, doing straight copy typing on standardized forms.

Obviously then, Mrs Lewis attempted to fit students with jobs according to what she perceived to be their ability level. This matching process was sometimes difficult, however, for as she indicated to a supervisor, sometimes one job contains multiple tasks whose degree of difficulty greatly varies. She said it was hard, for example, to find a student who would be happy working a photocopying machine for hours who also had the capability to operate a word processor. One student Mrs Lewis placed primarily for the more routine work of filing and photocopying was promoted the following year to a word processing operator. Mrs Lewis said she had underestimated her capabilities. 'I never thought she'd be able to work on the machines. I didn't think she had the ability.'

There was also a work site about which Mrs Lewis said she had 'a very special feeling.' She and REMIC had, so to speak, 'grown up together.' REMIC was a small, new, up-and-coming mortgage

insurance corporation located in a small area of an office building when Mrs Lewis placed her first COOP student there eleven years ago. She then dealt directly with the secretary to the president. Since that time, REMIC had become very successful and had built its multiple-story, modern world headquarters in Macomb. A COOP student from Woodrow High had been placed there every year. During the year of my field work, Nancy was the only student sent to interview at REMIC. Mrs Lewis had wanted to send Josie, her favorite student, to interview there, but Josie was interested in going into banking. Because she saw Josie as a very work-oriented person and a desirable employee, Mrs Lewis sent Josie to interview at a local bank even though they said they did not have any openings for a COOP student that year. Josie was hired on the spot.

At the beginning of the year Mrs Lewis had described Nancy as a sharp, bright girl who would go far, and had actively recruited her into COOP. While Nancy's academic record was fairly mediocre (she had a 2.2 Grade Point Average and Mrs Lewis had given her a C in a previous course), she was a strikingly attractive and fashion-conscious young woman. Unlike many of the other students, she frequently wore make-up, skirts and high-heels, and spent time arranging her shoulder length hair in different styles: braiding sections of it, parting it in various ways, decorating it with feathers, bows, hair clips or combs.

Mode of self-presentation was obviously another criterion Mrs Lewis considered in job placement; it was apparently important to a number of employers as well. In discussing this matter during an interview she said: 'I tend to look at appearance as being extremely important. For instance, in New York, what do girls who work in top-notch jobs look like: Fabulous! Well dressed, make-up, everything. That's the way it is everywhere.' If a student's appearance was poor Mrs Lewis would make the following type of comment: 'She could never be a teller. She would have to work behind the scenes.' If a student had an attractive appearance Mrs Lewis would indicate that she would have little trouble placing her even if she did not have much business background. This, in fact, was born out in the hiring process. One student's difficulties in finding a job best highlights the salience of mode of self-presentation.

By the end of their first two weeks in the cooperative program

all the students in the class had found jobs, except one. This student, Dorothy, stood out from the rest of the class in that she was overweight and, while always neat, dressed in old, inexpensive jeans, blouses and shoes. Not until the end of the second month of school did Dorothy find a job. Unlike the other students, who all found afternoon jobs, Dorothy was hired for an evening shift in an assembly-line type department of a large insurance company with no public contact.

Mrs Lewis explained to me during those initial weeks that she was not able to place Dorothy very fast because her business background was slim and her appearance poor. Dorothy did, however, have more business background than many of the students in her class, had the third highest senior class rank among the other COOP students, and had taken a more rigorous academic program than the two students who were ranked ahead of her. On an 11th grade standardized test, Dorothy had been placed in the 99th percentile for math computation and in the 90th for math concepts. She was one of the fastest, most accurate typists in the class, and was the only student who took classroom work home to finish. The other students were apparently quick to perceive her capabilities, for they often went to her for help on their own work. It became clear that her mode of self-presentation was the only reason she was experiencing difficulty in finding a job.

One of the places at which Dorothy applied was a small bookstore, where she was turned down in favor of Cynthia, a tall, slender model-type. I was told later in the year by a graduate (a nice looking, but plain, honor roll student who had also been rejected for the job in favor of a more attractive but less capable student) that the man in charge of hiring at the bookstore had a penchant for a certain type of female employee – blond and well-built. Nor did this appear to be an isolated example. In a critical tone, Mrs Lewis told the class about a similar situation in which a bank employer telephoned her a few years back to complain that she was not sending him very pretty girls.

Being 'very pretty' did indeed seem to help more students than Nancy and Cynthia find certain types of jobs. Three of the available jobs involved being the receptionist for a business or department. Each of those jobs was filled by a student who had been a cheerleader, pom-pom girl or model.

Maureen, for instance, was placed as the receptionist in a major city department which daily received a heavy flow of both city employees and the general public. She was, in fact, located just down the hall from the mayor's office and on occasion was asked to fill in for his receptionist. In explaining the placement process at the beginning of the year, Mrs Lewis said she sent Maureen to interview with the city because they needed good typists. As it turned out, Maureen was not a good typist. She had only a year of typing as a sophomore and often commented that she needed to improve her skills. When a typing assignment was given out in class, several students (including Dorothy) would finish the work more accurately and swiftly than she. Moreover, Maureen's job with the city required very little typing in comparison to jobs other students had. At the beginning of the year Mrs Lewis described Maureen as

> 'very outgoing and attractive . . . the type of person an office likes to have around. . . . She doesn't have a strong business background but that doesn't mean too much because even if a person makes up for it at the last minute, they should be allowed to take advantage of it . . . so I wasn't really too concerned about her.'

About Dorothy, however, Mrs Lewis had said the reason she was not placing her very fast was because her business background was so slim, her GPA was not very high and she did not have good skills. Only later in the conversation did she add, 'and her appearance is poor.' As indicated earlier in this chapter, only the last comment seemed to be an accurate description of Dorothy. Yet this factor apparently overshadowed Dorothy's job skills and prevented them from being noticed. Not until well into the semester did Mrs Lewis become aware of how skilled and conscientious a worker Dorothy was. She began by saying things like Dorothy should have gotten a better placement; that Jackson's Print Shop, for instance, would have been much happier with her than with Dana (the ex-model), whom they had hired as a receptionist and all-around office person.

Conclusion

This description of the selection processes into Cooperative Office Education jobs at the official and pragmatic levels should make clear that although Mrs Lewis attempted to implement the spirit of the official guidelines by applying objective criteria in a non-varying fashion to the students, assessment of ability level proved problematic, even with application data and prior experience with students. Some non-meritocratic gatekeeping thus occurred as Mrs Lewis attempted to send particular students to interviews at particular organizations. The basis of this selection appeared to be mode of self-presentation, with appearance or degree of attractiveness being the primary component. So although students had to openly compete for jobs once they were sent on an interview, only some of them were, so to speak, 'sponsored' by Mrs Lewis to some of the most desirable employers. Employers were then left to make the final decision on whatever criteria they saw fit: competence, general suitability, or attractiveness.

But the analysis of selection processes in the COOP program and into COOP jobs would hardly be complete unless the cultural level were closely scrutinized. In Chapter 4 I turn from the power of the school and school personnel in allocating students to an examination of the power students had in utilizing school programs for their own purposes. This analysis further points out the shortcomings of allocation models as well as of traditional socialization explanations of the status attainment process.

4

The students' selection processes

Traditional socialization theories have consistently examined and pointed to the significance and interaction of key variables in the 'status attainment' process. Among the most important of these factors are gender, race, social class, ability, aspirations, and achievement levels.[1] In seeking an answer to the question, 'What types of students apply to office preparation programs?' they suggest a helpful way to begin the analysis.

As indicated in Chapter 2, all the students in the COOP class were female. Indeed, gender is apparently still the primary determinant of curriculum placement, as it is of occupational attainment.[2] In its eleven-year history, only one male had taken the COOP program at Woodrow High. The same pattern obtained at two of the other three area high schools. Surprisingly, the COOP program at the third high school did have a history of male enrollment, although the most recent cohort was all female.

While unable to empirically account for this phenomenon, I suspect it has something to do with both the internal history and reputation of that school's program and the fact that this school drew students from a more professional family background than did the other schools. Taking an office preparation program probably did not have the same meaning or the same stigma for males that it carried at the other schools, especially at Woodrow (with its dominant working-class composition) where enrollment in traditional 'female' subjects generally labelled a male student as 'sissy' or 'faggy.' I will have more to say on this matter later. The point I am making here is that Woodrow High School was probably very typical in the extreme sex-segregation of its vocational classes.

This sex-segregation was primarily the result of a 'self-selection'

process. Unfortunately this term conveys an individual-voluntaristic connotation I do not wish to imply. The weight of cultural pressures on adolescents to choose traditional sex-typed classes is formidable. I use the term, however, to emphasize the primacy of internal over external mechanisms in the tracking process. For, while there were reports of such gatekeeping activities as a male counselor asking a hockey player, 'What the hell do you want to take a second year of typing for?' these incidents seemed to be the exception. Few hockey players ever considered taking Typing II.

The next potentially relevant variable is race. As with male students, teachers in Mrs Lewis's position felt some affirmative action pressure to recruit minority students into the class. She said there were also pressures from black business people to have more black students in the class. With approximately an 8% minority student population at Woodrow High School (primarily black and, more recently, Spanish-speaking), an 'equal distribution' of minority students to all classes would mean that one or two would take COOP each year. But, to my knowledge, the only minority student to enroll in COOP was Spanish-speaking and was the male student referred to earlier.

I am not well able to account for the absence of minorities in the COOP program. Mrs Lewis herself offered two conflicting explanations on different occasions. Her first explanation, during my first week of field work, was that black students did not want to pursue secretarial work, considering the work beneath them. She told me their attitudes were often bad, that they did not come to school regularly, and could not make a commitment to a COOP job. Her second explanation, well into the field work, was that black students were right in perceiving secretarial jobs as dead-end and they were smart not to waste their time preparing for a job with limited opportunities. In other words, her first explanation characterized minority students as the 'first-type' of student described in Chapter 3, those who were too short-sighted to see value in career preparation. Her second explanation characterized them as the second type of student, the type who understood the difference between office work and a *real* career. The discrepancy in Mrs Lewis's explanations possibly resulted from her own ambivalence toward office work: loving the nature of the work and seeing the potential in it if women were given more managerial

responsibility, while at the same time feeling that many office workers were underpaid and their skills underutilized. It is also possible that neither explanation accurately accounts for the absence of minorities in the program. A competing explanation is that whenever possible minorities group themselves in a way that de-emphasizes their minority status. A basically untracked school like Woodrow would give them the opportunity to choose their own classes (and classmates) and, hence, make sure they were *not* 'equally distributed' among the total school population.[3]

Males and minorities were, then, two groups of students who screened themselves out of Cooperative Office Education. From the literature on career aspirations and tracking I would also have expected exceptionally high SES and high ability students to be absent from the program, since it was so explicitly vocational in nature.[4] Such, however, was not the case. Mrs Lewis reported having a fairly representative sampling of students along the dimensions of both social class background and ability. She indicated that she once had the daughter of one of Macomb's most prominent families in COOP; this student later attended an elite East Coast college. She further indicated that she often had that year's valedictorian or salutatorian in the class and that one of the COOP students (whose father was a mathematics teacher at Woodrow) received a four-year accounting scholarship and passed all parts of her CPA Exam on the first try.

Mrs Lewis's perception of the COOP students' backgrounds, ability, and achievement records was corroborated by my other interviewees and through my perusal of the school records of the 1981 class. While most of the students had mothers whose work had been primarily that of homemaker and/or office worker and fathers who were blue-collar workers or civil servants, a few deviated from the pattern. Lynne's father had a university degree and was employed as a county agricultural agent; Carolyn's father was an industrial engineer; and Nancy's step-father owned a trucking company. Nancy's family lived in one of Macomb's nice subdivisions, an outlying area that gave homeowners enough property for luxuries like swimming pools and horses. Two students, Evelyn and Amy, had mothers who were former teachers. A social class background characterized by college-educated or professional/ managerial parents was apparently not a screening mechanism for COOP. Some students who came from these backgrounds,

somewhat surprisingly, did enroll in an intensive vocational preparation program.[5]

Nor were these students necessarily low-achievers. While they did not all have high academic averages, a number of them did. Evelyn had a high school GPA of 3.5; Anne was doing well in an accounting program at a major university; and Lynne, a first-year student in an allied health program, was considering pre-medicine as a very real possibility.

Some of the students from traditional working-class backgrounds also did well academically. Terri was a member of the National Honor Society; Maureen scored in the 75th and 85th national percentiles on the PSAT verbal and math tests; Donna, Josie and Dorothy all scored in the top quartile on a national 11th grade standardized math test, with Dorothy actually scoring in the 99th percentile on math computation. So, even though Mrs Lewis might have been accepting more lower-achieving students into COOP in recent years, this did not mean that high-achieving or high-ability students were not in the class. COOP students came from a diversity of social-class backgrounds and had widely diverse ability and achievement levels.

If ability, achievement and social class background did not characterize the students who enrolled in COOP, as one would expect drawing inferences from the stratification literature, one would still expect 'office career aspirations' to distinguish them.[6] But this, too, proved to be a false assumption. Only one-third of my interviewees said they took COOP because they liked office work or liked to type, saying things like:

'I knew I wanted to be a secretary since I was about fourteen. When I was little I played nurse, but I can't stand the sight of blood. I really like typing and bookkeeping.'

'I always liked typing. It was my favorite. I could sit and keep going for hours.'

'I always knew I wanted to work in an office. I guess when I was little and walked into offices it always looked real interesting and I thought I would like to do that. . . . And I liked to type.'

In the 1981 graduating class for example many of the students in the cooperative office education class did not have a clear idea of

what they would be doing at the year's end. Contrary to the literature, career aspirations do not appear to be stable at an early age, at least not in this stratum of young women.

The students also seemed to have only a vague and nebulous awareness of what different jobs entailed and the steps one would have to take to enter a specific line of work.

Kris, for instance, originally talked about going into beautician work, until she realized the year-long training program was eight hours a day, six days a week. A relative also discouraged her by remarking that beauticians had to 'put up with a lot' from customers. Dorothy, encouraged by her father, was planning to be a teacher. But during the course of her senior year, her father died, she became increasingly discontented with school, and she decided that teachers did not make that much money anyway. Katrina and Donna also planned to teach; Evelyn was considering commercial art; Maureen wanted to get a bachelor's degree and pursue a career in science; Dana and Cynthia were considering being flight attendants, and Janie a travel agent. These students obviously did not meet the state's guidelines of having 'clearly defined' office career goals. Most of them had, however, taken some business classes and did meet the mandated skill requirements.

Two questions now arise. First, did anything else characterize students who enrolled in Cooperative Office Education other than the fact that they were white, female, and, for the most part, had taken some business classes prior to their senior year? Secondly, why did they take business classes, especially the COOP class, if they were not set on an office career? Since the two questions partially address the same phenomenon, I will analyze them simultaneously.

One of the other teachers at Woodrow High School's Business Department, Mrs DuPree, offered a possible explanation. During one of our first conversations, Mrs DuPree asked me what particular aspect of the COOP program I was studying. When I replied that I was interested in finding out more about work aspirations, why students chose one particular orientation rather than another, and how firm their commitment was to it, she responded that she had two teenage children of her own and understood perfectly why students took COOP: it was a way of getting out of school in the afternoon.

The comments from students about their 'decision-making' process referred to in the previous section of this chapter lend a certain amount of credence to this explanation. For some students, enrolling in COOP immediately brought to mind visions of 'getting the whole afternoon off.' They said things like:

'I guess I decided to take COOP because I thought it was better than going to school. I would rather work than go to school. The only classes I ever liked were office and gym. . . . I just didn't like school. Well, I didn't like Woodrow, because I loved going to grade school. I guess its the size that makes the difference. I'm basically a shy person; its hard for me to get to know people.'

'I don't know, I thought I would like my afternoons off. And you get two credits for it you know. It was a way out. I wanted to be in school as little as I could. It's getting to me right now.'

But only six of my thirty-three interviewees gave this as a reason. And even for them, leaving school was never the decisive factor; it took the form more of an initial impression, meaning or image, rather than a significant part of their decision-making process. Moreover, a number of the students who enrolled in the class liked being in school and were actively involved in extra-curricular activities. Katrina typifies this group of students:

'I never thought too much about taking COOP my senior year because I liked school, was involved in cheerleading, and didn't think I wanted to leave at noon my entire senior year. But I did want a job. . . .'

Besides, Woodrow High School offered much easier ways of leaving school. Students did not have to remain in the school building if they did not have class and, since only 20 credits were needed to graduate, students could accumulate a number of free periods by their senior year. Skipping class was also a definite possibility and, as was evident from the information gathered during field work, students were frequently able to use this means of leaving school without jeopardizing course credit or incurring other forms of reprisals. As one of the students in the class commented: 'Getting out of school early doesn't really make that much difference because you just have to go to work.' In short,

Mrs DuPree's explanation does not render an adequate account of why students enrolled in COOP. For such an account, the explanation and backgrounds of the students themselves must be turned to.

To begin with, twelve of the young women I interviewed said they needed a job or the money. While for a few of them this 'need' meant saving for a winter vacation in Florida or the Bahamas, for the majority needing money was somewhat more critical. The family background information I gathered indicated that many of them would probably not be able to rely on their parents' financial support much after high school. Nine of the sixteen students in the 1981 class, for example, came from homes in which the father (the primary bread-winner in each case) was either deceased, retired, disabled, or no longer part of the family household. Two of the others came from families of nine children. Eleven of the sixteen students, therefore, appeared to have either consciously or unconsciously made work-related decisions out of the very real material conditions of their lives. They did not seem to have the luxury of pursuing a course of action just for the sake of avoiding something unpleasant, like school. So while family background did not act as a variable to screen students out of a vocational program like COOP, it did serve as a vehicle to draw them *to* the program.

Maureen provides a vivid illustration of this group of students. Life for her family was financially difficult. Her parents were divorced when she, the youngest of four, was only a few years old and her father never paid any child support. Her mother supported the family with a factory job and was proud that the family never had to go on welfare. Maureen started work when she was fifteen and, during her senior year, held down a second part-time job in addition to her COOP job, sometimes putting in close to forty hours of work a week in addition to a full morning of classes. Although she was not paying rent at home, she had to pay for anything else she needed or wanted, including shampoo, clothes and sometimes food. Maureen said her mother did not care if she went on to college or not, but she did expect her to be out on her own, supporting herself by the time she was eighteen. As a high school senior, she was well on her way to doing just that. Commenting on her motivation to take COOP, Maureen said, 'I never really thought I would like office work. I

mainly took the class because I knew it would be good in the future as a reference.'

Secondly, the students themselves offered very different reasons for taking COOP than merely wanting to leave school. While, as indicated earlier, many of the COOP students did not consciously plan to culminate their high school education with Cooperative Office Education and only about one-third of them said they took the program because they liked office work or typing, work-related reasons far exceeded school-related reasons. In addition to those who said they wanted to get out of school, or thought the class would improve chances for an accounting scholarship, or needed the class to collect social security, were a few who said there were no other classes they wanted to take, or they liked the COOP teacher, or they did not need any other school credits.

'I liked Mrs Lewis and if I took COOP I wouldn't have to take gym. That was a strong consideration. . . . But I probably would have taken the class regardless of the gym situation because you get credit plus the money. And it's easy.'

'I had enough credits. I only needed 1½ more my senior year so I figured I might as well work. . . . Besides, I was real interested in accounting and I thought Mrs Lewis could help me find a job in that area. I was very shy in high school and hesitant to go out and look for a job myself.'

As these comments indicate, even students who elected COOP as a choice *against* school, had work-related reasons behind the choice. A negative school orientation was never sufficient reason for a student to enroll in COOP.

The most frequent reasons for taking the Cooperative Office Education class, however, took the form of either 'testing' the world of office work or 'using' office work experience as a step to something better or as a safety net if other options fell through.

Students who took COOP as a test to determine whether office work was the type of employment they wanted to pursue after high school said things like:

'My mother recommended that I take some business classes while I was in high school. She said these would be good skills to develop and that I would see if I would like that work.

So I started taking typing, shorthand, bookkeeping, the office procedures class, machine calc, and then the COOP class. I thought it would be a good way of finding out if I liked office work.'

'I thought I would take COOP to see if I liked that kind of work.'

'I have no idea why I took COOP. I didn't know what I wanted to do after high school so I guess I took it on a trial basis. I figure if I didn't like it I could always switch.'

There was a similar group of students who were uncertain about whether or not they would like office work, but these students, by contrast, tended to be consciously considering an alternative to office work:

'In high school I knew I wanted to go to college, but I didn't know what area I wanted to go into. So I took things like bookkeeping, typing, modern office and the COOP class because I thought these would be good background for getting a summer job or a part-time job while going to college. Or – if all else failed – it would be something to fall back on.'

'My mother encouraged me to take business courses. She said that if, God forbid, anything should happen that I couldn't get another type of job, a secretary's job would be good to get into. She also said I might even be able to use it when I'm in college typing my own term papers, or maybe getting a part-time job in an office typing – to help with tuition.'

As these comments indicate, the COOP students' parents were often actively involved in helping their daughters plan for the future. These parents did not view office work as something to aspire to; rather they wanted their daughters to have a reasonable and workable alternative if other options did not materialize. One father, for example, who worked in the city's sanitation department and put his older daughter through a bachelor's degree in library science only to see her end up as a sales clerk in a local department store because of the flooded job market, strongly encouraged his younger daughter to enroll in COOP.[7] When, as a sophomore, Joan showed interest in typing, her father

bought her a brand new typewriter: 'My dad kept pushing it; he really wanted me to get into it. He said there would always be a job out there for someone with good secretarial skills.'

The two questions raised a few pages ago are now able to be answered. Very little distinguished the Cooperative Office Education students as a group, besides being white and female, other than that they experienced material need or were preparing for a future in which office skills could safeguard them from the need to accept less-desirable employment. Taking COOP was not the result of either 'office career aspirations' or an oppositional school culture. Instead, it represented a sensible accommodation to their future possibilities and probabilities as the students and their parents saw it. This view of future probabilities resulted not only from a realistic perception of the job market, but also from a notion of what was a good job 'for a woman.'

This view was shaped to a certain extent by class cultures or definitions, and to a much greater extent by gender definitions or, what I would call, a culture of femininity. Even though a few women who had gone through the COOP program had attained or were preparing for jobs like accounting or engineering which clearly crossed traditional class and gender lines, for the vast majority such jobs rarely occurred to them or if they did were spoken of as passing thoughts or childhood fantasies.

Mary Jo, for example, explained how she had wanted to be an archeologist when she was in the eighth grade, how she had loved to watch accounts of digs in various parts of the world. But even at fourteen years of age she knew that was an impractical fantasy. She knew she had to get on with her life: to settle down, get a job, prepare for marriage and a family. So she planned to go to the community college after high school for a degree as an accountant clerk. When I asked why she had decided on a two- rather than four-year degree she responded, 'Why should I waste my time in school? I'd rather get going right away and get it over with.' Mary Jo said she had this old-fashioned idea of raising a couple of children and working part-time.

Similarly, Marian, a graduate of the program, had once seriously entertained thoughts of being a gynecologist. She even sought out an office job in a health insurance company because it was related to the medical field. This student, however, had started going steady at sixteen, upon high school graduation had

moved in with her boyfriend, and, at the time of our interview, was setting a date for their wedding. She said that if she had had the money and had not met Chuck she probably would have gone to medical school. She was, however, supporting his pursuit of higher education.

Even the most career-oriented of the women I spoke to defined her future by very distinct and traditional gender relations. In discussing her career, Kathryn, a 1980 graduate and an accounting student at a major university, said, 'I want to be independent for my own satisfaction, so I can prove to myself that I can do it . . . so no one has to take care of me.' She went on, however, to explain that only if she remained single would she ever attempt to be a CPA, an auditor, or the president of a credit union. That type of work, she said, was too stressful to have other responsibilities as well. Since she definitely wanted a family she would probably never hold those jobs, but said she would instead look for an accountant's job at a small business or credit union which would be a good job and good salary 'for a woman.'[8]

The other range of jobs students rarely spoke of or spurned when I questioned them about those jobs directly were things like factory work, maid work or restaurant work. While a number of them had mothers who had been employed in these occupations at least part-time, none of the COOP students could imagine themselves working in those areas. Office work was perceived as definitely superior. Students spoke of these other jobs as leading nowhere, undesirable places to work, or jobs you could not take pride in. One student who had worked for a while in a restaurant used the word disgusting when describing it and asked how I would like to clean up after other people. Another student, who worked in a factory job for three weeks said she did not last there because the work was so boring. She stood six hours at a time putting sausage in boxes that came down an assembly line. 'If you got tired of putting sausage in,' she said, 'you could trade jobs with someone on cheese.'

Factory jobs or mechanic jobs were also often ruled out on the basis of gender definitions. These jobs were definitely considered 'for men only' since they made it impossible for women to maintain their feminine appearance:

'I would never be a mechanic. You get messy.'

'I don't want muscles or to get dirty. I still want to be pampered. I'm not into all that liberated stuff.'

'I can't imagine myself getting my hands all gooey, being sweaty and dirty all the time.'

'I wouldn't want to work in a garage – to be a mechanic. I wouldn't want to come home greasy.'

Nor did many of the students consider being construction workers, police officers or fire-fighters. To them, these jobs should still be reserved for men who, unlike women, have the strength and ability to do them.

'I don't think ladies should be police or firemen either. They're just trying to show the guys they can do it and have the ability.'

'On REAL PEOPLE they showed two women who were working on the docks doing loading. I'm sure they needed the job, but I think they were also proving a point.'

'I think jobs like construction and firefighters should go to men. Some women are trying to prove they're as equal as men, but the jobs should go to the guy.'

Other researchers have also noted the restricted range of jobs women consider (Gaskell, 1975; Sewell, Hauser, and Wolf, 1980) and the tendency for girls to make more traditional occupational choices as they approach graduation (Rosen and Aneshensel, 1978; Wolpe, 1978). Wolpe, for instance, states:

By the time teenage girls reach school leaving age they articulate their future in terms of family responsibilities. They reject, often realistically, advice about pursuing school subjects which could open up new avenues; the jobs they anticipate are not only within their scope, but more importantly are easily accessible to them and in conformity with their future familial responsibilities (p. 326).

The one job many of the students did mention as being desirable, the one job they would have gone into had the market not been flooded and if remuneration for their work had been more adequate, considering the training and work entailed, was

teaching – mostly elementary or pre-school – traditionally considered as much a female occupation as is office work. Louise, for instance, who was the valedictorian of her graduating class, was dissuaded by her mother from going into child care:

> 'I was very interested in working with little children. I always did a lot of babysitting and thought I would like to get into child care. But my mother said that day care centers didn't pay very well. Even if you owned one you probably wouldn't make very much. So she recommended that I take business classes while I was still in high school to see if I liked that area.'

Dorothy, on the other hand and as mentioned earlier in this chapter, resisted her father's desire that she be the first in her family to obtain a college degree because, as she put it 'people are convincing me that teaching's not a good field to go into.'

Even those students who were planning to get teaching or other four-year degrees knew their college diploma might not necessarily get them a job in their area of preparation. Office skills, again, became that sensible safeguard against unemployment or employment in even less-desirable positions. Office preparation was a sensible accommodation to a work world that was limited either by views of what was appropriate or desirable for a woman, or what was possible for a woman.

Donna, for example, decided not to get a degree in business because in her words, 'I found out that if I would major in a business field I probably wouldn't get a much better job than what I've got right now.' As evidence for her contention Donna gave two examples. One was a magazine article she had recently read in which the author wrote of her experience trying to get a business job in New York City. She had an MBA and all she could find was the lowest of secretarial positions. The other bit of evidence came from her own perceptions of the job structure at F & M Savings and Loan Association, her place of work as a COOP student, where she said, 'it seems like the men are the ones who are going to get the higher positions.' Donna knew these men had a lot of training and education, but still could not determine how they got where they were because she presumed 'even the President of a big corporation' has to start out at the bottom just like everyone else. Her dilemma was that she never saw any men

in positions at the bottom. The situation of seeing no women in the middle or top positions, having the career ladder totally obscure to her, and reading about women who do not make it even when they have the credentials was enough to eliminate business as a possible career choice for Donna.

Coupled with their experience and perceptions of a job market that held limited possibilities for women, which functioned to draw them towards office work or preparation in office skills, was the experience of independence, maturity and freedom that holding a job and earning a paycheck gave them. This factor, in a sense, served to deflate college careers; it served to 'cool' students out of competition for higher-level jobs. This, however, was a very different process of cooling out than Burton Clark describes, having little to do with the manipulating actions of school personnel and a great deal to do with the sense of identity these women were developing. Examples of four students will serve to illustrate my point.

Maureen had initially planned to major in biology at an established university. But her COOP experience had whet her appetite for business and a work environment that allowed her to interact with people. She began to feel that a career in science would demand isolated concentration and work, and that she would have to devote everything to it at the expense of good times. So she shifted her focus to business and enrolled in the Executive Secretary program at the community college, saying that she still definitely wanted to 'eventually' get a four-year business degree and go into some type of supervision:

'I do plan to go through a four-year program in business at the university eventually, but I don't really have the money to do that now. Besides, I figure if I get the work experience I'll feel more confident about myself and I think if I have both school and work experience behind me I'll have more of a chance than if I had just one of them. I think I'll get more out of it too because I can apply things while I'm learning them and that way I'll take more interest in school.'

The autumn following her high-school graduation, the local paper announced that Maureen was engaged to be married.

Eleanor never went to college although she had been an honors student in high school, had initially planned to go on for an

accounting degree, and was encouraged by both school and work personnel to pursue higher education. She claims she took COOP because she was extremely shy and hesitant to look for a job herself; through COOP, job placement is facilitated by the teacher. The thoughts of four more years of school 'scared' her, she liked her job as a cash receipts clerk in the accounting department of REMIC, liked the people she worked with, the money she was making, and the freedom to socialize in the evenings without having to worry about homework. Besides, she said,

'if I leave that job for college I would have to interview at another place for another job and I'm too shy. I don't like big major changes. If I knew for sure I could get a better job if I went to school, if a specific job were being held for me so I didn't have to look for one, I would go back to school.'

Charlotte and Lynne, on the other hand, did enroll at the state university when they graduated from high school. Lynne was a first-year student in an allied health program at the time of our interview and had initially wanted to be a pediatrician. She was working part-time at the university credit union and had recently been offered a full-time position there with advancement opportunities. She was tempted to take the offer because she was finding college harder than she expected and disliked the impersonal climate of the large campus, at which she was dorming. She liked work better than school saying, 'I enjoy myself when I can work right with people, when I can show myself what I can do.' Lynne was learning a different aspect of her job each day and had a lot of public contact – two job features she liked. Although Lynne's parents were dissuading her from dropping out of college and taking the full-time position, saying that a college education was the best way to obtain a higher position in the business world, and although Lynne said she thought she would feel better about herself getting a higher position through education, she also stated that 'a lot of work doesn't depend on your education at all – a lot depends more on experience.'

Charlotte also knew in high school that she would go to college, but even then was aware that she did know what area she wanted to go into. So she took a strong business concentration as well as a strong academic concentration. She considered this wise planning: the business background would be good for getting a summer

job, for part-time work while in college, or, if all else failed, would be something to fall back on. During her second college semester, however, she was put off by the competitiveness of the business courses and had some personal problems she needed to deal with. So she decided to drop out until she knew what she really wanted from college. Charlotte had been hired in a university academic department as a COOP student, and was kept on when she started school there. The following year a full-time position opened up and she took it. At the time of our interview Charlotte had been out of school and working full time for three years. She said the longer she stayed out of school the less likely she was ever to go back because you forget how to study, it's hard to associate with undergraduates when you're so much older, and it was difficult to imagine life as a poor student again. Still she could not imagine staying in her type of work, claiming it was dead-end, with only lateral moves possible.

Conclusion

The shortcomings of the allocation and socialization models of status attainment are now able to be analyzed in relation to this ethnographic data regarding the selection processes of Woodrow High School's COOP program and students. First, as stated throughout this chapter, the applicability of most allocation theories is limited, since the number of openings in both the COOP program and in office work in general is greater than the number of students seeking such job preparation.

Thus, even though the official state guidelines mandate specific entrance requirements and outline a selection procedure for the teacher-coordinator to employ, overt external screening mechanisms seldom prevented students from enrolling in the program.

Although lack of information about COOP and the time commitment required of students in the program were offered as initial explanations of why Cooperative Office Education does not attract more students, another factor is hinted at in much of the interview data just reported: namely, office jobs are not seen as highly desirable. Even the students who enroll in the program do not do so primarily because they 'always wanted to be secretaries,' but because other possibilities either seem worse or might not

materialize. Even Mrs Lewis, who loved performing the actual tasks involved in office work, bemoaned the treatment secretaries and clerical staff receive from managers, the low salaries they command, and the low esteem in which their work is held. Most women who do end up in office jobs do so not because of aspirations, motivations and intensive vocational preparation as high school students, but because, given culturally accepted standards and the availability of jobs, office work is regarded as respectable employment 'for a woman.'

This brings us to a second shortcoming in the mainstream status attainment models: the disregard with which the real structure of job availability is treated. Somewhat surprisingly, the subjects in my research seemed much more attuned to this factor than either social scientists or professional educators.[9] They listened to friends and relatives, read articles, and drew implications from experiences others had encountered in the job market.

Stratification literature does *allude* to the structural limitations of the economic sector. Kerckhoff and Campbell say, for example, that they 'do not deny the significance of the opportunity structure in determining the distribution of attainments' (1977: 711). Yet the model they construct to explain race and social status differences in the explanation of educational ambition is founded on perceptions of the opportunity structure, operationalized as a 'fatalism' construct. Thus, the real limitations or deterrents of the social and sexual divisions of labor come to be seen purely as psychological blocks to achievement.

A similar problem can be found in Rosenbaum's *Making Inequality*. The author reports that 90% of the 'female graduates who took full-time jobs after graduation' ended up in very similar work: that of 'secretary, typist, teletype typist, key punch operator, clerk-typist, clerk, office girl, telephone operator, receptionist, sales clerk' (1976: 100–1). Yet his analysis makes nothing of this factor because it so narrowly focuses on the inequities of a high school tracking system, on the hidden mechanisms by which students are prevented from going to college.

While faulting an author for failing to produce a level of analysis he never claimed to be undertaking may not be entirely fair, this criticism is a necessary corrective to mainstream stratification approaches. By not attending to the real opportunity structure, these analyses leave the impression that job selection occurs in an

unconstrained market, that ambition itself is sufficient to explain occupational attainment.

Poulantzas (1978: 29) clearly addresses this problem when he states:

> while it is true that the agents themselves must be reproduced – 'trained' and 'subjected' – in order to occupy certain places, it is equally true that the distribution of agents does not depend on their own choices or aspirations but on the reproduction of these places themselves.[10]

The conflation of 'places' and 'agents' leads writers such as Garrison (1979: 176) to claim, for instance, that 'change in aspiration must be logically prior to change in the distribution of persons across occupations.' Such a remark can only be made in view of an absolutely static occupational structure. As the twentieth century has assuredly taught us, no such static structure exists. Women, for example, did not apply for office work at the turn of the century because their attitudes had suddenly changed, but because 'the expansion and consolidation of enterprises in the 1880's and 1890's created a large demand for clerical labor' (Davies, 1979: 252).

Similarly, if office jobs continue to increase while manufacturing and professional jobs disappear, women will undoubtedly apply for office work in ever greater numbers. They can also be expected to internalize an even stronger sexual divison of labor ideology as competition among males increases for the few remaining industrial jobs. Women's place will be regarded more strongly as somewhere that is not messy, greasy or dirty. A traditional culture of femininity wherein women are regarded as soft, clean and delicate creatures will probably intensify.

I would predict, however, that if the market for particular kinds of office workers continues to expand at its present rate (though under current conditions such a forecast is unlikely) greater proportions of males, unable to find jobs elsewhere, will begin to apply for office work. If this happens, two things are likely to occur. First, the status and salaries of office workers in general are likely to increase, since a close correlation exists between the dominance of men in job categories and the status and salary scales of those jobs.[11] Secondly, with more men and women doing similar work, the bi-polar construction of masculine and feminine

identities might weaken, with similarities between the sexes emphasized and differences de-emphasized.[12]

This discussion of the importance of bringing the real opportunity structure to bear on questions regarding the distribution of agents leads to my next criticism of the traditional socialization models of status attainment. Qualities like ambition, aspiration and sex-role identification are fundamentally misconceived when posited as individual level, psychological variables. Although certain dispositions and forms of consciousness ultimately reside within persons, although they ultimately shape identities, these characteristics do not initially emerge from the individual, but from the cultural context, itself formed (in Bourdieu's terminology) by an objective structure of job probabilities.

> Only by constructing the objective structures (price curves, chance of access to higher education, laws of the matrimonial market, etc.) is one able to pose the question of the mechanisms through which the relationship is established between the structures and the practices or the representations which accompany them, instead of treating these 'thought objects' as 'reasons' or 'motives' and making them the determining cause of the practices (Bourdieu, 1977: 21).

Objective structures, not the individual, give rise to particular common-sense notions and cultural orientations from which 'job aspirations' emerge. These objective structures ultimately must be brought into the analysis in order to explain why certain jobs are considered reasonable or unreasonable, desirable or undesirable for particular groups, for it is the structures that establish for people a sense of what is possible, a sense of what is 'reality' (Bourdieu, 1977: 164).

Where Bourdieu's analysis of this objective/subjective relationship falters, however, is in the position of an absolute inner/ outer homology, a problem endemic to his work. Such a close correspondence leads him to write phrases like 'ineradicable adherence to the established order' (p. 164) and the 'external necessity' of the sexual division of labor (p. 78). It also leads to assumptions about dominated groups being inclined 'to love the inevitable' (1977: 77) or to attribute their lowly societal status to their 'lack of gifts or merits' (Bourdieu and Passeron, 1977: 210). Like many of the allocation and socialization models, this view

of legitimation is inaccurate. The COOP students did not view themselves as failures; they did not blame themselves for failing to achieve more education or a better job. In terms of class position, they certainly did not regard those with more social status as superior beings. In fact, they would frequently refer to the students from Macomb's middle-class schools as 'stuck up,' 'snobs,' and 'rich, high class ding-dongs,' claiming that just because they had money they thought they were 'better than everyone else.'

Stratification theorists are wrong, therefore, to frame their analysis in a manner that assumed the attainment of status is a conscious goal. Occupational choices are not always made on the basis of their leading to upward mobility. As Wrong (1961) so pointedly argues, no such universal abstraction as 'the status-seeker' of the twentieth century exists. While status might be an important goal or concept for certain groups, sociologists should not presume that their own preoccupation with 'status attainment' is the preoccupation of the general population. Moreoever, as Gaskell (1983) claims, since most of the research in this tradition is based on young men, it should not be assumed that the model fits the work orientations and goals of young women.

As the foregoing data suggest, the status-attainment model certainly does not fit the group of young women who enrolled in office COOP. While some of the students were pursuing work that technically was of higher occupational prestige than their parents' jobs, the students did not consciously pursue office work as a means of upward mobility. Office work was simply the best of available options. Openings existed in clerical areas and the work was not degrading to the students' sense of feminine identity. The decision to obtain training in office work is indicative of a sensible accommodation to the real occupational structure, given the cultural limitations (but not the inevitability) of the sexual division in both wage and domestic labor.

PART THREE
Reproducing the technical relations in production

5

A service economy and automated offices

While the preceding section analyzed why and how students took cooperative office education at Woodrow High School and obtained certain types of office jobs, Parts Three and Four explore what they learned about office work and their 'roles' as workers from their COOP experience. This section focuses solely on the skill or technical dimensions of office work while the more overtly ideological and social dimensions are explored in Chapters 7–9.

The analysis offered in this chapter begins by examining the embourgeoisement/proletarianization debate regarding the need for skilled workers in a corporate capitalist society. This debate is relevant to an analysis of the reproduction of labor power since it highlights the ambiguity with which concepts like skill and work knowledge are generally discussed. I will argue that the concepts of routinization and specialization are far more useful in analyzing the skill dimensions of a job than are references to either a service economy or automation.

Using the concepts of routinization and specialization I then examine the nature of the work the COOP students were asked to do during their apprentice year, the sort of training they received for those jobs and how they felt about their work and training. I argue that the proper focus of vocational programs is the need of workers for interesting and challenging jobs, not the need of work places for productivity, efficiency and control. The best way to place workers in a position to demand such jobs is through a more rigorously skill-oriented education than that which the COOP program provided the students.

In order to understand what the COOP students learned about their role as workers, how in fact they became office workers, it is necessary to examine not only what they learned in the class-

room about the tasks they would most likely perform, but to examine the precise nature of the work their apprentice jobs actually entailed. This approach operationalizes a basic tenet underlying this analysis: that what people do, the work they are engaged in, has a profound effect on the way they think about themselves in their social roles. This assumption, as Kusterer (1978: 2) points out, is a central claim of both phenomenology and Marxism: 'the meaning statements and reality definitions which people develop out of their work experience form the most basic, most central level of knowledge, upon which all other consciousness is built.' And as Bills (1981: 256) suggests, referring to the work of Kohn, Kanter and others, the assumption is not untested: 'there is substantial evidence showing that what people actually do, i.e., what their tasks are, during their time at both school and work, has far-reaching consequences for their behavior and modes of consciousness.'

There are, however, two distinct and in many respects opposing bodies of literature that would lead one to come to very different conclusions about the nature of office work. For the purposes of convenience (although the literatures cannot be said to fall strictly within these categories) I will refer to the two approaches as embourgeoisement and proletarianization theories.

Embourgeoisement theory basically claims that on a variety of dimensions (e.g. pay, security, mobility, skill) changes in the occupational structure have been in the direction of jobs being upgraded. The dimension central to the analysis of this chapter is that of 'skill.' Embourgeoisement theorists claim that increasing amounts of skill are needed by workplaces and assume that high levels of skill make workers more productive. This position was stated succinctly by Schultz in his 1960 presidential address to the American Economic Association, where he claimed that

> underinvestment in knowledge and skill, relative to the amounts invested in non-human capital would appear to be the rule and not the exception. . . . The strong and increasing demands for this knowledge and skill in laborers are of fairly recent origin. . . . It is simply not possible to have the fruits of a modern agriculture and the abundance of modern industry without making large investments in human beings (1977: 321).

Proletarianization theory, while traceable to Marx and through Mills, found its most systematic expression in Harry Braverman's formulation of 'the degradation of work in the twentieth century.' Others, primarily Marxist sociologists, have utilized and refined the concept, which basically suggests that the skill level of most workers, including those in what have been traditionally considered white-collar, middle-class or skilled occupations, becomes increasingly redundant under conditions of advanced capitalism. This process of deskilling, they claim, is the result of management decisions which seek to increase efficiency, control workers, and lower the cost of labor. These effects are achieved through the fragmentation, routinization and mechanization of the labor process.[1]

There are three key areas in which the two theories come to opposing conclusions. Those three areas deal with the relation between service occupations, automation, education and worker supply. Embourgeoisement theorists basically make the following interrelated claims.:

(1) the shift from a production to a service economy has increased the need for skilled workers;
(2) the development and utilization of automated machinery has also increased the need for skilled workers;
(3) schools must assist the economic sector in overcoming the shortage of skilled workers and the low levels of productivity this shortage creates.[2]

The proletarianization claims can be stated in almost exact opposite terms.:

(1) although the U.S. has in recent years shifted from a production to a service economy,
(2) and although automated machinery has been increasingly utilized, these changes in the labor process have not increased the demand for skilled workers;
(3) this means that the educational system is not called upon to turn out highly trained workers.

Although my evidence indicates that this second analysis is more accurate than the first, both approaches, despite their apparent contrast, tend to have three shortcomings in common. First is the problem of the high level of abstraction and generalization at

which the theories are argued. This overgeneralization, as I will indicate later in the chapter, applies to organizations, the labor process, and the notion of skill.[3] Secondly, both approaches tend toward technological determinism, suggesting that machines have definite consequences regardless of the system of social relations in which they are embedded. The third shortcoming is their assumption of a 'fit' between schools and workplaces, the assumption that schools produce the right quantities and qualities of workers.

In the rest of this section I will elaborate on the controversies between the embourgeoisement and the proletarianization theorists, bring my data as well as other theoretical positions and empirical evidence to bear on these three debates, and attempt to reformulate the way in which they should be argued and the perspectives that should be taken into account.

A service economy

Assumptions are often made that service sectors of the economy need to employ primarily skilled workers, whereas the majority of jobs in manufacturing sectors require only semi-skilled or even unskilled laborers.[4] In a 1975 policy paper prepared for the National Commission for Manpower Policy, for example, the educationist Ralph Tyler contends that

> trend data indicate continuing increase in the numbers
> employed in human service occupations, with corresponding
> reductions in unskilled labor. This evidence suggests that there
> will be an increasing demand for academic skills and for skills
> in interpersonal relations (1976: 109).

While Braverman does not dispute the 'increase in the numbers employed in human service occupations,' he does argue that this trend does not necessarily mean unskilled labor is reduced. He claims, in fact, that this 'reduction' is an artificial tautology of a classification system that merely labels everyone in a certain occupational category as skilled and those in other categories as unskilled. 'Classifications of workers,' he writes, 'are neither "natural" nor self-evident, nor is the degree of skill a self-evident

quality which can simply be read from the labels given to various such classifications' (1974: 428).

Even more strongly, Braverman contends that the trend toward office occupations will actually decrease rather than increase the need for skilled workers, since offices needed only to become sufficiently large to make it worthwhile for management to rationalize (specialize, routinize and mechanize) office labor processes. In fact, he says, clerical operations are easier to rationalize than industrial work since (1) they are conducted on paper, a material that lends itself to a standardized and routine process and (2) they often involve numerical operations and so can be structured according to rules of mathematics (p. 315). A series of articles written by joint authors, Glenn and Feldberg, and based on first-hand observations of several work sites, corroborate Braverman's basic position. They claim that due to changes in the organization of office work 'old skills have been made trivial and opportunities to develop new skills have been reduced' (1979b: 61).

While my data do not allow a direct comparison between the skill levels of office jobs and industrial jobs, Kusterer's analysis of 'skilled,' 'semi-skilled,' and 'unskilled' jobs does. In *Know-How on the Job: The Important Working Knowledge of 'Unskilled' Workers* Kusterer compares the working knowledge of a wide assortment of occupations.[5] Defining specialization as 'the number of production functions assigned to the job' (p. 134) and routinization as 'the degree of variation in the performance of each function' (p. 178) and using those concepts as independent variables, Kusterer concludes that

> the amount of working knowledge required on a job is . . .
> largely determined by routinization and specialization. . . .
> The jobs studied in this research that required the most
> knowledge were secretaries, mechanics, and ink men
> ('skilled'), longshoremen ('unskilled'), truck drivers and
> welders ('semi-skilled').

Other office occupations in Kusterer's sample (production control clerk, bank teller, mailroom clerk, copy machine operator, and computer operator) actually required less working knowledge than those officially classified beneath them on level of skill. This analysis throws into serious doubt the assumption that occu-

93

pational upgrading necessarily corresponds to the expansion of the service sector of the economy.

My data basically confirm Braverman's and Kusterer's contentions that the label 'skilled' occupation tells little about the actual skill(s) or working knowledge required by a job. Even at the entry or apprentice level, although the amounts and ranges of skill varied according to the specific job category, more of the COOP students than not were overqualified for the jobs they were doing and by the end of the year were privately expressing a certain amount of dissatisfaction. In line with Kusterer's analysis, this dissatisfaction directly varied with the degree to which their jobs were routinized and specialized, which in turn varied according to the degree the organization in which they were employed was bureaucratized.

By using information from the COOP students' mid-term and final examinations, I was able to compare the degree of specialization in each of the occupational categories in which the students were employed. On both examinations, they were asked to describe as thoroughly as possible what their jobs entailed, what work they performed on a daily, weekly, or monthly basis.[6] Their accounts can be summarized under ten basic production functions.[7] When these functions are organized according to occupational categories, the range of working knowledge the students actually used on their jobs (or learned from their jobs) becomes apparent. (See Table IV.)

The jobs of the file clerks and typists were far more specialized than those of the clerk typists or account/credit clerks. The range of skill typists and file clerks could utilize or develop was constricted by the nature of their jobs. Their work schedules involved only three or four production functions, whereas the work schedules of the clerk typists included ten production functions and those of the account/credit clerks nine. Those students employed in one of the latter two categories had a much more varied work schedule and greater opportunity to gain more work knowledge and experience.[8]

Even more central to the skill level and work knowledge necessary to do a job than the degree to which a job is specialized is the degree to which it is routinized. Because certain production functions are less routinized than others, a person could be employed in a job that required more knowledge and skill even

Table IV: Percent of students who used the various production
functions according to occupational categories

	File clerk	Typists	Clerk typists	Account/ credit clerks
filing/sorting/ alphabetizing	100%	50%	100%	100%
typing	50%	100%	100%	33%
photocopying/ collating	25%	100%	88%	33%
stuffing/mailing envelopes		50%	100%	100%
answering phones/ taking & delivering messages			75%	100%
record keeping			38%	33%
handling credit/ account data			13%	67%
greeting people/ making appointments			50%	33%
giving directions/ running errands			75%	
using word processor			38%	67%
N =	4	2	8	3

though the job comprised fewer production functions *if* those
functions were less routinized. I would contend, for instance, that
if the only task the credit clerks performed was handling credit
data, that their jobs would require higher levels of skill than
most clerk typists whose jobs consisted of more but more routine
functions.

If job specialization and routinization are envisioned along

95

Reproducing the technical relations in production

Kusterer's notion of independently varying dimensions, the following diagram can be drawn. (See Figure II.)

Figure II: Office occupations classified along dimensions of routinization and specialization

	Specialized		Non-specialized
Routine	file clerks typists		clerk typists
		1\|2	
		3\|4	
Non-routine	account/credit clerks word processing operator		secretaries

File clerks and typists would fall into area 1, representing routine/specialized jobs. These are the office jobs that require the least skill. (As I will show directly, file clerks utilize less skill than typists.) Area 2 represents routine but relatively non-specialized jobs. This describes the clerk typists. In area 3, the specialized but non-routine jobs are the account/credit clerks. Included in the diagram are two occupations excluded from the analysis thus far. These two occupations, word processing and secretarial, are relevant to the analysis offered here, and although none of the young women in my sample held these jobs as COOP students several moved into them soon after high school graduation. Word processing operators would fall into area 3 and secretaries alone (relative to the other occupations discussed here) would be considered office workers who performed non-routine, non-standardized work and, hence, would be those who utilized the most working knowledge. A close look at official descriptions and the day-to-day activities of workers in these occupational categories will indicate their differences in specialization and routinization and, consequently, their differences in skill/knowledge requirements.

According to Crozier (1965: 80), *file clerks* are 'at the bottom of the social scale in the insurance companies.' This seemed to be the general consensus of my sample who also observed, as did Crozier, that these positions had a high rate of turnover because file clerks are often hired on a temporary basis to begin with, quit

due to dissatisfaction with the job, or apply for other positions within the company at the first opportunity.

File clerks are basically responsible for maintaining a company's documents in an ordered manner so that information can be speedily retrieved when needed. The *Dictionary of Occupational Titles* says that the category of file clerk 'includes occupations concerned with classifying, sorting, and filing correspondence, records, and other data' (p. 158). Only rarely, however, are file clerks involved in the determination of a classification system; they seldom have a say in the way in which an entire file system is organized and broken down into categories. In fact, they do not often have the leeway to determine how even a particular document is categorized or cross-indexed. I came across only one situation during my research where an interviewee was involved in the classification of a file system. This was in the F & M Word Processing Office where the filing system was relatively small.

Only four of the COOP students and alumnae I interviewed were file clerks for the duration of their senior year. All the others, however, spent a significant part of their work time doing filing: a few worked in a filing department for a quarter of the academic year; the rest had filing responsibilities as part of their daily or weekly work load. Even if a COOP student worked in an office where there was no filing, she would be the one sent to help out in files if the work load in her department happened to be light on a particular day. Because the COOP student was the youngest and newest employee, she was the one asked to do the filing. It was obviously the job (along with copy-making) that employees were happy to be relieved of. Even the COOP students generally put that task off to the very last whenever they could. It was tedious, time-consuming and often backbreaking work because of the bending and lifting involved.

From my observations it was apparent that the *DOT*'s description of the labor process of the file clerk (classifying, sorting and filing) was both inaccurate and non-comprehensive. File clerks also spent much of their time retrieving files and, on occasion, had to create, code, copy, distribute, purge, update, check for misfiles, and load and unload files as well. None of these tasks, however, was viewed as a reprieve from the daily routine.

So even though file clerks do more than sort and file during the

97

course of their day's work, the task that requires the most knowledge and judgment, that of classification, is generally outside their job scope. Their remaining tasks are quite routine in nature, with variation either trivial (being rotated to a different set of files) or a source of frustration (trying to locate a document improperly filed).

File clerks need to be literate and numerate so they can identify and properly place files, and coordinated enough to physically handle reams of paper or microfiche on a daily basis. Unless high levels of speed are required for the job, even a worker classified as mentally retarded (as was one of the COOP students) finds the routine nature of file clerking hard to tolerate.

The work of a *typist* may seem so apparent as to warrant any job description redundant. Crozier compares a typist's work to that of a machine operator, with the exception that for typists language is an important component, making social and cultural differences in workers key factors in job performance. Thus, Crozier states that comprehension and communicative skills are of great importance except where typists' jobs are highly standardized. In his sample of insurance companies, Crozier found that typists generally worked in isolation and that those who typed correspondence enjoyed the greatest variety in their work and were 'generally better typists who have had more education and are prouder of their qualifications' (1965: 83).

None of the typists in my sample, however, were responsible for correspondence, although, as in Crozier's sample, each of them worked for an insurance company. They spent their days instead doing highly standardized, straight-copy typing of insurance forms. Straight copy work meant transferring onto the appropriate form a typed version of handwritten (or in some cases rough typed) information passed onto them by their supervisors from agents or underwriters. Sometimes the information given them was in a form that closely approximated the final typed version; at other times it was buried in more extensive information and had to be searched for.

But even when the information to be typed on a form was minimal (e.g. a name and address) or came in the most standardized form possible, most typists needed more working knowledge than did file clerks. This is because their work, while often more specialized, was less routine. The mere process of typing (coordi-

nating materials and machinery to transcribe numeric and alphabetic symbols) includes more variables than all of the sub-functions of filing. This higher level of skill is recognized in the practice of schools to offer up to four semesters of typing (no one offers courses in filing) and in the practice of employers to advertise for typists who can produce so many words a minute.

Relative to the other office occupations, however, typists would still be among the most specialized and routinized. Seldom did their work day involve any production functions other than typing.[9] And, even though, as with the file clerk, typists' work involved a number of auxiliary or sub-functions (such as searching through files to find all the necessary and relevant information, proofreading final forms, routing forms to their appropriate places, or looking up codes or other information missing from the file on microfiche or the CRT), the vast majority of their time was spent sitting at their typewriters, inserting forms (previously stacked on their desks by supervisors) into the carriage and lining them up correctly, locating the information to be transcribed, pressing the appropriate keys which print onto the form, and removing the form from the carriage.[10]

If the descriptions of *clerk typist* given in the *Dictionary of Occupational Titles* (p. 154) and in the *Clerk Typist* brochure advertising the one-year diploma program at Macomb Community College are compared to the clerk typist production functions listed in Table IV, the broad scope and non-specialization in this amorphous category become evident, with the specific combination of tasks highly dependent, as the brochure notes, 'on the size of the firm and the number of clerical employees.'

Community College description	*DOT description*
(1) filing records and reports	(1) sorting and filing records
(2) compiling and typing various documents	(2) writing or typing bills, statements, receipts, checks, or other documents
(3) cutting stencils for duplicating machine	(3) copying documents, using office duplicating equipment

99

(4) sorting and distributing mail; addressing envelopes

(4) addressing envelopes on packages; stuffing envelopes; stamping, sorting and distributing mail

(5) operating a telephone switchboard

(5) answering telephone, conveying messages

(6) posting information to record

(7) computing accounts

(7) receiving money from customers and depositing in bank

(8) acting as receptionist

(9) running errands

(10) stamping or numbering forms by hand or machine

(11) proofreading records or forms

(12) counting, weighing or measuring material

In his insurance companies, Crozier found two separate categories, clerks and typists, but not a combination of the two. Either these functions were strictly differentiated in each of his organizations or typing was such a taken-for-granted aspect of accomplishing the other tasks that it was not mentioned. Since I also failed to observe any combination of the two functions in the large insurance companies in my sample (refer to the 'corporate' column in Table V) the first interpretation is quite possibly correct. This interpretation gives salience to the hypothesis that division of labor and specialization are found to the greatest extent in large bureaucracies.

As also indicated by Table V, with the exception of one case, clerk-typist jobs were all located in either the small family or competitive private sector or in the public sector. Few of the clerk-typist positions were found in corporate capitalist offices. Approximately fifteen of my interviewees held jobs in this category as COOP students. (Five went on to other positions by the time of our interview.) A large number of offices are apparently

still organized in such a way that job specialization is either not possible or not desirable.

Again, however, a close look at the day-to-day activities of the clerk typists indicated that although they were involved in a much broader range of production functions than were the file clerks or typists, these activities were no less routine, taking a few days, at most, to learn. Many of these functions, however, (e.g. acting as receptionist, operating the switchboard, handling the mail, computing accounts) involved utilization of equipment or personal interaction not encountered in the file clerks' or typists' work. These elements called upon additional skill and knowledge if the clerk typists were to satisfactorily accomplish their work.

Two occupations fall into the third category I have created in Figure II: word processing operator and *account/credit clerks*. Both these jobs are specialized but non-routine and therefore require the utilization of greater skill and knowledge than the previously described occupations. Since I will be dealing with word processing operators in some depth in the next section of this chapter on office automation, I will only describe the work of the account/credit clerks here.

The *DOT* describes Accounting and Computing Occupations generally as those 'concerned with 1) examining, analyzing, and interpreting accounting records, and 2) systematizing information about transactions and activities in accounts and quantitative records and paying and receiving money for such occupations' (p. 91). Nine occupations are listed in this general area, headed by accountants and auditors, running through bookkeepers, cashiers and tellers, and ending with the miscellaneous computing and account-recording occupations. The women in my sample fell into this last general category, which the community college labels the 'account clerk' and in which a one-year diploma can be attained by taking such courses as sole proprietorship accounting, corporation accounting, payroll accounting and income tax, machine book-keeping, business mathematics, etc. The community college brochure says that the account clerk performs 'routine calculating, posting, and typing duties related to accounting procedures and handles one or more of the many kinds of work involved in keeping a complete set of books.' Typical duties include

– recording business transactions (allotments, disbursements,

– payroll deductions, pay and expense vouchers, checks and claims)
– totalling accounts
– computing and recording interest, refunds, charges, and rentals
– typing vouchers, invoices, statements, payrolls, reports and records
– collecting data from sales slips, invoices, check stubs and inventory records.

Working in an accounting or credit office does not necessarily mean an employee will be engaged in accounting-related work. Clerk-typist functions are just as essential in those settings as they are to any office. In fact, only one of the five account clerks in my sample was responsible solely for accounting work during her COOP job. This student took the COOP class for only the last semester of her senior year and accepted a seasonal, part-time position with the Department of Revenue (which hired temporary help at tax return time) helping to process tax forms by double-checking the figures on the individual returns. But most account-clerk positions are not of this temporary nature, dependent on a particular cyclic function. They tend to be more complexly woven into the multiple operations of a given office, with numerous clerical and accounting tasks performed on any given day. In small offices or credit unions especially, account clerks might act as receptionists: answering phones, or working with the public at the front desk. In these situations, there is virtually no difference between the account clerk and the clerk typist. As can be seen in Table IV, the account/credit clerks performed virtually the same production functions as the clerk typists. The primary difference in their daily work was that they spent far less time typing and photocopying than did the clerk typists and far more time in processing accounts. What this quantitative difference does not reveal, however, is the qualitatively less routine nature of account/credit functions these workers performed. A brief description of the COOP students' work at the Safeco Credit Company will illuminate that difference.

The two credit authorizers at Safeco Credit Company, Patti and Evelyn, spent the majority of their day working on 'approvals.' This seemingly routine job was actually the most difficult

production function (had the most sub-functions and the most variables) of the work tasks described so far. Mrs Lewis attested to this by sending only her brightest students there to be interviewed. The difficulty of the job also became apparent when Evelyn, a high-ranking student academically, told both her supervisor and Mrs Lewis when she was about two weeks into the job that she thought she would have to quit because she just could not handle it.

During my afternoon observation of Patti and Evelyn at work, I noted that their work seemed more complicated than the others I had observed because of four factors: (1) the variety of forms they had to make decisions about, (2) the various pieces of equipment they had to learn how to operate: phones, computer terminals (CRT's), and printer, (3) the speed at which messages came in, forcing them to work quickly and to handle multiple calls at once, and (4) the codes and computer formats they had to be able to interpret and use.

The only occupational category in my sample that fell into area 4 in Figure II (non-routine, non-specialized work) was that of the *secretary*, although, as I will indicate, a secretary was also often indistinguishable from a clerk typist. Only five of my interviewees did work that could in any way be classified as secretarial; none of them started out in those positions as COOP students.

The small number in this category is probably the result of two factors: the women in my sample were primarily young, new workers, and secretaries are drawn from experienced and highly trained office workers; and, secondly, the proportion of secretaries in relation to total office workers has dramatically declined during this century. This decline has been attested to by a broad range of studies and analyses of office work (Lockwood, 1958; Braverman, 1974) and is, again, related to the overall transformation in the size of offices. Tellingly, Crozier's six major office categories (file clerks, keypunchers, typists, clerks, policy writers, and claims adjusters) did not include the occupation of secretary. Apparently, in terms of number of employees, that was a relatively minor occupation in Crozier's insurance companies.

Both the *DOT* and Macomb's community college describe the secretary as an executive or administrative assistant. While the *DOT* (p. 153) says she performs 'minor administrative and general office duties,' the community college brochure takes its definition

103

from the National Secretaries Association (an organization which comprises approximately 1% of office workers and whose goal is the general professionalization of the secretary), stressing her high level of skill and responsibility:

> A secretary shall be defined as an executive assistant who possesses a mastery of office skills, who demonstrates the ability to assume responsibility without direct supervision, who exercises initiative and judgment, and who makes decisions within the scope of assigned authority.

Their typical duties, states the brochure, are

acting as receptionist,
reading and routing incoming mail,
assembling documents for employer,
taking and transcribing dictation,
composing and typing routine letters,
filing documents,
operating the telephone or switchboard,
scheduling appointments and travel,
compiling and typing statistical reports,
supervising and training clerical staff,
keeping confidential reports,
operating the duplicating machine, and
recording minutes of meetings.

As should be readily apparent, many of these are also the functions of the file clerk, the typist, the accounting clerk, and the clerk typist. The three aspects of the position that seem to distinguish the secretary from the other occupations are

(1) her level of responsibility and judgment (supervising employees, keeping confidential reports, and composing correspondence),
(2) her knowledge of shorthand (taking notes at meetings), and
(3) her personal work relationship with her employer (scheduling appointments, writing letters, etc.).

Since there is no necessary connection between these functions, and since dictation is now so often done with dictaphones, these three areas of job responsibility are often separated and given to

employees who are not secretaries. Supervisors of office staff are
not necessarily secretaries, for instance; and if the secretary is the
only office personnel, she has no one to supervise. Similarly,
word processing operators can be responsible for most dictation
(including confidential reports) without assuming any of the other
responsibilities of a secretary.

It seems, then, that the real distinguishing secretarial function
is her personal work relationship with her employer(s) or
manager(s). There is no intermediary between the two, no second-
line supervisor. This type of work relationship was much more
common in the early nineteenth century office (Lockwood, 1958).
It is now limited primarily to small offices or found in upper
echelons of corporations. So, unlike her other office counterparts,
the role of the secretary is defined primarily by social rather than
technical relations. Secretaries seem to work directly for the boss;
other office staff work for the company or department (although
they too often personalize authority relations). The responsibility,
initiative, judgment and skill mastery that characterize their work
are not so much distinguishing marks of a secretary as they are
marks of a good and experienced clerk typist.

The primacy of social relations does not necessarily give the
secretary the subjective experience of a better position than her
other office counterparts. Much depends on the way her personal
relations develop with her employers, the way she is viewed by
them, the terrain she established, etc. Debbie, for instance, who
was the only office staff in a small city department called herself
'the little Toby, the little slave, the go-fer, the person they send
to do this and that.' She resented the work her supervisors gave
her because she regarded it as 'shit-work' they could have done
themselves if they weren't so lazy, but accepted work from the
laborers, which was technically outside her job scope, because
they appreciated the help she gave them.

The experience of the secretary's position is also mediated
through the compensation she receives for her work in the form
of pay, which again may not be substantially different from other
office employees, despite her title, her numerous and varied
responsibilities, and the claim that she has mastered office skills,
needs no direct supervision, and exercises initiative and judgment.
As Charlotte said, 'The woman who cleans the bathrooms makes

as much or more than me – which is not to put her down. It just gives me an indication of how much I'm worth.'

What should be apparent from this close look at office occupations in a service economy is that high levels of skill are not necessarily needed to accomplish the jobs. In fact, if this shift to a service economy is accompanied by a corresponding shift from family to corporate businesses, which it appears to be, the service sector might be creating huge categories of specialized, highly routine work. This should be evident from Table V:

*Table V: The occupational categories of the COOP students by employer type

		Employer type				
Job type		Private sector			Public sector	
	Family N = 2	Comp- etitive N = 9	Cor- porate N = 13	City N = 5	Univers- ity N = 2	State N = 3
File clerk N = 5		1	4			
Typist/word processing operator N = 7		2	4	1		
Clerk typist N = 10	2	2	1	2	1	2
Account/credit clerk N = 7		3	3	1		
Secretary N = 5		1	1	1	1	1

* Many of the alumnae had changed jobs since they were COOP students. For purposes of this chart, I reported the last office job they held at the time of the interview.

file clerks and traditional typists (not word processing operators) were found only in the competitive and corporate areas of the private sector. So, while the scenario of the proletarianization theorists needs to be modified through a specification of particular categories of office jobs within particular types of work organiz-

ations, it seems to be more accurate than the upgrading thesis of embourgeoisement theory.

The automated office

A second basic area on which embourgeoisement and proletarianization theory disagree is on the effect of automated machinery. Embourgeoisement theorists see the increased automation of production forces creating a need for a more highly skilled labor force. Harold Entwistle (1970), for instance, has this to say:

> The logic of automation . . . is not that it creates armies of unskilled workers, but that it makes the unskilled redundant (p. 10).

> In automated industries themselves, there is increased demand for skilled work at all levels (p. 36).

> The expansion of work opportunities which can be a consequence of the automation of industry will certainly require from workers much greater knowledge, intelligence and skill (p. 43).

More recently, in elaborating the implications of Antonio Gramsci's writings for technical and vocational education, Entwistle (1979) again asserts

> the modern accelerating shift from highly mechanised manual work towards automation, with the consequent diminution of the demand for manual (especially unskilled) labor and an expansion of the professions and para-professions in the middle ranges of the economy (p. 143).

In *A Nation at Risk*, the National Commission on Excellence in Education assumes the same link between automation and skill. Stating that 'computers and computer-controlled equipment are penetrating every aspect of our lives,' and that 'technology is radically transforming a host of other occupations,' the report claims that these changes necessarily mean a rapid acceleration in the demand for highly skilled workers (p. 10).

Proletarianization theorists tend to take the opposite view, that even if an automated machine has the capacity to upgrade the

skill requirements of workers it is utilized in capitalist economies in a way that serves not only to increase production, but to control, fragment and deskill workers.

> The office computer does not become, in the capitalist mode of production, the giant step that it could be toward the dismantling and scaling down of the technical division of labor. Instead, capitalism goes against the grain of the technological trend and stubbornly reproduces the outmoded division of labor in a new and more pernicious form . . . the concentration of knowledge and control in a very small portion of the hierarchy become the key here, as with automatic machines in the factory, to control over the process (Braverman 1974: 328–29).

Since word processing has, thus far, been the primary way in which offices have been automated (along with data processing with which it can be easily merged, and electronic communication systems) my argument about office automation will focus mainly on that particular form of automation. The proletarianization theorists, Barker and Downing, have the following to say about this technological 'advance.'

> Word processors and auxiliary office equipment are intended to increase productivity by an average of 100% by radically changing the relation between capital and labour due to the conscious application of science and technology to office work. Capital is attempting to gain greater control over the relationship between labour and the means of production leading to deskilling and the subsequent cheapening of labour (1980: 90).

More specifically, Barker and Downing describe the concrete ways in which word processors increase productivity, and control and cheapen labor. First, they eliminate wasteful typing and re-typing. This occurs in two ways: (1) since the key-boarding and printing functions of the typewriter have been separated in the word processor errors can be corrected by depressing the back-space key. They never reach the printed page; and (2) since word processors have storage capacity, a revision of any document can be done without a total re-type. The rough draft can be called up from memory, lines eliminated, paragraphs re-ordered, words

replaced, sentences re-written, etc. Secondly, the authors claim that word processors ensure that typists do more work through (1) control units that continuously feed in dictated work and (2) electronically monitor the flow of work. Braverman and others also refer to these capacities.

> The worker experiences great pressure to work quickly, accurately, and to maintain the pace set by the machines (Glenn and Feldberg, 1979b: 62).

> As in the factory, the machine-pacing of work becomes increasingly available to office management as a weapon of control (Braverman, 1974: 333–4).[11]

The third way in which Barker and Downing see word processors increasing both productivity and control is by auxiliary task fragmentation and automation. In terms of the terminology I have been using in this chapter, production functions become more specialized (fragmented). The worker who once handled filing and typing and phones and mail is now consigned to one specific production function: word processing. In addition, these auxiliary functions (such as filing) are simultaneously becoming automated. Fourth, the authors claim that word processors eliminate the need for traditional typist skills in producing neat and well-laid-out work. This claim is principally based on the form of the document to be programmed into the machine (by a higher-level employee). All the typist need do in this situation is put the correct bits of information into the pre-established slots, the office equivalent of painting by number. The machines, rather than the typists, now

> indent, centre, justify margins and tabulate. . . . In removing the need for these skills, word processing effectively removes one of the most important areas of control which the typist has over both her work and her typewriter; through choosing how to lay out a particular document, the typist is instructing the machine on what to do, her skill and initiative are guiding the typewriter through its various functions. With word processors control is limited to pressing the appropriate button and letting the machine do the rest (1980: 91–2).

The last means by which this form of automation controls workers and consequently productivity, according to the authors,

is by eliminating the need for the typists to leave their seats since the memory capacity of the computer will give them necessary documents at the push of a button.

While I am not able to generalize my argument to all forms of office automation or even to all forms of word processing organization, my observations and interviews lead me to conclude that automating typing does not necessarily lessen the skill requirements of workers or provide the means for greater control over workers, although it does increase productivity. In fact, the typists I interviewed who were employed in word processing centers were doing some of the most skilled work of the women in my sample. By going through Barker and Downing's five assertions, I will be able to argue my case.

The authors first claim is totally accurate. Word processors definitely eliminate wasteful typing, a function which obviously increases worker productivity. But Barker and Downing make no attempt to explain how this capacity cheapens or controls labor. One way in which the typing cost overall might be lessened for the employer is through the more efficient utilization of fewer typists, but Barker and Downing do not make this claim; and as Glenn and Feldberg argue 'the capacity to store and process huge amounts of information appears to contribute to a demand for even more information, which eventually means more clerical workers' (1979b: 56–67).

More importantly, the elimination of wasteful typing (in the form of errors particularly) removed one of the greatest sources of frustration for office workers. It was experienced as a helpful labor-saving device, not a negative control mechanism. Freed from the dread of having to correct errors or type an entire form over, these typists were able to accomplish their work more quickly. As Tanya put it, 'the machines give you confidence to type faster.'

Besides, the slow pace of work and the resulting boredom it brings on is an even greater source of dissatisfaction for office workers than the demand from management for a high production rate. Although I am sure there is a point at which 'speed-up' would be more intolerable than a slow work pace, viewing automation strictly as management's attempt to extract extra surplus value misses the way it is experienced by workers: being provided with the equipment their skills deserve, being thought of highly

enough to be relieved of tedious typing work by management investing in sophisticated equipment. In fact, once office workers become acquainted with and experienced in the use of various types of word processors, one of their greatest complaints about the labor process is not being provided with good enough equipment. This subjective experience of the labor process, of course, enables the employer to expropriate more easily increased amounts of surplus value.

Barker and Downing's second and fifth claims can be analyzed together since they both deal with specific ways of controlling work productivity: by a machine-controlled pace, by an electronic monitoring system, and by feeding work through the machine. Their evidence for all these control mechanisms is not based on ethnographic or survey data, but on 'sales pitches' by manufacturers trying to convince management to buy their products.[12] One of the criticisms Burawoy makes of Braverman's *Labor and Monopoly Capital* is relevant here: management ideology is assumed to be management practice and the actual labor process and the determinants of that process are overlooked (1978: 35–40). In the fourteen offices I was in, I observed no electronic monitoring devices and no machines that continuously fed in dictated work. Work pace was not technically controlled, although, as indicated in Chapter 1, the National Organization of Office Workers found extensive monitoring, particularly in large corporations. Nor did I witness work called up through the machine (eliminating the need for typists to leave their seats). But even if it were, this function does not drastically change the labor process of the typist: supervisors often placed documents to be typed that day on the typist's desk. Movement can also be controlled through non-technological mechanisms.

Barker and Downing's third claim, that word processors fragment and automate auxiliary tasks, is an accurate description of the organizational effects of word processing technology. What is inaccurate is the implication that this somehow 'deskills' workers. True, the job scope of these typists is more limited than the scope of clerk typists, but even though it is more specialized, it is also less routine. A higher degree of knowledge (as I will demonstrate shortly) is needed to be a word processing operator than to be a clerk typist. In addition, there are still whole non-automated offices filled with traditional typists, whose job scope also excludes

111

these auxiliary functions. Separating typing jobs from filing does little to deskill workers since filing is the lowest level office occupation to begin with. Nor does the separation of printing from typing somehow 'fragment' the work force. Most printing is done by the typists at work stations adjacent to their CRTs. And even though this separation of functions technically 'fragments' the labor process, that fragmentation is again helpful in overcoming the most tedious aspects of typing. If the two elements were not separated, errors could not be so easily corrected, and multiple original copies of documents would have to be typed multiple times. This way they need only be typed once.

Barker and Downing's fourth claim, the direct assertion that word processors eliminate the need for skill, contains their greatest misconception. They appear to conceive of typing skill primarily in terms of 'lay-out': indenting, centering, tabulating, etc. My criticism is twofold. First and simply, although word processors make it possible for someone other than the typists to program the form of the document, there is no inherent reason why it cannot be the typist. In my sample it generally was. In addition, Barker and Downing seem either to forget or not to realize that a large percentage of traditional typists spend their entire days filling out information on pre-printed forms. Established formats did not need office automation to be introduced. And, secondly, the authors' definition of skill is not only extremely narrow, but extremely low level as well. One of the main sets of skills the typists from my sample needed were verbal skills.

Since letters and other forms of information to be typed are often orally transmitted through the use of dictaphones, the possession of English and grammar skills is often far more critical for word processing operators than it is for their typing counterparts. Oral transmission made it necessary for them, for instance, to be able to distinguish homonyms, to know the spelling of every word, and to determine punctuation requirements. As Tanya said,

A lot of the work comes over the dictaphone and people don't always know how to use it right, so it causes problems.
Sometimes their grammar isn't good. They throw in any word and it sounds terrible.

Moreover, after a word processing operator had proven her capabilities, she systematically engaged in editing work, often

changing words, phrases, or syntax during the initial listening. During our interview Connie said, 'I'm at the point where I can hear one thing on the dictaphone and type it differently right on the spot.' Such a practice demands both fluency and confidence in language use.

The women who worked at F & M Savings and Loan, for instance, took correspondence courses in Effective Business Writing and often spent time going through or discussing the exercises together. Under the direction of their word processing supervisor they had established specific correctives to standard problems. But, more often than not, the word processing operator had to use her own knowledge and discretion in transforming prose that sounded awkward or wordy. Only the two or three highest ranked officials in the association were immune from having these women correct their work.

These workers were not mere passive transmitters of received information. They were actively involved in qualitatively improving upon both the form and content of that information. Moreover, one of the women had recently spent six months composing a 600 page manual containing samples of all the types of form letters generally used by the association. With the input from personnel from each department, she had updated, revised and generally improved the association's correspondence. Although employees still had leeway in how they used the samples from the manual, once Connie had completed the revisions she did not send them to department heads for approval, explaining to me, 'It's not their job to tell me how a letter sounds. Especially since I spent two years taking Effective Business Writing I and II. I didn't feel it was their place.'

And because word processing equipment has the capacity to be programmed with different and expanded capabilities, operators are in the position of continually learning new things.

'The CPT 640 can do so many things it's just amazing. We don't even know all it can do yet and they keep adding new things to it. . . . They (the machines) are so sophisticated. You never come to the end of learning. It's fun to know you know the machines like the back of your hand and yet there's always more to learn.'

The utilization of this capacity expands the job scope and

increases the variety in the word processor's work, two aspects that consistently emerge as sources of job satisfaction: ('I like learning new things. It varies the job.') At the time of my study, the Accounting Department of F & M Savings and Loan was consulting with the word processing operators about utilizing their help since their equipment was already programmed to perform arithmetic functions on rows and columns. The women in this department were also in the process of learning each other's work (which was basically divided according to the complexity of the various documents they needed to transcribe) so that they could all help each other out and even the work load. This again helped increase their work variation and job scope:

'At one point my work was repetitive and monotonous. I was doing the same type of letters for a long time and it wasn't challenging any more. I was getting really bored and Beverly realized she had to switch things around more and have everyone doing and learning everything.'

The emphasis I am placing here on the skill level of word processing operators does not mean that I support Entwistle's technological determinist vision of the 'logic of automation' requiring workers with greater skill. Much of typists' work could be performed on word processors without affecting the skill level of the workers. While the elimination of wasteful retyping would certainly result, due to the separation of typing and printing functions, little change would occur in the requisite knowledge of the typists after they had learned how to operate the machine.

The proletarianization theorists make a similar technological determinist error in presuming that the capacity of a machine to control the labor process will necessarily be utilized by employers and passively submitted to by workers. From the information I gathered, it would seem that employers do not know a machine's capabilities or do not need automation to control workers. Moreover, workers did not resist the imposition of automated machines but actively urged employers to provide them with equipment that would enable them to be more productive.

While employers certainly are constrained in their decisions by needs for efficient and productive work organizations, they do not always need to employ automation to this end. Supervisors often provide sufficient guarantee that necessary levels of output are

produced, especially (as Chapter 7 will further indicate) when workers have their own motivation for being productive. So while word processors may increase worker productivity, they do not necessarily have the effect of deskilling office workers and cheapening labor, though they can provide employers' 'reason' to decrease wages through job scope restriction. Although I do not want to underestimate the potential automation gives employers to control workers (as described in Chapter 1), proletarianization theorists are mistaken when they posit the intrinsic unity of automation's capabilities (controlling, fragmenting and deskilling work) and when they overlook workers' struggles to upgrade their positions through automation.

6
Schooling in office skills

The analysis presented in Chapter 5 has obvious implications regarding the role of schools in the preparation of a labor force. Those who maintain the embourgeoisement perspective stress the insufficiency of worker's skill to meet the needs of a highly technical and service oriented economy. The executive director of the American Vocational Association has stated, for instance, that education has much to contribute to overcoming the shortage of skilled workers and that 'business and office education must equip individuals to function in an automated office of the future, which means not only competence in using new equipment, but the ability to work in new kinds of organizations' (Bottoms, 1982: 14–15).

More relevantly, the need for skilled office workers is a theme that runs throughout the *Cooperative Office Occupations Program* manual prepared by the Bureau for Career and Manpower Development of the State's Department of Public Instruction. Although the manual does not raise the question of whether office workers need to be more or less skilled than in the past, its contents are based on the assumption that education develops those skills in future workers that increase office productivity. In listing its advantages to the community, the manual states that COOP 'increases the economic health of the community as companies are able to meet their needs for skilled workers.'

The proletarianization perspective stresses, conversely, the 'waste' of education for a labor force that needs minimal skill development to adequately function in their jobs, and the 'waste' of humanity, in whom ability remains untapped and unutilized. Braverman (1974: 439–40) claims, for example, that 'the continuing extension of mass education for the nonprofessional

116

categories of labor increasingly lost its connection with occupational requirements' and that 'the commonly made connection between education and job content is, for the mass of jobs, a false one.' Quoting the early scientific management proponents, he concludes:

'Training a worker . . . means merely enabling him to carry out the directions of his work schedule. Once he can do this his training is over, whatever his age.' Is this not a perfect description of the mass of jobs in modern industry, trade, and offices?

Bowles and Gintis (1976) affirm Braverman's assertions by stating that schools are not really needed to reproduce the technical relations in production, implying that the skill requirements of most jobs are meager and easily learned. They refer to these jobs as dehumanizing, alienating and incapable of promoting human development, and capitalize on Adam Smith's well-known statement that:

in the progress of the division of labor, the employment of the far greater part of those who live by labor . . . comes to be confined to a few very simple operations. . . . (The person employed) generally becomes as stupid and ignorant as it is possible for a human creature to become (p. 25).

In an earlier article, Gintis (1971) claims that vocational education's misplaced emphasis on 'skill content' accounts for its notorious failure to provide economic returns to its graduates (p. 267). This analysis leads the authors to emphasise the role of schooling in reproducing the social rather than the technical relations in production, a point that will be taken up in the next chapter.

In terms of the specific types of office jobs relevant to this analysis, both positions are exaggerated generalizations. Service occupations and automated technology do not necessarily upgrade the skill requirements of workers; but neither does their organization within capitalist economies necessarily degrade skill requirements. The more precise dimensions of specialization and routinization (as well as the social organization of automation) are much more helpful to an understanding of the role of schooling in the reproduction of the technical relations in production.

Given the nature of the jobs the students in the Cooperative Office Occupations Program at Woodrow High found themselves in, what 'skill' training should they have been provided with to do their jobs? What skill training were they actually provided with, and, if there was a discrepancy, how is that to be accounted for? Moreover, and at a more philosophical level, should the role of the school be to prepare students for jobs, regardless of the nature of those jobs? And lastly, what does this training teach the students about office work and about their role as office workers?

First of all, then, what technical skills did the students need to do their jobs? Table IV in Chapter 5 indicates that of the seventeen students in the 1981 graduating class, sixteen said that their jobs involved filing, thirteen said typing, twelve mailing, eleven photocopying, nine handling phones, six running errands or giving directions, five acting as receptionist, four word processing and three each record keeping and account handling. The four most commonly performed production functions were the most routine and, therefore, the easiest to learn; the others a bit more specialized and complex. If, however, the COOP students were to be prepared to do any but the most routinized and specialized of office jobs, the expectation would be that they would all get training in the various aspects of the ten production functions.

Although preparation for office work incorporates a much broader range of both formal and informal learning situations than the two specific business classes I will be analyzing, the explicit purpose of these two classes was to prepare high school students to function as office apprentices during their senior year. The expectation was that the courses would sharpen the skills (grammar, typing, etc.) they had acquired in other contexts. And, if one looks at the syllabus Mrs Lewis devised for the junior-level Office Procedures class, one sees a rough correspondence between the production functions the students were called upon to utilize in their job placements and those that were taught in the classes. The semester-long Office Procedures devoted about a month to filing and to report typing, and about two weeks each to invoicing and telephone techniques. The year-long Office Education class devoted about four months to different aspects of typing (letter styles, use of dictaphones, proofreading, etc.), a month to grammar, and about three months to various aspects of record keeping and account handling. It is not, however, until the in-use

curricula, the actual day-to-day practices within the classroom, rather than the formal syllabus are examined that the role of schooling in the reproduction of a 'skilled' office work force can be understood. A close examination of a few of the units will reveal some significant patterns and relations.

Filing: Filing, taught in the junior-level class, was the most teacher-directed of the units taught in either class. Although the materials were pre-packaged, simulating an actual filing system, they were relatively complex, involving twenty rules, different types of filing (alphabetical and numeric; subject matter and geographic filing were sub-units but were not taught), and timings of rate of production. Mrs Lewis was more demanding of the students in this unit than in any of the others, telling them that they could not miss deadlines or make up missed work, that timings would only be given on certain days, that their grade for the unit would be based on the problems they did, and that homework would be given.

Once each of the students had constructed her own miniature file unit (the pre-packaged materials were individual cardboard boxes containing documents to be filed and step-by-step directions), Mrs Lewis began teaching a few of the filing rules a day and then led the students through exercises based on these rules, which could become quite complex when numbers or titles were part of a name, when political divisions or groups were involved, when the filing unit involved a foreign language element, prefix, etc. There were often exceptions for each rule.

Filing quizzes were regularly given. Some of them involved stating the various rules; most were multiple choice quizzes which involved ordering a series of names or organizations. Students also were timed on how quickly they could file a series of documents and retrieve previously filed documents. In addition, they practiced cross-referencing procedures on documents that could logically be filed in more than one place.

After the first day of this unit I wrote in my field notes that the unit stressed highly routine, step-by-step procedures and rule following. There was no room for individual decision making. The students were told what to do down to the minutest detail:

Bring a sharp pencil with a big eraser to class each day. Take your pencil. Draw one line under the word Smith. That

119

represents the first unit. Draw two lines under the word Susan, and three lines under the initial K. Print the name as it will be put in the file at the top of the card.

Mrs Lewis further advised the students that it is 'always important to establish work habits and procedures, and to follow those procedures. That way you will never make a mistake.' All in all, the day-to-day exercises involved in this teaching unit most clearly correspond to Braverman's and Bowles and Gintis's observation that schools teach students how to follow directions. What is missing in that straightforward and somewhat simplistic analysis, however, is that a real mastery of the rules and filing techniques taught in this unit would give the students both the confidence and competence to do the one thing most file clerks never get the chance to do: classify (setting up or re-organizing a file system). A number of the students, particularly the ones who worked in small offices, mentioned the disarray or the illogic of their office's filing system, but, with the exception of the student mentioned earlier, none of them were involved in classification. From an efficiency viewpoint, it would seem a waste to encourage a high level and rate of mastery over filing complexities, unless practice in following directions makes it worth the time. A simple third or fourth grade alphabetic or numeric understanding would suffice for the work of most file clerks. But should efficiency, in this situation the fit of workers into low-skilled jobs, be the primary criterion used by educators?

Typing: Various typing exercises, emphasizing different aspects of typing (proofreading, editing/correcting/modernizing correspondence) were interspersed throughout both the junior- and senior-level classes. Although a few of the exercises stressed typing bits of information onto printed forms (the kind of typing most of the students generally performed on their jobs), most of them involved editing correspondence and reports. The seniors were also taught how to take correspondence from dictaphones and type it in mailable form. These latter activities approximated the higher-level work of the word processing operators and, according to Crozier, make comprehension and communicative skills of great importance.

When form or layout were the key aspects of the lesson, explicit directions were invariably given by Mrs Lewis as to the proper

format. When explaining to the Office Procedures class how to do report typing, she had them copy down ten rules as she wrote them on the board. The rules covered such things as:

- indent five spaces for a new paragraph;
- start two inches from the top of page one, that is twelve lines, so start typing on line thirteen; on the rest of the pages resume typing on line ten;
- type to space 85 on elite typewriters; that is also where the page number belongs, on line seven;
- leave a one inch margin at the bottom, but never leave one line of a paragraph hanging.

Even when Mrs Lewis told the students they could decide how to lay out the title page, that this was their opportunity to be creative, she ended up telling them that they should type the title using all capital letters, let the word 'by' stand in a line by itself, move down several lines on the sheet so the information was centered, etc. When Mrs Lewis came across a title page one of the students had completed which she thought looked nice, she held it up to the class as an example, resulting in twenty-five 'creatively laid-out' title pages looking amazingly similar.

Where the students did end up using their broader knowledge and judgment was not in matters of typing form, but in editing the content of the letters. During the first semester of the senior-level class, for instance, the students spent well over a month on a sixteen-exercise proofreading unit. The exercises started out with simple directions to circle and correct spelling and punctu-ation errors in the text of reports and letters, gradually moving into more complex procedures. The directions for exercises 15 and 16 were to 'eliminate all wordy phrases, change long to short words, rewrite sentences, keep sentences short – expressing one idea.' Counter to what Barker and Downing claim, it seems obvious that a typist's skills are primarily those of language, not layout.

As in the filing unit, however, most of the students did not actually use these higher-level language skills on their jobs. Nor did Mrs Lewis encourage high quality work or a continuous 'rate of production.' Once she had spent a few minutes presenting the overall unit she generally absented herself from involvement in

the students' assignments (reading at her desk, working in her back office, chatting with individual students or teachers).

These factors seemed to provide sufficient reason for the students not to take assignments seriously. When Terri, the most diligent student in the class, had completed exercise 16, some of the others were still working on exercise 6. Although Mrs Lewis told the class they should finish by Thanksgiving (Terri did so without hurrying and without doing any homework), the unit dragged on until Christmas vacation: about three weeks later. The students also took advantage of the answer book Mrs Lewis left available for them to check their work. A number of them used it, or the work of other students, to copy answers.

When I spoke to Maureen, a student who worked on her own to complete the exercises, she expressed relief at having finished the unit, claiming the exercises simply required students to do the same things over and over. She did not think they helped her get any better at the work.

Since Mrs Lewis's pedagogical style was to assign work tasks and then leave them to the students to complete on their own, rather than to assess problem areas and help students resolve them, I basically concurred with Maureen's analysis. Mrs Lewis seldom watched students to determine if they were having difficulty with assignments. Not until work was handed in would students know if they were doing something wrong. Given this form of pedagogy I could understand why Maureen felt as though she was not improving her skills or learning anything.

Vocabulary/Grammar: During a regular evaluation session with one of the supervisors, the problem of poor class attendance arose. The student, Josie, was present at this meeting, and although she was receiving high evaluations in most areas, her poor grammar was a problem – especially since she worked in a bank president's office. Mrs Lewis used this problem to underscore the importance of Josie coming to class. She told Josie she was missing important skill learning by not being there, that the class was doing exercises in punctuation, the very area in which Josie was having trouble.

But the fact was, the vocabulary and grammar exercises were assigned the same way the typing exercises were. Mrs Lewis would distribute mimeographed sheets, students would fill them out, then they would either go through them collectively to check the

correct answer or would check them individually in the answer book Mrs Lewis left available.

By way of collectively checking a vocabulary sheet called 'Words Frequently Confused,' for example, Mrs Lewis called on individual students to tell which of two words was the correct choice in the context of a sentence [e.g. 'The (gorilla, guerrilla) escaped from the circus']. On several occasions, the student who was called upon did not know which was the right selection. Mrs Lewis did not have an answer key to the exercise and on occasion did not know which was the correct word either. In these situations she would have a student check the words in a dictionary while the rest of the class went on with the exercise.

While correcting an exercise on capitalization, Mrs Lewis explicitly asked the class to help her out with the answers since she did not have the answer key and was not sure of the answers. At one point, Mrs Lewis responded to a student, 'All right, I'll take your word for it.' At other times, Mrs Lewis would tell the class the correct choice but was unable to tell them why. At the bottom of my own copy of the exercise sheet that day I wrote, 'What's the point of doing this exercise if Mrs Lewis doesn't know or can't explain the difference between words or the meaning of words?' I suppose one lesson would be the importance of using a dictionary, but that would have been a subtle message, one that was not in any way articulated.

The punctuation unit Mrs Lewis had the students do consisted of thirty sheets emphasizing different comma rules: for parenthetical statements, clauses, series, appositives, etc. Each sheet gave the statement of the rule, an example, directions, and ten sentences which the students were to punctuate. Mrs Lewis told the students to read the directions at the top of each sheet, fill in the commas right on that sheet, then go to the answer booklet and check each sentence. She further instructed them to check one sheet first before going on to the next one. After that Mrs Lewis spent the rest of the class time in her back office making a series of tele- phone calls. This process continued for several days. When one of the students was having trouble figuring out the punctuation for a particular sentence and told Mrs Lewis she did not know whether a comma belonged there or not, Mrs Lewis responded, 'Just look in the book.'

Potentially, then, the Office Procedures and Office Education

classes could have helped the students acquire knowledge and skills that would have enabled them to be very good at their jobs and, possibly, to advance to higher-level jobs. But neither Mrs Lewis nor the students worked very hard at skill mastery. How is this phenomenon to be accounted for? In terms of Mrs Lewis, three factors appear to have influenced the pedagogical style she assumed with the COOP students: the structural arrangements of her teaching, her perception of the students, and her perception of the job market.

Dreeben (1970) has noted that among professional workers, teachers are the only ones who do their work in isolation from their own peers. This factor, recently accompanied by the practice of granting teachers tenure, makes them relatively immune from criticism or accountability. Mrs Lewis literally had no one to formally account to for the performance of her professional duties. Work standards would be guided in a situation like this primarily by professional pride and ethics. Other structural factors also came into play. The faculty in the Business Department at Woodrow High School had, according to Mrs Lewis, taken the position that if they had to take school work home with them in the evening, if they did not get their lessons planned and their papers checked during the school day, they must be doing something wrong. This philosophy gave strong endorsement to check papers during class time and to give assignments that required little preparation. (At times, for instance, Mrs Lewis did not look at assignments she gave the students until the moment she handed them out, constructed 'questions to be answered' or short quizzes on the spot, and used some of the same assignments in different classes.)

As far as I can tell, this philosophy and classroom practice stemmed from the realization that among professional groups teachers' work is poorly remunerated,[1] and the feeling that other departments were not carrying their fair share of the teaching burden. During my year's observation, I picked up hints of departmental rivalry: Mrs Lewis complaining to a 'downtown' official how certain teachers spend three hours a day playing cards in the faculty lounge while she is asked to take on extra monitoring duties; squabbles over budget allocations across departments; complaints that English and math teachers did not adequately prepare students in basic skills, etc.

Furthermore, Mrs Lewis was more accountable in some of the other classes she taught than in the Office Procedures and Office Education classes, which she herself created and which no one else had ever taught. Sections of her other classes, on the other hand, were also taught by other members of the department so there were unspoken expectations to be lived up to. Or, they were classes that were part of a sequence, like Accounting I, so that a definite syllabus was laid out for each semester. From my observations I could tell that Mrs Lewis spent much more time and effort in preparing them than her office classes and in helping students grasp the content and improve their skills.

When I asked Mrs Lewis about this difference I observed in her teaching style, she told me that she liked to establish a more relaxed, personal relationship with her COOP students because they have a long-term, intense working relationship. She liked to take on more of a counselor's role with them as they moved into the work force, so they could feel as though they could confide in her. She also said that my presence as an observer inhibited her somewhat because she did not want me to see her ugly or volatile side. Normally, she said, she was not as patient with absences, lateness, failure to meet deadlines, poor work habits and the like:

> 'I hate to see myself become a paycheck person, someone who doesn't care about her work. As you saw in my other classes, I'm a very demanding person. I would have flown off the handle more over incidents that happened in class if you weren't here. I did in the past and I'm sure I will again.'

In addition to these factors, there was some indication that Mrs Lewis was so casual in her teaching because of her perception of the students. Reference to families suggested that the students' own work trajectories would be a straight derivation from their parents' work histories. She expected great things from Josie, whose parents, she said were very ambitious themselves and hard workers. She expressed surprise about students who were not ambitious if their parents held good jobs. She also told me one day that it was senseless to try to change high school students' habits and attitudes since research had shown that basic personality structures were formed by the time a person was three years old.

125

Mrs Lewis also had a definite characterization of the residents on the east side of town. When, for instance, Maureen graduated a semester early and planned to go to the local community college the next semester rather than the university which she said she could not afford, Mrs Lewis said to me, 'Isn't it just like them not to plan ahead and save?'

And although she loved business education, Mrs Lewis was upset that students were not as bright as she wanted them to be – or as bright as they used to be. She said she had a hard time working with low-ability students and that she needed more intellectual stimulation than they were able to provide. Her greatest concern about these students was that they would not be able to compete for higher jobs because they lacked the necessary drive and ambition. But, she said,

> 'I don't think I can change attitudes. They come from such different backgrounds and I can't fight that. I've learned I have to retire from thinking I can. That's their attitude and their way of life and that's that.'

Mrs Lewis's perception of the labor market also influenced her pedagogical style. She said that secretarial jobs did not give enough in terms of pay, responsibility or decision-making opportunity to attract a decent ability-level person. Secretaries were not made part of the team, they were more like slaves, so many capable women were going elsewhere for jobs. These comments are consonant with a proletarianization perspective.

But although Mrs Lewis bemoaned the routine nature of office jobs, she did not necessarily see any reason why they should change (or *could* change) as long as low-skilled workers were being hired to fill them. A discussion that took place at a COOP Advisory Council meeting I attended with Mrs Lewis illustrates this point.

The Advisory Council was composed of office COOP teachers from the area schools and representatives from a number of workplaces which regularly employed COOP students. One of the council members, a business man, brought a newspaper article to the attention of the group. The article was written by an attorney who worked for a neighboring state government; it complained of office workers who typed 'slower than snails,' claiming that 30 wpm was now accepted as a satisfactory performance level. The

attorney went on to complain that the work habits of clerks and typists were so bad that an office memorandum had to be written forbidding dancing and cooking at desks, curling co-workers' hair and walking around the office in bare feet.

The question this council member raised for group consideration (and as a challenge to the teacher members) was, why are schools turning out students with such poor skills and work habits? Mrs Lewis immediately reversed his query with the retort, 'Why are you hiring people who can't perform?' She went on to suggest that if students who only type 30–40 wpm can obtain office jobs, they feel no compulsion to improve their skills. The students' experiences contradict the school's claim that the acquisition of high-level skills is a prerequisite for obtaining an office job and the school's mission to teach, to develop ability, is subverted.

According to Mrs Lewis, then, the basic relationship between schools and workplaces is one in which the power of the school to teach is basically determined by the nature of the labor market. This viewpoint was supported by the fact that few of the supervisors had complaints to make about the COOP students' work performance. Although a few of the students received a grade of C for the class part of the COOP program, none of them obtained lower than a B on their work performance either first or second semester. In fact, as final grades, five of the students received Bs and ten of them received As.

Moreover, on those rare occasions during evaluation sessions when supervisors did have complaints about the student workers, those criticisms were usually based on the nature of the labor process rather than on the characteristics or preparation of the students. Generally the supervisors attributed lack of quality production either to the boring nature of the work the students were engaged in or the speed at which they were required to work.

Dorothy's supervisor at United Group Insurance Company, for instance, told Mrs Lewis that a lot of times her department was forced to do 'quantity not quality work.' This time pressure resulted in half the work being returned to the department to be done over which was very frustrating to the workers. As this supervisor said,

'The women aren't given time to get organized, to think about

127

what they're doing. Who wants to sign their name to something that's done wrong? Everyone thinks, "Oh, who's that who made all those mistakes?" '

Even more frequent were instances when work quality suffered because of the boredom produced by the work, boredom resulting from the slow pace at which work arrived, or the repetitive, routine or, in one supervisor's words, 'piddling' nature of the work. Some of the supervisor's were even apologetic to the COOP students or Mrs Lewis because of this, saying things like,

'I wish we had something stimulating here to interest her.'

'I know the work you did at first was not very exciting. Thank you for bearing with us.'

Given the structural conditions of most of the COOP students' jobs then, there was little direct incentive for Mrs Lewis to conduct rigorously skill-oriented office education courses. On those rare occasions when a supervisor would complain to Mrs Lewis about a student's inability to outline, to take dictation for a simple letter, to use required tabs, or to proofread, Mrs Lewis would fall back on her theory of learning: 'I teach them all I can and leave it at that. When I get them as juniors and seniors it's impossible.'

The students themselves did little to contest this manner in which they were taught, soon falling into patterns of skipping class, coming late, leaving early, requesting (and receiving) 'mental health' days, dragging out their work and copying answers. There are typically three theories for these behaviors. The first is the school personnel explanation of 'senioritis': the universal phenomenon of seniors being less attentive to school work than freshmen, sophomores or juniors. The second explanation is the more sociological one offered by Mrs Lewis regarding family background influence: children from working-class backgrounds simply are not raised with the same commitment to schooling as are middle-class children. The third explanation is also sociological and generally falls under the categories of teacher expectations, the self-fulfilling prophecy, or the pygmalion effect (Rosenthal and Jacobson, 1968; Spring, 1978). This theory posits simply that 'one person's expectation for another's behavior could come to serve as a self-fulfilling prophecy' (Rosenthal and Jacobson, 1968: 174). In the case of the COOP class, the impli-

cations of the theory are that the students merely internalized Mrs Lewis's perceptions and expectations that they either could not or need not learn to perform at a higher skill level.

While not denying a possible foundation for each of these explanations, I would like to advance a competing theory, one more in keeping with the theoretical framework of this analysis and supported by both the data I have collected and the work of other social scientists. This alternative explanation suggests that a significant influence on students' attitudes and behaviors in high school is the relation students see between their course of studies and the futures they envision for themselves (Farman, Natriello and Dornbusch, 1978; Stinchcombe, 1964; Willis, 1977). For the COOP students, this perception operated in the following manner.

As suggested in Chapter 4, in the eyes of many of the students, the value of taking COOP rested primarily in job placement. Only in this type of program could a high school student get work experience that either looked better on a résumé than 'slinging hamburgers at McDonalds,' or that would lead directly to full-time employment and, possibly, a better job:

'COOP helped a lot. It gave me my work experience. Even if that didn't help me get my job at REMIC, I felt good that I had that to put on my résumé.'

'COOP can be helpful for getting a job, but mostly you learn to work by working.'

'As far as what you learn in school and in the business world, they're two different things. . . . I think all the school can teach is the basics and I think I got that.'

This belief that the skills taught in the COOP class were basically insignificant was confirmed by the fact, as indicated throughout this chapter, that most of the students had the knowledge and skills needed to do their jobs when they started work. When low-quality work was produced, the reason was not that a student lacked the requisite skills, but that she was either nervous about her new responsibilities and needed a short period of adjustment or, more frequently, that she was bored with the repetitiveness of her work. Even supervisors acknowledged the fact that work quality tended to decrease when there was not much work to be done that day.

129

What, then, did the COOP students learn from their school and work experiences about their roles in the technical relations in production, about their roles in accomplishing the tasks required of the various types of office workers? They learned that even before completing their high school education they were technically qualified to perform the production functions which characterized clerical work and that, were they to stay in these types of positions, the job dissatisfaction they were already experiencing after only a short time in the labor force would intensify since, for the most part, it was caused by the routine, unchallenging nature of the work. (See Table VI.)

Table VI: Numbers of students who expressed job satisfaction or dissatisfaction by job type

	Satisfaction	Dissatisfaction
File Clerk	1	7
Typist	1	4
Clerk Typist	8	
Account Clerk	7	
Word Processing Operator	3	
Secretary	3	2

But when these students experienced dissatisfaction with their office jobs, they did not, for the most part, decide to attend college (although most of them were quite capable of attaining bachelor's degrees). Rather, they tended to fall back on those jobs they were acquainted with through either their own, their mothers', or their older sisters' work histories, jobs like waitressing or sales clerking. Nancy, for instance, said, 'I used to want to be a secretary like my mom' but was starting to change her mind toward the end of her COOP year. She had spent several months in the filing department in REMIC where, she said, 'I always felt like I was going to fall asleep . . . it was the same stuff over and over.' So instead of accepting the full-time job REMIC offered her upon graduation, Nancy said she wanted to continue working there part-time and look for a part-time job at one of the clothing stores in a large shopping mall, saying she would

130

meet a lot more people out there and it would be a lot more interesting.

This last point brings us to the concluding question of this chapter: is the role of the school to prepare students for jobs, regardless of the nature of those jobs? Presumably, the foregoing descriptions of file clerks and typists have prepared the reader to answer no to that question since these types of jobs truly make possible Adam Smith's claim that a person thus employed 'generally becomes as stupid and ignorant as it is possible for a human creature to become.' Obviously the goal of the public school system should not be to withhold knowledge and skill training from vast numbers of students even though from a social efficiency point of view such training would be considered dysfunctional.

The question must even be raised as to whether COOP students should be placed in a strict filing or typing job. As one of the graduates said:

'If a girl gets the opportunity to learn the different things the department does, that's great. If she doesn't, I don't see how it can help her in terms of experience. Anyone can file or copy. I hope there aren't any girls who do just that. I hope they're given opportunity at their work. I definitely think everyone has the ability to do more than file or copy. And if that's all they do, what about the ones who don't stay full time? Their work on that job hasn't benefited them at all. One COOP student I knew just handled microfiche all day. She wrote down what was past due and how long and that's all. That wouldn't benefit her much.'

Speaking more broadly, and from an idealist perspective, Dewey long ago stated:

the kind of vocational education in which I am interested is not one which will adapt workers to the existing industrial regime; I am not sufficiently in love with the regime for that. It seems to me that the business of all who would not be educational time-servers is to resist every move in this direction, and to strive for a kind of vocational education which will alter the existing industrial system and ultimately transform it (Simon, 1982: 16).

Although educators and social scientists have become less opti-

131

mistic over the last several decades about the efficacy of any educational program, Dewey's basic insight is still useful. My data, as well as other analyses (Willis, 1977; Levin, n.d.; *Work in America*, 1973) indicate that dissatisfied and overeducated workers make demands on their work organizations that can force them to alter the labor process. While some analysts like Willis consider such alterations like job enrichment and job rotation as 'trivial,' they are not experienced as trivial matters by those who do the jobs, as Table VI suggests. Only an elitist interpretation would make such a claim.

Dorothy, who worked in the most routinized and efficiency oriented of the filing departments, made that clear, explaining to me that there was a big turn-over in her department because 'it's so boring at the beginning' people don't put up with it and end up quitting. But because Dorothy was a good worker, she quickly got moved on to new jobs. By learning all the different production functions, she was rotated throughout the day to different ones. Dorothy was the only file clerk who did not express dissatisfaction with the work tasks she did each night. Moreover, by the end of my observation period, a university team had been commissioned to do a 'study' of Dorothy's department. My information came solely through Dorothy who was not quite sure of the purpose of the study, but she thought they were called in by the company to try to 'make things better.' Employees were asked to fill out forms expressing their feelings about their work. She said that since the study began they were rotating jobs more and learning new tasks more quickly.

In *The World of the Office Worker*, Crozier confirms the finding that overqualification can lead to not only job dissatisfaction, boredom and low productivity but to demands from workers for more satisfactory working conditions as well. Crozier states that 'employees who are educated and have higher aspirations . . . aim higher than their current position and are much more demanding in their relations with the company' (1965: 146–7).

This finding was affirmed by some union organizers I spoke with in the course of my field work. One of the organizers, who worked for a large utility company that routinely hired COOP students, said that she regularly counseled these young women to further their education, even if they were planning to stay in office work. She did this, not because she thought college training would

make them more promotable, but because it would help them develop self-confidence in approaching the work world, in saying what they felt about their work lives.

This effect of education seemed to occur not only at the college level, but at the high school COOP level as well. A number of the students talked about how their training helped them overcome their shyness and develop a certain degree of confidence and comfortableness in dealing with people. They said things like:

'I think Woodrow is a really fine high school. It gave me my business background. . . . I've used my typing skills and what we learned about phone usage – how to be pleasant and things like that. I ·vas really scared at first. Maybe that training gave me confidence.'

'The COOP class helped me grow up faster. . . . Before I was really quiet and shy; I didn't know what I was doing. The class made me more aware of myself.'

'I would definitely take the COOP class again. It gives you so much background. . . . I never thought I would like working with people because I've always thought of myself as being so shy. . . . Now I can talk to the supervisor very easily, where before I couldn't.'

Conclusion

This chapter has indicated that the office jobs COOP students worked at were highly routine and specialized, and that there is evidence that office jobs are becoming more deskilled. I have argued that the role of the school should not be to graduate students with only those skills needed on the job, but to encourage students to develop as much skill and to obtain as much work knowledge as possible so that, even though the students might be bored by their work, they will be able to protect their job boundaries, resist deskilling processes, and negotiate job enlargement or enrichment.

This, however, is a formidable task for the school to accomplish. For although there are few direct mechanisms through which the economic sector influences the educational domain, institutional

structures, teacher consciousness, and student orientations and perceptions tend to promote a disinterest in high levels of skill attainment.

While this adaptation or accommodation to the realities of the labor market might evidence a certain amount of common sense on the part of both teacher and students, behavior that militates against skill development can only serve to marginalize students' work identities and keep students locked into entry-level jobs. Such behavior is, perhaps, even justification for workplaces to further routinize jobs.

PART FOUR
Reproducing social relations in production

PART FOUR
Reproducing social relations in production

7
Exchange relations

Both traditional and radical versions of the role of school in the preparation of young people for the world of work emphasize the importance of students learning 'proper' dispositions and attitudes as well as necessary skills. A functionalist like Parsons would call this aspect of work preparation the moral dimension and would point out the necessity of students internalizing such qualities as responsibility, cooperativeness, respect for the teacher and good work-habits, qualities important for 'successful performance in their future adult roles' (Parsons, 1959).

As argued in Chapter 1, I would reject the functionalist assumptions underlying the use of the concept 'moral' and would be more in agreement with Marxists like Althusser or Bowles and Gintis who would call this aspect of work preparation the ideological dimension. They would stress such qualities as 'respect for rules of the order established by class domination' (Althusser, 1971), or, as Bowles and Gintis (1976: 130) would phrase it: 'to reproduce the social relations of production, the system must try to teach people to be properly subordinate and render them sufficiently fragmented in consciousness to preclude them getting together to shape their own material existence.'

Given the persistent and often central position assigned this ideological dimension throughout the literature, I approached my field work anticipating its significance, expecting to find ideological aspects of work preparation not only in the formal corpus of school knowledge, but in aspects of the hidden curriculum as well.

Yet, two other traditions within Marxist social science led me to be suspicious of the claim that the reproduction of the social relations in production was fundamentally and primarily the function of the education system inculcating students with the dispo-

sitions they would need to become good workers. These two traditions are cultural reproduction theory, best exemplified in Paul Willis's *Learning to Labour: How Working Class Boys Get Working Class Jobs*; and labor process theory, best exemplified in Michael Burawoy's *Manufacturing Consent: Changes in the Labor Process under Monopoly Capitalism*.

As Chapter 1 explains in some detail, cultural reproduction theory differs from what I will call ideological reproduction theory in that it identifies culture rather than ideology as the principle determinant of 'properly trained' labor power. It replaces the image of passive agents, upon whom 'dominant interests and ideologies' which correspond to system needs are imposed, with the image of active individuals and groups whose everyday material practices form the ground upon which ideology is transformed into (un)conscious dispositions. These transformations are not necessarily productive of capitalist (or patriarchal) relations, as ideological theories would have it. Cultural production and reproduction means instead 'an ever-repeated creative process which each time carries no more guarantee than the last' that social reproduction will occur (Willis, 1981: 60).

In contrast to Althusser and Bowles and Gintis, Willis and Burawoy both argue that the school is not a privileged site of social reproduction. But where Willis basically argues the importance of 'extra-productive general conditions for the maintenance of capital' (1981: 51), Burawoy claims that the labor process itself (and the practices, relations, ideologies and cultures produced in that process) is sufficient for the maintenance of capitalist relations. He claims there is no need for extra-productive conditions or ideological 'super-structures' to ensure their reproduction:

> In other words, interests are not given primordially, nor are they necessarily brought to the shop floor from socialization experiences outside work. Rather, they are organized by the specific form of relations in production (1979: 85).

> . . . consent is produced at the point of production –
> independent of schooling, family life, mass media, the state,
> and so forth (1979: xii).

While the organization of the labor process might indeed be

sufficient to ensure the reproduction of specific aspects of the relations in production under certain conditions, I will argue that cultural and ideological processes outside the labor process do have a bearing on the way in which young workers participate in the labor process. Moreover, Burawoy himself admits the limitations of this work in testing for the possible differences between male and female orientations to work. My data suggest that the differences in male and female orientations are pervasive and are learned long before young people begin to participate in the labor process.

The analysis in this section proceeds by drawing upon and reconciling the best aspects of each of these three partially antagonistic theories. From the ideology perspective I utilize the notion that the school definitely is, and in many ways is consciously structured to be, an ideological training ground for workers. It is not and cannot be, as Entwistle (1979) for instance claims, an ideologically neutral institution. By analyzing both the formal and informal aspects of the Cooperative Office Education curriculum I extract and analyze three sets of ideological configurations that represent essential aspects of current production relations (exchange relations, authority relations and gender relations) which will be explained in due course.

From the cultural perspective, I utilize two notions. The first is that while ideological processes are real and pervasive, they are not necessarily internalized and do not themselves constitute working-class identities. They are negotiated, contested and reworked; they are transmitted through 'social and cultural dialectics, mediations, and struggle' (Willis, 1981: 57). The second notion I utilize is that while the school is an important site for cultural production and the constitution of various forms of consciousness and subjectivity, Althusser's *a priori* claim that the educational system is the dominant ideological apparatus has little basis in either Marxist theory or empirical evidence. Other sites must also be analyzed, chief among them, the family and the labor process itself.

From the labor process perspective, I utilize the notion that there are times at which, or ways in which, the relations in production themselves are better at reproducing ideologically prepared workers than are the sites outside the wage labor process (e.g. the family and the school). But since my data indicate the

bearing of previously learned cultural orientations upon the labor process, I am not prepared to accept the conclusion that the labor process in itself is always and only the site that manufactures worker consent, or that it can be sufficient unto itself. A more fruitful way of undertaking an analysis of the reproduction of the social relations in production is to examine the relations among ideological, cultural and labor processes. What aspects of the structured totality converge to produce workers with appropriate forms of consciousness and behavior and what aspects diverge, rendering discrepancies, contradictions and potential conflicts in the preparation of workers for the social relations in production?

Extensive ethnographic accounts of exchange, authority and gender relations in educational ideology, in the organization of the labor process in the various offices, and in student/worker culture(s) form the basis of the following chapters. Special attention is given to the correspondence and contradictions within and between each of these levels since these are the relations that centrally shape the young women's consciousness, work orientations and practices. What I have found somewhat surprising is the extent of a critical perspective among the students despite what might be called the overdetermination of an essentially conservative work ideology presented at the school coupled with an already traditional, conformist cultural orientation to work. This can be seen in the following analysis of exchange relations.

The exchange of wages for labor power forms a central dynamic within the social relations in production for virtually all office workers, whether in the private or the public sector. In this relation, labor power is a commodity sold in the labor market for (generally) a set hourly wage. Since what the employer needs, however, is not merely the capacity for labor but labor itself, not the potential for productivity but actual production, the purchase of labor power creates an immediate problem for the employer: how to make employees productive while maintaining control of the cost of labor.

As the following account makes evident, ideological dimensions of the COOP program generally supported employers' desires for highly productive and low-paid workers. The culture of the students and aspects of the labor process also formed them into hard workers with few demands, irrespective of a notion of a 'fair' exchange relation. Although I have theorized issues of pay and

140

productivity as two sides of a basic relationship, for analytic purposes they initially will be presented separately.

Considering pay

In the organizations I observed, employers seemed to use two tactics in directly controlling wage demands: discouraging workers from considering unionization and discouraging knowledge of and discussion about pay scales. Several of the workplaces had a 'no discussion' policy, which was commented on during the interviews. Donna, who worked at a Savings and Loan, said for instance: 'Employees can't cash their checks here. They don't want you to know how much each other makes, so nobody can say, "I do the same thing she does so I should be getting more money." ' When I asked how she knew that was the reason, she said her supervisor told her. A co-worker of Donna's confirmed the rationale, stating in addition that money was something they could not talk about and that she had no idea what she was paid relative to other employees. She did, however, assume Savings and Loan companies were low-paying in general.

And although it is technically illegal for employers to retaliate against workers who organize, employees are often made to feel they would be jeopardizing their jobs if they talked union. As Mary, who had been working at the same bank for ten years said:

'Union. That's a nasty word around here. So is asking for a
cost of living increase. As far as I know there has been no
serious union attempt; just a few of the girls talking about it
among themselves. But that could be something that might
get you fired if they ever heard about it. . . . It's probably not
a bad idea though.'

This perception of employer retaliation was corroborated by one of my union organizer informants who stated, in addition, that employers attempt to elicit information during interviews to determine whether or not the job applicant has a history of activism.

These were the most obvious attempts companies made to keep the cost of labor as low as possible. They constitute the employer's role in the wage side of the exchange relation between employer

and employee, a role the students' school experience in many ways simulated.

Even though Mrs Lewis was herself a strong advocate of and participant in Macomb's teachers' union, she neither indicated to the students that clerical unions existed nor that they tended to play a part in determining exchange relations between employers and employees. Similarly, she actively discouraged students from discussing their hourly wage with anyone, saying it was a personal matter and no one else's business but their own.

This practice of not discussing pay, of treating it as a purely personal matter, did break down at the beginning of class one day, however, when Janie and her best friend, Dana, were speaking to Mrs Lewis in the privacy of her back office. When Dana and Janie came into the classroom Dana was obviously upset, complaining that she was still at minimum wage while Janie, who worked for the State and whose office workers were unionized, had received several raises (many of them automatic). Dana was saying things to Janie like, 'I hate you,' and 'It's just not fair.'

Mrs Lewis later informed me that Janie had brought up her raises out of the blue and that (hyperbolically), she 'could have killed her.' She also informed me that she had taken Janie out into the hall and said to her

'Don't you see how unhappy you've made your friend? You don't want to do that do you? Pay is a very personal matter. I don't know what any other teacher makes in the department and I don't want to know. That is something you really shouldn't discuss.'

This incident happened only a few weeks before graduation. Janie and Dana were continually together during and after class and often planned after school activities together. If they did not know until May what each other was making, I doubt that many students did. In fact, I know of only one student who knew another's hourly wage.

Evelyn, for instance, did not know Patti's rate of pay, and Patti worked right next to her; they usually punched in and out of work at the same time. Mary did not know what other people were making at her bank, nor did Dorothy, who informed me: 'We're not supposed to talk about our raises at work 'cause then people will feel bad if they don't get one.' Evelyn said she never asked

or tried to find out what others were being paid because she figured it was none of her business. She presumed people were making enough to support themselves.

I would suggest that the reason this 'pay is private' ideology is so acceptable to the students is because it converges with two basic aspects of their feminine culture: caring about others' feelings and identifying more with unpaid domestic laborers than with wage laborers. If this convergence were not present, if the 'wage packet' were as essential to their cultural identity as it is to masculine shop-floor culture, I would expect far more contestation or covert resistance to the idea that pay is a private concern.

Still, the tenuousness of this ideology is indicated by Dana's striking reaction to Janie's rate of pay. If workers *did* know what others made, their primary reaction probably would not be to feel bad about themselves, but to negotiate or struggle for more comparable rates of pay. Further examples will be discussed at the end of this section, but first I must explain what the students learned about the other aspect of the exchange relation: productivity.

Lessons in productivity

Employers engage in numerous and varied practices to obtain the desired quantity and quality of work from their employees. Edwards (1979) classifies control mechanisms according to three types: simple, technical and bureaucratic. Simple control is embodied in personal authority relations, technical in the machinery itself, and bureaucratic in the organization and rules of the workplace.

As explained in Chapter 5, although the technical means to control and monitor both the pace and quality of office work has been marketed, I witnessed little of its implementation. So the two primary means of control brought to bear upon the students' production were simple and bureaucratic control. Since the relation of office workers to their floor supervisors will be analyzed under authority relations, the remainder of this section will focus on the manner in which bureaucratic control can be used in offices to ensure production standards.

The fact that raises and promotions did not occur automatically,

but were largely dependent on how hard they worked was no secret to the COOP students. Raises, Marion said, were

'determined by things like "workability," how you can handle responsibility . . . it's measured by your attitude, how you apply yourself to the job. If you piss and moan all day long and give your supervisor nothing but baloney, well that's pretty obvious. But if you have a positive attitude you'll move up.'

At least one employer started COOP students at the minimum wage for the explicit purpose of having a cash reserve with which to give merit pay increases during the course of the year. Adequate improvement would result in a 1–15c hourly raise. If improvement exceeded expectations, the increase would be in the 16–25c range.

The COOP students also knew that their jobs were not secure. They were informed at the beginning of the year that none of their employers had a commitment to them beyond their cooperative year, and that if they did not work out satisfactorily, they could be released. In fact, they knew that they could be fired during the year if all did not go well. Many of them had been employed in non-office jobs, prior to their senior year, in which being fired was a possibility. COOP students had also been dismissed from their workplaces in past years and Mrs Lewis made the students aware of this.

The most systematic attempt to procure a high rate of productivity was undertaken by United Group Insurance, one of the largest insurance companies in the area. Five of my interviewees had been employed there as COOP students in four different departments and each of them described the company's use of a 'time lapsing' system to measure productivity.

Time lapsing was an extremely rigid accountability system in which workers had to keep track of both time and quantity of work, sometimes every five minutes. The following statements describe how this system of bureaucratic control functioned:

'Every night we have to fill out production sheets. These give the company an idea of how much work is actually being done. The supervisors then give percentages of how you are doing. Some jobs require writing down the amount of time you

spend on the job. But most of them require the quantity of work. Everything we do must be counted so that it can go on your production sheet.'

'We do time studies all the time. I have kept track of my production record every hour I've worked there. . . . They want to know how long it took you to put 200 files in order. . . . That's how they know what you're doing. How fast can you accurately push the pencil. They don't give you a pace you must work at. The pace is set by the employees. So if you cheat and say you can do more in an hour than you actually can, it's going to hurt you. . . . The work you put out is what you get back to do again. . . . Lapsing pushes people to outdo one another in performance and accuracy.'

'At United Group we had to write down what we did: when we started, finished, how long it took, how long it was supposed to take. . . . There was a monthly report – how many errors you made and what you actually got done. The supervisor would put the report on your desk and then come around and talk to you about it. I think raises depended on it.'

In addition to this time-study system, United Group had also instituted a rigid penalty system, with so many rule infractions leading to dismissal. As Joan explained it:

'They have these things called freckles, like if you come in late or something. Six freckles lead to an occurrence and if you have so many occurrences you can be fired. It depends on your supervisor. . . . Like a phone call is a freckle. You get docked for it.'

Although Mrs Lewis did not institute any bureaucratic policies that even remotely approximated United Group's time lapsing or 'freckle' system, she did stress the importance of the students improving their productivity, often using the maxim 'a fair day's work for a fair day's pay.' The issue of fair pay was never raised as a problem, however; the assertion was simply made that workers are being paid to be productive and that if they did not produce they should not be paid.

Quantity of work, for example, was one of the explicit areas in

which students were evaluated in their jobs and the following remarks are characteristic of the comments Mrs Lewis made to the students' supervisors about the relation between productivity and pay:

'We want them to have a good production rate. It's a problem for the young girl especially. They don't see the connection between what they're being paid and the work they do each hour. They don't see that they're being paid to produce and that it should be a good amount. So we have to start making them aware that they need to do a certain amount, that they should be up-ing their speed after they've been working a while.'

'The students need to learn that we are measuring their production. We, both of us, at school and work, need to emphasize that. We're watching to see how much they're getting done. They're getting paid for the hour's work they do, so they have to ask themselves "What am I producing for that hour?" Many people go through their entire lives not even realizing that connection. That's especially a problem with state employees, particularly at the lower levels. . . . I had to tell one student in class today that she owed *me* money for the hour, that's how bad it was. She didn't get a thing done.'

And although, in practice, Mrs Lewis seldom encouraged the COOP students to work diligently or to meet deadlines, she would direct the following types of comments to them:[1]

'Ladies, one reason people are fired is for standing around the door waiting for the bell to ring. Employers expect you to work until the last minute.'

'Okay, girls, we don't have any time to lose. We're not going to stand around here and take half pay today.'

These remarks focus the problem of pay on the student/worker. The unspoken assumption in each of them is that a fair day's pay is offered, so the student/worker must live up to her part in the exchange relation and give the employer a fair day's work in return.

In fact, the first comment quoted here implies that the employer

is not only being fair in the exchange relation but is actually giving the student/worker more than she is entitled to, so that once the young worker is more experienced on the job, she should not be paid more for her increased productivity, but should now compensate the employer for her less productive beginnings.

The ideological dimensions of the productivity/pay relationship presented to the COOP students are, then, twofold: fair work for fair pay is presented as a self-evident, natural relationship, and the fair pay element of that relationship is never questioned. Yet in reality, no objective or universal standards to measure 'fairness' exist; that concept has meaning only when embedded in concrete social and historical practices.

As Michele Barrett (1980, 166) says, wages and wage differentials are often dependent on 'the assumption that some workers require more wages to reproduce themselves than others,' or, as David Lockwood (1958: 102) reports, on 'the social standing of the worker.' In either case, wages are not based on productivity but on culturally produced assumptions about the nature and needs of various types of workers. Nor are these assumptions produced once, for all times and places. Rather, they are matters of daily struggle and contestation (as Mrs Lewis' active involvement in the teacher's union taught her). The slogan 'a fair day's work for a fair day's pay,' therefore, as Richard Edwards (1979: 15) states so clearly, has the potential of making both aspects of the relationship 'matters of conflict.' Yet on most occasions only one side of that conflict was presented to the COOP students as a legitimate concern.

There were a few times, however, when Mrs Lewis presented curricular materials or made comments that suggested the possibility of workers being unfairly compensated for their labor. On the first day of class she told the students she used to feel sorry for COOP students hired by the city because it did not adhere to federal minimum wage regulations. She also told them later in the semester that women with the same skills and abilities made only 59% of what men made in comparable jobs. On another occasion, when a student reported on a magazine article entitled 'Why Secretaries Are Paid Unfairly,' Mrs Lewis commented that in private industry the secretary's salary is tied into the grade of her boss, while in government work there are generally set classifications.

Although in each of these situations Mrs Lewis was implicitly criticizing pay scales, the criticism was never made explicit. Nor was it presented to the students for reflection and discussion. And because the students' experience with and knowledge about wages and salaries was quite limited, they did not seem to have the conceptual sophistication needed to raise questions about exchange relations.

This does not mean, however, that the students never privately wondered about or discussed issues of pay, productivity and equity, especially as they gained insight from their work experiences. While most of the students did believe that what others made at work was their personal affair, some resented being told what was or was not their business. As Dorothy said: 'I think that if you want to talk about pay and raises, that's your problem. I don't think they should tell you. I don't like the do's and don'ts of the whole thing.'

Moreover, the experience and bits of knowledge picked up from their workplaces led them to question whether pay was really based on productivity and whether it was or should be based on other factors. Eleanor, for instance, who believed that being paid for what was produced was a fair system, used that argument against salaried employees. Taking the position opposite Mrs Lewis's (who stated that salaried employees were expected to put in overtime when necessary without additional compensation), Eleanor, like a number of my interviewees, complained of salaried workers who took long lunch hours and coffee breaks, who stood around telling stories and jokes, and who sat at their desks with apparently little to do. Eleanor thought a solution to this problem would be to pay everyone on an hourly basis: 'I think it's better if people are paid on an hourly basis. That way, if they're not there, they're not paid for it. That's the way it should be. Everyone should be on that basis – even the big bosses upstairs.'

Other types of experiences also raised questions about whether or not pay was based on productivity. Diane, who had been employed in both the private and the public sectors, noted the pay differential between the same type of job in the two areas. Although she knew the clericals in the public sector were unionized, she did not associate this with the higher rate of pay, saying simply: 'The pay in private industry is low. I don't know why. The public places pay more.' And Connie, who compared her

rate of pay to other employees within her own corporation rather than across sectors, thought there was a similar discrepancy. Referring to their work in the Word Processing Department, she said: 'I think if you compared what we actually know, if you compared our knowledge to other workers, you would find we were terribly underpaid.'

Although Connie was implicitly drawing a connection between knowledge and productivity, the introduction of this concept is, of course, quite a different factor in the determination of pay than simply productivity. It was also a factor that a number of students referred to as a condition for higher levels of pay. More knowledge, skill, or responsibility were all considered to be good reasons for higher pay:

'People should get paid more if what they're doing is harder and needs more thinking power. And supervisors should get more because they have a bigger responsibility.'

'I think you should get a raise every time you advance up.'

Conversely, the students argued, if work was easy, if it did not require much thought or training, if it was a routine job anyone could do, then the level of pay should not be very high. During my week of observing her on the job, Katrina made an unsolicited remark about pay. She was stuffing a pile of envelopes and getting the day's mail ready to go out when she remarked, 'Isn't this work easy? Don't you think it's easy? It's so easy I probably shouldn't even be paid for doing it.'

This she contrasted with her normal typing duties which she considered to be real work: difficult and important. And although she did not follow her remark up with an implication about pay, Carolyn expressed a similar notion of what constitutes work, saying, 'the job I'm doing now I don't even consider work . . . I just purge files all the time, and it's not hard to do. I would like it better if it were harder and if it required more concentration.' If this attitude that easy or routine work is not real work is pervasive among office workers, processes discussed in Chapter 5 which rationalize work tasks and deskill workers could definitely have the effect of lowering pay expectations. If workers see pay as the exchange they receive from the employer for what they produce and if they do not place a high value on either the product

or the work process, they could quite conceivably feel as though they had no basis upon which to claim more pay. This tendency would be exacerbated by the fact, referred to earlier, that many of my interviewees had little knowledge of pay scales in general and often felt, and were taught, that they had no right to know. If workers have no basis of comparison for their own wage packet, they have more difficulty in claiming they are 'underpaid,' as Connie was able to claim when a job study was done of the work in her department.

Mary, for instance, the oldest of my interviewees, who had been working at the same bank for ten years and who had a general feeling the pay she was receiving was low, could not substantiate that claim since she did not know what comparable workers were making in other banks or workplaces and did not know what other employees in her own bank were making. Commenting on her low pay, she said to me, 'I sometimes wonder how men supporting families can make it. Of course, many of them are officers, so maybe they're making more. A lot of them seem to be assistant vice-presidents.'

Lowering pay expectations is not, however, the only possible outcome of job fragmentation and rationalization. Not all the students thought easy or routine jobs should be low paying. Donna, who tried to make sense out of the fragmented information she had about wage scales, came up with a theory of compensatory pay. Reflecting on jobs that paid more than hers, Donna concluded that boring work brought higher pay. Carolyn, she said, was paid the relatively high wage of $4.00 an hour because she was filing all day, a job so boring she herself would refuse to do it for $10.00 an hour. When asked if she would be paid more by her company to file, Donna responded with an indirect yes:

'I think the COOP student who works in the basement gets more than I do. And she does filing of records and record tapes. And it's the same way with Internal Revenue. A girl who was in the COOP class last year worked with Internal Revenue and she got $5 something an hour to sit there and file and sort papers. . . . She said it was the most boring job she's ever had in her life.'

But even though the students did have some questions and

criticisms about rates of pay, the most significant factor about their willingness to be productive was that they worked hard for reasons quite apart from believing they were engaged in a fair exchange relationship with their employers. These reasons were far more intrinsic to the student's culture and sense of identity and to the demands of the labor process itself.

First of all, the students derived a sense of personal pride from what they produced; they took great satisfaction in their accomplishments, often rendering close supervision unnecessary. One afternoon, for instance, while observing a COOP student's work at a photocopy machine, I inquired about a plastic object she was placing over the original copy. She offered the following comment by way of explanation:

'I like myself to look good, so I make sure things are centered on a xerox machine, and I put a white plastic cover on the back so shadows don't show through, even though I don't have to.'

Donna also said that she got 'a kick out of seeing letters I've typed actually mailed out to someone. I can say, "I typed this"!'

In explaining why she preferred clerical work to a job like waitressing, which she had also done, another student said it was because 'in a clerical position you can take more pride in your work and feel better about yourself. . . . I like to do things I do well. It makes me feel good about myself.' Jessica, a recent graduate of the COOP program, described a similar sentiment regarding the increased responsibilities her new job entailed:

'Just recently I had to take notes at a meeting. I had never done that before and I did really good. I got lots of compliments on them. . . . But it was hard to take minutes because they kept switching from one subject to another and I had to keep up and get everything.'

The second reason why many students did not need to be taught productivity was because they saw their work as 'service' to the customer and wanted to deliver that service as well as they could. In explaining why she liked her job, for example, Marion stated: 'I feel as though I'm accomplishing something, as though I'm helping people who need help. If the insured aren't happy with what they have, it's important to me because they're paying my

salary.' Other students extended this 'service' orientation to the nature of the company itself. Two students wrote the following descriptions of their workplaces on their final examinations:

> 'Our bank is very important in today's society because it is a place where you can save your money and earn interest, but also get loans, a checking account and financial advice. . . . We have special events coming up like June Dairy Day where the bank gives away free ice cream cones and cheese.'

> 'While the private mortgage insurance industry remains an unknown among the general public, it has helped a significant segment of the nation's home buyers. REMIC has made it possible for thousands of prospective home buyers – particularly young first-home buyers with adequate incomes but a relatively small amount of savings available for a down payment – to obtain a mortgage loan. A great American tradition, home ownership, has been perpetuated with REMIC mortgage insurance.'

This notion of serving or helping also extended to their co-workers and provides the third reason why 'teaching productivity' was not a critical task for the school or a critical problem for the employer. When I asked the students and graduates what they liked most about their jobs, one of the most frequent responses was, 'The people I work with.' They used expressions like 'they were very welcoming to me when I started working,' or 'we're just like one big family.' Frequently, the women would shop together on their lunch hour or go drinking together after work. Nancy's description of her co-workers is typical: '. . . the people are really nice. They explain things well and don't just throw it in your face and say do it. . . . They treat you nice.' Because of these personal ties, the women wanted to get their work done and do it well. If they did not, friends and co-workers would have to share the burden.

Sometimes, student/workers even took on extra work to help out co-workers they liked. Denise, who openly resisted doing work for her bosses because they treated her 'like a slave,' would voluntarily do work for the maintenance crew. 'I do work for the guys downstairs. I type up their work schedules because the guy

152

who's supposed to do it can't type. But I don't mind doing their work because they appreciate it.'

When positive relations between co-workers did not provide the incentive necessary to work, the thought of worker retaliation did. If the office workers did not carry their 'fair share' of the work load each day, they would eventually be 'dumped on' by other workers. Dorothy described this process at work in the claims department of the insurance company in which she worked. As described in Chapter 5, the work in Dorothy's department consisted in processing (retrieving, copying and re-filing) thousands of insurance claims and policies each day. Two crews, a day crew and an evening crew, had to be hired to keep up with the work that accumulated each day. An unspoken understanding existed between the two crews that each would put out full effort in processing the microfiche. If one crew left stacks of work for the other crew, they could be sure to find a similar, if not larger, stack of work left for them to process the next day.

Another way in which the labor process provided productivity incentive was that boredom was dreaded far more than hard work. In fact, as indicated earlier, hard work was often a very satisfying experience. Boredom, on the other hand, was one of the greatest sources of job dissatisfaction for these young workers. As Nancy said to me about her first COOP job:

> 'At first I was bored, but now there's more stuff to do and I
> like it better. . . . Before when I was just in files I always
> felt like I was going to fall asleep. In filing it was the same
> stuff over and over. Now I do more exciting work; you have to
> use your mind more. It's more challenging and I like that.'

And as Kris freely wrote on her mid-term examination:

> 'I think I would like to do something else because I do the
> same thing every day and it gets pretty boring. I would like
> to do different things. And learn something else, too. I like
> working down in the mail room because you're always
> keeping busy and time goes by really fast.'

Because the work flow in an office is seldom steady, there were times when the student-workers consciously stretched out their work, not to avoid doing more work, but to prevent an extended period of time in which there was nothing to do. When I asked

Dolores, who worked in a word processing center, if there were any ways in which she would like to see her job changed, she responded: 'The only way my job could be improved would be to have more updated equipment. We'd be able to put out more work. Now we have to sit a lot and wait for it to finish the run.' Job pressure, isolation, eye and back strain were not Dolores's chief concerns with her job, although these conditions were objectively present. For her, the primary problem was sitting and waiting.[2]

Conclusion

This chapter has revealed some attempts employers make to control their workers' wage demands and their level and quality of productivity. The analysis has also indicated that, at least in the case of Woodrow High's Cooperative Office Education Program, the school's role in training workers with the proper dispositions for wage labor is a contradictory one. Although the primary messages of the overt curriculum were that workers *owe* their employers high rates of production for the fair wages they are paid, statements on the part of the teacher at times implicitly questioned the fairness of that relationship. Moreover, although the overt curriculum stressed the necessity of being productive, the curricular practices of the COOP class clearly indicated that production rates were not important and gave students experience in staging slowdowns of the labor process.

However, the primary reason why the COOP students were good workers was not because they had internalized the expectations of their employers or the lessons of the school, but because they had their own personal and cultural reasons for producing work of high caliber. I would predict, however, that if the student culture did not emphasis production and de-emphasize wages, that the school would be called upon by employers to play a more concerted and central role in preparing ideologically adequate workers.

8
Authority relations

The example of United Group's accountability system in Chapter 7 should make clear that even though many office workers have internalized productivity standards, workers will not necessarily be as productive as some managers want them to be. Moreover, even if they would consistently perform at high rates of productivity, management, not knowing that beforehand, institutes forms of control over the pace and quality of work. Hierarchical structures are almost always used within work organizations not only to coordinate the flow of work, making production efficient, but to monitor the pace of it as well.

In *Schooling in Capitalist America*, Bowles and Gintis argue that authority relations within a capitalist mode of production are always problematic: 'Wherever possible, workers demand control over the decision-making about working conditions toward the improvement of their conditions' (1976: 81). Attempts are therefore made to give hierarchical relations the appearance of legitimacy and inevitability, and to develop in workers those forms of consciousness necessary to 'facilitate their harmonious integration into the hierarchical order of the enterprise' (p. 95).

The legitimacy of authority relations, Bowles and Gintis continue, is achieved by fragmenting the labor force and work tasks so that workers are convinced they are incapable of controlling the labor process, and by ensuring that 'relationships among superiors, subordinates, and peers (do) not violate the norms of the larger society' (p. 82). In other words, authority figures should be members of the dominant sex and race, have the proper educational credentials, be the right age, and 'act, speak, and dress commensurate with their position' (p. 82).

The forms of consciousness and personality characteristics

155

needed to integrate office workers into the right authority relations would include such qualities as perseverance, dependability and docility. These characteristics, Bowles and Gintis argue, are not primarily inculcated by the exhortations of teachers and the content of the formal curriculum, but by the very structure of educational relationships, which correspond to the structure of work relations. In this context, the key area of correspondence is that between teachers and bosses:

> . . . the social relationships of education – the relationships between administrators and teachers, teachers and students, students and students, and students and their work – replicate the hierarchical division of labor. Hierarchical relations are reflected in the vertical authority lines from administrators to teachers to students. . . . By attuning young people to a set of social relationships similar to those of the work place, schooling attempts to gear the development of personal needs to its requirements (p. 131).

Since Bowles and Gintis rather hastily dismiss the overt ideological dimensions of the curriculum from consideration, I think it important to examine these aspects of school training into authority relations as well as the more implicit structural aspects. The data presented here indicate the development of workers' consciousness that is far from docile. That does not mean, however, that schools and school personnel do not attempt to instill 'proper' attitudes toward authority figures.

Legitimating authority relations

The Cooperative Office Education class at Woodrow High School attempted to convey two primary messages about authority relations to the students: that these relations were natural, right or inevitable, and that any problem with a workplace supervisor or manager was an individual matter and should be handled privately, if at all. As such, the messages bore a striking resemblance to those regarding exchange relations.

The first day of class can be seen as the students' initiation into proper respect for their supervisors. After speaking to a few students privately about their job interviews and spending a few

minutes instructing students on public relations techniques, Mrs Lewis spent the rest of class time telling the students about the appreciation banquet they would have for their supervisors at the end of the year, as a thank you for all the supervisors would be doing for them:

'At the end of the year we'll be having an appreciation banquet. It's a thank you to your bosses, because it really is a lot of bother to them to hire students and we want them to know we appreciate it.'

Since the students had to decide upon and engage in a lengthy money-raising project for the banquet, and since they themselves made all the preparations (deciding on a restaurant, the menu, the speakers, the theme and decorations) the notion of 'appreciating' supervisors filtered in and out of classroom time throughout the year. Students were divided into various banquet committees which would meet while other students were working on a particular instructional unit. On several occasions entire class periods were devoted to preparation for the banquet. In addition, students carried their fundraisers (candy bars) to their other classes, extra-curricular activities, and to their workplaces for about six weeks. During this time, the candy bars were a constant symbol of the appreciation due supervisors.

The concept of authority relations also arose during a unit that taught students how to do a company's payroll. Mrs Lewis explained that there were three different types of employees who were paid in different ways: administrators, who were paid by the week and not paid overtime which was regarded as a normal part of their work; regular staff, like themselves, who were paid by the hour; and piece workers, who were paid according to the amount they produced. Piece work, Mrs Lewis said, was common in factories, but not in offices unless work had to be done at home where time could not be supervised as it could be at the workplace.

The payroll materials employed a system of penalizing workers 1/10 of an hour for every six minutes or fraction thereof that they punched in late for work. While Mrs Lewis was explaining to the class how to calculate this penalty and deduct it from the worker's paycheck, Dorothy asked what happened if someone punched in early: were they penalized for that? 'Or,' Josie added, 'don't they get nothing?' To these questions Mrs Lewis responded that

overtime had to be authorized, that they could not just 'work slow' every day and expect to receive overtime pay.

At this point, Mrs Lewis told the students that they were considered white-collar workers and were given more responsibilities and more respect than the type of factory workers they were dealing with in the payroll unit, who had to use a time clock to punch in and out of work (although Coleen and Pam immediately responded that they punched a time clock). Mrs Lewis concluded the discussion by telling the students they had to understand that a lot of people 'lived differently.' The implication of this remark seemed to be that as white-collar workers, they did not need the strict supervision blue-collar workers needed because, unlike blue-collar workers, they had internalized a work-ethic or company loyalty. This remark was, however, contradicted by Mrs Lewis's earlier comments about office workers being paid on a piece basis if they took work home, since supervision was not possible there.

Although no class discussion followed these remarks, the fact that students did not automatically internalize the message about class distinctions conveyed in these comments became clear in things they said in interview sessions about their bosses and their families. Although both Mrs Lewis and the students distinguished classifications of workers on the basis of their work ethic, the characterizations of these classifications were, at times, the exact reverse of one another.

Where Mrs Lewis projected the image of bosses as so hard-working that they were expected to put in overtime without pay, the boss-image students gleaned from their work experience was often quite different.[1] Finding themselves working hard for their take-home pay, the students were frequently surprised or angered when they perceived those in supervisory or management positions doing or having to do less than that.

One alumna, who worked at United Group Insurance where production rate was stringently measured and the pressure to increase productivity very intense, complained, for instance, that the supervisor was exempt from this accountability system: 'What makes it worse is that the supervisor gets 100% no matter what and the supervisor might not even be working.' Another alumna, who worked in a state department, offered these reflections about

work demands in a hierarchical division of labor and the men in the top administrative positions:

'It seems that the lower you are on the chart the more work you have to do. I think that when some of the directors are asked to do reports, instead of gathering the information themselves, they call down for it. I don't think they're doing other things. They're just putting off things they should handle themselves. . . . Sometimes I go on deliveries and their offices don't look like they're busy. I've heard they're in their positions because of brains, but I'd think they'd at least have papers on their desks that they're working on – or something.'

And, as Lois said to me after an upper-level employee walked past the photocopier at which she was working: 'The big shots should do my job for a while and see how they like it. Like that guy who just came in. As far as I can tell, he doesn't do much of anything.'

Apparently, observations during their work times were more salient in determining the COOP students' attitudes about the productivity of bosses than were the lessons they were taught at school. Similarly, what they learned from their 'blue-collar' fathers and mothers sometimes contradicted the image conveyed in class of workers who needed to be under constant supervision because they were not the type of people who were responsible about doing their jobs.

Some of the students with parents who worked in blue-collar jobs learned about hard factory-like working conditions, about workplaces which pushed employees beyond the point of what was considered fair or tolerable. Rather than seeing blue-collar workers who would not put in a fair day's work unless coerced, students heard about employers who did not offer a fair day's pay or fair working conditions. Some of the students had parents go on strike, and they generally supported that activity. One alumna's father was on strike at the time of our interview. Her account of the conflict was that the employees were protesting working conditions, that the employer had attempted to speed up the pace of work, forcing workers, literally to run when making deliveries. In addition, they worked in an unheated area and had to 'bundle up in coats' so that by the time they went outdoors into the cold

they were 'overheated and ended up getting sick.' Her father was currently carrying a sign that said 'we're men, not machines.'

The students' work experiences also taught them that the designations administrators, white-collar workers, and blue-collar workers did not adequately describe the hierarchical division of labor they experienced. One quite salient division for many of them was that between upper managers and floor supervisors. As Erik Wright (1978: 52–71) argues, this division is primarily the result of the expansion of the capitalist enterprise and the development of monopoly capitalism.

Monopoly corporations (and large state departments) tend to create 'complex hierarchies of social control,' differentiating levels of control and power. Two of the most fundamental levels are those of top managers, who have 'control over the entire labour process' and supervisors, who control the immediate, day-to-day labor process. Those in top managerial positions can also have control over the 'physical means of production' (what is produced as contrasted to how it is produced) although these two functions of management can be separated and hierarchically ordered.

As would be expected, then, the top managers exerted little direct authority over the students' work process. Nonetheless, more often than not, the women I interviewed were quite critical of these managers. As suggested by some of the women's reflections quoted a few pages back, these criticisms often focused on the perceived inactivity of this stratum of workers, a perception that seemed quite prevalent. One alumna told me that 'the bosses are always out to lunch. They're never there. I don't know how they got their jobs. Sometimes they don't do much of anything.'

At the beginning of a COOP class one day in February, I overheard Katrina telling another student how angry she was about an incident that happened at work the day before. Because Katrina did not have time to eat lunch between the end of her morning classes and when she was scheduled to begin work, her supervisor had given her permission to eat at her desk for the first ten minutes of her pay period. Someone apparently objected, so Katrina was being docked for that time even though she continued to work and practically 'swallowed my lunch whole.' She went on:

'It seems like the guys at work who are in charge just walk

around and don't do much for most of the day. And they get paid so much money. I'd like to get their paycheck. And it's the people under them who end up doing all the work.'

And although in the last sentence Donna attempts to rescind her statement, written as part of her final examination, there is little doubt that a critical tone accompanies this description of her corporation's highest executives:

'I don't know exactly what goes on up in Corporate. All I know is that the president of our Association, and all of his vice presidents have their offices up there. All I ever see them do is shuffle papers from one side of their desk to the other, sign their important John Hancock's on documents, smoke, drink coffee, and have never ending all day meetings. I don't mean to be critical or to make fun of them. I'm sure whatever they do is very important to the well-being of our Corporation.'

Besides being critical of managers' apparent lack of productivity, the student-workers were also seldom taken by the trappings or symbols of status that so often accompany those positions.

Almost invariably, for instance, whenever a company was located on more than one level, the bosses' offices were on the top level. Unlike the work space of the average office worker, these offices were private, comparatively large, and nicely furnished. The distinction did not go unnoticed by the lower-level employees. 'One of the big bosses who sits upstairs is over my supervisor. That's where all the really nice, lush offices are.' These symbols of status did not end with work environment, but extended to cars, cash, and a leisurely, self-determined work pace.

'Lately what's been bothering me is that the president got the board to get her car classified as a company car so the credit union pays for it. That bothers me because she uses it for personal business too. I'd like to audit people who do things like that – whether it's just a rip-off or something illegal. And at the end of each month she gets $125.00 tax free for business expenses. She doesn't even have any business expenses. And it's like that. People with big salaries get big raises and people with little salaries get little raises.'

'A lot of top priority people get all the money and don't do heck. I'm sure it will always be like that too.'

These perceptions of managers, and the worker cynicism they seem to embody, probably undermine the very control a hierarchical division of labor supposedly ensures. Hierarchy comes to be seen not solely as an organizational necessity, but as a way in which individuals increase their status, power and wealth.

Somewhat contrary to the widely accepted position that complex hierarchies deflect class conflict by focusing worker aggression on foremen or immediate floor supervisors rather than higher level managers, who often come to be seen as workers' protectors (Rosenberg, 1953), I found that the student-workers had more favorable perceptions of their immediate bosses than they did of the managers.

This situation was, I believe, the result of two conditions that characterized the COOP students' work. First, as noted in the relationship between Mary Jo and her supervisor, the student was often in an apprentice relation to her supervisor, who functioned more as a teacher than a traditional floor supervisor. The COOP student primarily needed to learn the tasks and duties that were part of her work role in that particular office, seldom did she have to be disciplined to do that work.

This situation resulted in the COOP students being genuinely fond of and grateful to their supervisors, who often taught the students more 'useful knowledge' than they believed they were getting at school. Mary Jo's comment captures the sense of this relationship.

'My evaluation of my supervisor is very high. She is always there to explain anything to me. Almost everything that I do is new to me, so she helps out a lot. My office situation is very casual; my supervisor makes everyone feel very comfortable. I think that we have developed a very good relationship. I feel that I learned a great deal from my supervisor, because she helped me learn so many things that I never knew before.'

The second condition that evoked favorable perceptions of supervisors extended this role of helper. Not only did the supervisor teach new workers departmental tasks and assist even experienced workers with problems that inevitably cropped up, but she

162

was also most often a worker herself and generally the most skilled worker in the department. Although she oversaw the work of the entire office (distributing, monitoring, collecting, and rerouting finished work), she was often engaged in doing much the same work as the office staff. She was, in many ways, one of them, not over them. In a few places, the COOP supervisor had a work role quite distinct from her supervisory capacity; sometimes she would be physically some distance from her supervisee, with walls or partitions separating them from one another. In these cases she would meet with the student at the beginning of the afternoon to explain the work that needed to be done, or would simply place self-evident work on the student's desk. In some instances the work flow carried on naturally from day to day so that daily direction was not even needed. If the student had a question, she would seek out her supervisor. The supervisor here carries the identity more of lead worker and helper than boss or watchdog, an identity that was invariably extolled by the students: 'The ideal boss would be understanding and would help out without griping.'

These teacher/helper roles played by the supervisors produced a community or family culture in many of the offices. In fact, the word 'family' was spontaneously used by a number of the students during interviews or on their examinations.

'Our bank has approximately 100 employees. It may seem like a lot, but it really isn't. We are like one big family.'

'My company has grown from a one man development to one of the world's largest merchandising organizations. I am now considered part of the family of 400,000 employees.'

Contrasting her experience at REMIC to previous experiences at United Group, Jenifer said,

'The people from United Group stand out in my mind as really stuck up and unsociable. It seems like they just go to work there. At REMIC, its more like a family. People welcomed me. No one at United Group ever did that.'

This family culture that emerges in offices, and which seems in some instances to be consciously cultivated by the company, to a certain extent mystifies the authority and exchange relations at the heart of the capitalist enterprise. Just as United Group's time

163

lapsing system was instituted to guarantee high rates of productivity, so too this family culture, whether consciously promoted or not, functions to guarantee a high level of worker loyalty. The supervisor's role in this culture, by relegating the authority aspect to the background, helps to affirm and create happy family members who produce without her supervision. These supervisors, so to speak, embody the concern of the company for the employee.

Not all the workplaces gave supervisors the roles of helper and teacher, however. Not surprisingly, the offices in which supervisors were most clearly authority figures were those of United Group Insurance. These supervisors tended to receive worse evaluations from students than most of the other supervisors. Students claimed that these supervisors had favorites, made them feel bad about their production rate, did not themselves have to produce to claim a high production rate, and complained in general about the 'shit they gave out.'

These comments are somewhat at odds with Richard Edwards's conclusions in *Contested Terrain*. United Group seemed to employ the most rigid system of bureaucratic control of any of the organizations I observed. Yet Edwards claims that one of the benefits of bureaucratic control for the company is that it removes conflict from the actual work site by embedding control in 'the impersonal force of "company rules" or "company policy" ' (p. 131). The workers at United Group apparently did not realize that supervisors were carrying out the policies of the organization. They blamed them and not the company for the strain, pressure and demands under which they worked. But even though bureaucratic control did not function at United Group the way Edwards predicted, it was still a successful method of control: the company squeezed high rates of productivity from workers who ended up blaming, not the company, but their floor supervisors.

Privatizing authority relations

Because the syllabus for the COOP class was primarily skill-oriented, not many other occasions provided the opportunities for overt messages about authority relations to be conveyed to the class as a whole. Because I never intruded myself into private

evaluation sessions Mrs Lewis had with the students, I do not know what they were told in that context, in which the topic of authority relations might well have been raised. I would assume, however, that those messages were consistent with responses Mrs Lewis gave when a student raised supervisor problems in front of the other students. At those times Mrs Lewis generally took the position that beginning workers did not know enough to evaluate their superiors, or that they needed to adjust to unpleasant situations.

When Katrina, for instance, elaborated on how the disorganization and carelessness of the men she typed for multiplied her own work, Mrs Lewis laughed, said 'that's life,' and moved the discussion on to a different topic. The message seemed to be that even if bosses were not perfect, and order-giving not efficient, there was nothing to be done about it, so it was best to adjust to the situation.

On another occasion,, Mrs Lewis mentioned to the class that some companies were going into 'flex-hours,' allowing employees some flexibility in determining when they would put in their hours of work. Dorothy spontaneously commented that her place of employment, United Group, had that policy, but that her boss would only let employees she liked take advantage of it. Mrs Lewis responded with the technological determinist suggestion that the type of work they were engaged in made it impossible to utilize such scheduling. Dorothy, who would not be dissuaded, reacted with a quick, 'oh, no . . .' but Mrs Lewis, who apparently did not want students to fall into the practice of criticizing supervisory practices in front of one another, shifted the discussion on to a different topic.

This practice of diverting or cutting off discussions of conflictual relations with authority was particularly evident in the curriculum unit that directly addressed that area. One month, *Harper's Bazaar* magazine carried a special section called the 'New Secretary's Guide.' Mrs Lewis decided to utilize the articles in that section for instructional purposes and distributed them to the students to read. One of the articles was titled 'Office Trouble-makers: Ways to Beat Them at Their Own Game!' The first sentence read:

No doubt you have run across them: hypercritical bosses who

unerringly find flaws in your most creative work;
overagreeable subordinates who cheerfully make promises
they can't fulfill; indecisive associates forever fearful of
upsetting the status quo

and went on to suggest strategies for handling all three types of
problem situations: those with bosses, with subordinates, and with
co-workers. The last example in the article dealt with know-it-all
bosses, those who 'know the right way to do everything, and
believe most people are inept and ill-informed.' None of the
COOP students had subordinates. Most of them had associates,
and all of them had bosses.

On the day Mrs Lewis handed this article out for the students
to read she made the introductory remark: 'The reason I like
these articles so much is that they don't just moan about the
problem; they give you helpful hints on how to overcome some
of them.' She then told the students that the word 'troublemaker'
actually connoted peers, entry level workers, people who perhaps
did not get their work done:

'There are many types of office troublemakers. You could all
probably mention one. I'm talking about one on the same level
as you. See if you can write down an example. It needn't be
personal. Maybe it's something the person next to you does.
Say, a person might take supplies home from work. It's not
right, but it's common. It's taking advantage. Write a few
things down about what's going on. I'll be back in a minute.'

When Mrs Lewis left, Donna told Evelyn about this real 'snotty'
lady at work who treated her as though she were her doormat
and a guy who kept ordering her around. Although Mrs Lewis
had clearly told the students to think of peer examples, trouble-
makers for Donna were obviously those who were in an authority
relation to her.

Upon returning, Mrs Lewis distributed mimeographed sheets
titled 'Petty Larceny' and 'No Personal Calls.' Each was a brief
scenario of an office situation followed by three questions asking
students how they would respond to the two problems of seeing
co-workers taking stationery and stamps, and of overhearing
personal calls during work time on company phones.

After the students read the scenarios, Mrs Lewis asked what

they would do if they observed something like that happening. They all said they would tell the boss. No one said why they would respond that way and Mrs Lewis did not ask them. She merely said that such peer behavior could put them in a difficult situation since, on the one hand, they would not want to be implicated in the situation, but on the other, they would not want to gain a reputation of reporting co-workers. The class then discussed the different policies their offices had regarding personal calls. Once again students were assiduously kept from focusing on problems with supervisors; the only conflictual relations legitimate for discussion were those with peers.

Although Mrs Lewis was consistent, throughout the year, in her attempts to avoid group discussions of supervisor problems, she did alter her position regarding the students' ability, and therefore the students' right, to evaluate their supervisors by the end of the year. This change took the form of telling the students that as part of their final examination they were to evaluate their workplace as a training station, and if they wanted, they could also evaluate their supervisors. Two specific events influenced this change.

During a final student evaluation meeting, Mary Jo's supervisor, who always had the highest praise for Mary Jo's work and once called her 'a little bit of sunshine who comes in every afternoon,' directly told Mrs Lewis that now that she was finished evaluating Mary Jo she would welcome Mary Jo's evaluation of the job she had done as a supervisor so she would know if there were any ways in which she could improve.

The other situation was Dorothy's criticism of her supervisor and her persistence in raising those issues in front of the class. During one such outburst, Mrs Lewis told Dorothy that the situation she was describing had nothing to do with her, that she should let those involved handle it and 'keep her nose clean.' Mrs Lewis did, however, emphathize with Dorothy's attitudes toward her supervisor and because she respected Dorothy's skill and work effort was influenced to let the students formally evaluate their supervisors if they wanted. Again, however, the form of the evaluation was totally private and individualized. It took place on the last day of school and was seen only by Mrs Lewis.

Conclusion

This account of authority relations had indicated that both the school and workplaces engage in practices to transmit a docile respect for authority and to accommodate young workers to their place in a hierarchical division of labor. But, contrary to the claims of Bowles and Gintis, my data lead me to conclude that young workers may exhibit loyal, dependable and docile behavior even while they are quite critical of work behavior of their superordinates. Moreover, this study has indicated that the primary factor in the integration of the COOP students into their places in the work hierarchy was the personal relationship so many of them developed with their supervisors which created a family-like culture in the workplace. It was not, as Bowles and Gintis claimed, the structural correspondence of authority relations between school and work organizations.

9
Gender relations

The organization of work within offices is characterized not only by a hierarchical division of labor but by a sexual division of labor as well – a division in which men and women both fill different positions and have different relations to wage and domestic labor. As the details of this chapter suggest, the ideological messages the students received were fairly congruent with the gender-specific patterns and relations they had become accustomed to both in their homes and at school. Their primary mode of behavior, therefore, was to accept, almost naturally and spontaneously to fall into, a sexual division of labor and the subordinate roles for women it implies. In the process of elaborating their lives at work, the students utilized a fairly conventional culture of femininity which identified them not as 'raw labor power,' but as sex objects, on the one hand, and as office wives and mothers, on the other. In so doing, they partially realized (in the dual sense of created and were aware of) their double subordination, in domestic labor and in wage labor. But because this awareness was only partial, and because they saw no alternative, they tended to fantasize an ideal future in which they worked part-time and stayed home part-time, regardless of the fact that this solution would only strengthen their subordination, keeping them dependent on a male provider and condemnning them to low level positions in the job market.[1]

The office worker as sex object

Messages about sexual appearance and sexual behavior were integral elements of the students' office education training both at school and in the workplace. On the level of appearance and self-

169

presentation, the young women were encouraged to emphasize and utilize their gender identities. But on the level of practice, when it came to actual behavior, they were warned to control their sexuality. The subtle message was that they would be blamed if sexual improprieties occurred at work.

In terms of their mode of self-presentation, students were informed in numerous ways how important it was to cultivate a feminine, even provocative, appearance if they were serious about getting a job and being promoted once they had a job. Early in the school year, for instance, a woman from a job placement center spoke to the students about interviewing, stressing the importance of their appearance:

'Look professional. Your best source for that is GLAMOUR magazine. It regularly runs sections for the professional woman: her image, what to wear, how to get a job. Dress like you already have the job, like you would to find a boyfriend. That's a good parallel. You have to attract someone.'

Later that week, Mrs Lewis re-emphasized how important it was for the students to sell themselves at an interview. In encouraging them to listen calmly and collect their thoughts before they answered a question in order to organize their ideas and speak intelligently she used the phrase, 'just like the finalists in the Miss America contest.'

This association of job with sexual attraction was graphically depicted throughout the year by an advertisement on a classroom bulletin board. Although the overt purpose of the bulletin board display was to show examples of new office machines and technology, in so doing, it also presented a certain image of women office workers. The most striking example was the advertisement for Dictaphone's Dual Display Word Processor. In an attempt to encourage readers (presumably male managers) to purchase Dictaphone's new equipment, the creator of this advertisement cleverly equated obsolete office equipment with the Stone Age and used a photograph of a young, attractive woman clad only in a leopard skin to demonstrate the point. Because this picture was displayed without comment in a business classroom of a public school, it seems that an unspoken approval or legitimation of the image was necessarily conveyed.

The issue of appearance was also regularly discussed during Mrs

Lewis's evaluation sessions with supervisors. Appearance was, in fact, one of the criteria on the formal student-trainee evaluation report, which included such items as quality and quantity of work, attitude, attendance, reliability. On the evaluation sheet, appearance was defined in a sex-neutral way as 'neatness and personal care, appropriateness to the job.' But in conversation Mrs Lewis often added a gender-specific element:

'You might do her a favor. She's a pretty girl. She could do a lot with herself and I don't think she's doing it. A lot of women in businesses are making appearance an important part of their day. She could capitalize on that.'

'She puts herself together very nicely. She was wearing some very sexy shoes the other day.'

While not forbidden, clogs and slacks, particularly those cut like men's which were the fashion at the time, were frowned upon. One supervisor talked about how her student-trainee had a figure for skirts, not slacks, how slacks put twenty pounds on her, and how you could see the look of disgust on the older men's faces when young women came to work dressed casually. Appearance, she said, was a definite factor in promotability, even for a woman who was extremely capable.

The accuracy of this perception was born out in the students' experiences with job placement. As pointed out in Chapter 3, only the 'socies,' the popular, attractive, cheerleader-type students obtained front-desk jobs. Other students often lost out to them in job interviews even though they were more qualified, and had to continue searching for jobs. If a student's appearance was unattractive, chances were she would be forced to take a position in a large routinized department with little public contact.

Cultivation of a feminine appearance is only one aspect of the situation that women must deal with, for they must learn not only how to use their femininity, but how to control it as well. Sheila Rowbotham makes this same point in *Woman's Consciousness, Man's World*, when she says that a certain 'contained sexuality' is required as part of the office worker's job.[2] Both Mrs Lewis and the students seemed to understand this requirement.

During a classroom discussion of a magazine article on the topic of sexual harrassment this issue of 'contained sexuality' arose. Mrs

Lewis stressed the importance of an appropriate degree and type of sexual conduct on the job. While on the other occasions she had been subtly encouraging the students to present themselves with a certain amount of 'sexiness,' on this particular day she highlighted the importance of knowing what the limits should be if they wanted to avoid detrimental consequences. She told them they would be asking for abuse if they were too timid to control the situation or if they wore attire that was too skimpy, giving signals that they wanted to be noticed. She cautioned them to be aware of what they were communicating through their dress and bodies, indicating an awareness that their sexuality was not only something they could use to gain job benefits but was also something that could be used against them.

In order to make the most of opportunities on the job, then, young workers apparently have to be skilled not only in running typewriters and photocopiers, but in monitoring their sexuality and sexual lives as well. But in case workers do not internalize the 'proper' sexual code, companies often have either formal or informal policies about social and sexual relations.

One personnel department, for example, discouraged employees from dating each other. If two employees married, one had to quit the job; that was official company policy. (The one who quit was generally the woman, of course, since she typically had the lower-paying job.)

Eleanor, a 1980 graduate, told the story of a bachelorette party for female employees held at a local bar. As part of the entertainment, a young male employee clad in bikini underwear and bow leapt out of a gift box during the course of the evening. He ended up quitting his job shortly thereafter because of the treatment he was receiving from his supervisor over the incident, treatment that included a demotion.

Needless to say, students and employees did not always appreciate or accept attempts to control their sexual identities and practices. One student, for instance, explicitly rejected the 'image of the secretary' that was conveyed to her. As she put it:

'Mrs Lewis had this obsession with secretaries looking gorgeous. Getting up at 5:00 in the morning to do their hair and nails. She taught us a lot about appearance, eye contact, interviews, dressing up. I thought that was good, but you

don't have to put on all that make-up. Cleanliness is the
important thing.'

Most students, however, did not verbalize any opposition to
suggestions that were made about their appearances. But in their
non-verbal behavior, in the manner in which they actually dressed
for work, there were indications that they, like many office
workers, were not passively accepting imposed standards, but
were negotiating and creating their own style. This style combined
the popular men's cut slacks with open-toed, spiked, 'sexy' shoes.
It was a definite blend of a unisex work look with a feminine
social look, and appeared to be an attempt to control the issue of
appearance while still emphasizing sexuality.

Resistance to the company definition and control of their identi-
ties as women workers was also exemplified in a widely distributed
cartoon. The graphic simply added two words and a visual to the
universal phone memo that is the staple of the secretary's office
life. The originally staid and official memo thus read, 'While you
were out fucking off . . .' and displayed a naked boss 'making it'
with an extremely buxom nude woman. The term 'fucking off'
here obviously connotes both sexual intercourse and having fun,
wasting time, using company time for personal pleasure. It thus
attacks both the sexual and the work identity of the boss,
projecting onto him the demeaning identity women office workers
feel is at times attributed to them.

But all in all, most of the students seemed to internalize defini-
tions of themselves as women workers that took into account
traditional notions of what feminine appearance should be. Many
of the jobs they could or could not imagine themselves doing
hinged on physical criteria. As Jennifer said, 'I thought of being
an airline stewardess, but I weighed too much. You have to only
weigh 120 or something.' And, as the students quoted in Chapter
4 indicated, they could not envision doing work that caused them
to get dirty or messy.

So, although there was some disagreement, resistance, and
negotiation about the exact amount and type of 'femininity'
women office workers should cultivate and display, there was
basic agreement on a more fundamental level. In general, a
gender-specific, feminine appearance that could be contrasted to
a masculine appearance was accepted and adopted.

This internalization of a gender-specific identity, an identity defined in many ways in relation to men, was strikingly evident in graffiti written on a sign posted on one of the company's bulletin boards. The sign announced 'Fun and Games' at a Women's Christmas Party. The graffiti responded, 'How can we have fun without men?' and 'Who are we going to play games with?' While obviously acting to reject what they perceived to be the company's attempt to control their social and sexual lives, the women, at one and the same time, affirmed and reinforced their dependence on men. They could not visualize an identity, or even an activity, for themselves apart from a relation to men. What they appear to object to is not their subordination to men, but to interference from the company in the way they acted out that identity.

The office worker as wife and mother

The second way in which office work roles were linked to the students' gender identity was through an association of office work with domestic labor, either through the equation of the work with women's work in the home or through the subordination of their role in the office to their role in the home.

The observation has often been made that the role of women in the office parallels their role in the home: picking up after men; doing the daily, repetitive, tedious housekeeping tasks; and keeping men's lives organized and undisturbed, so they can concentrate on their important work. Quoting a 1935 *Fortune* magazine article, Margery Davies claims that male bosses preferred women over 'pushy young men' as office workers because, as *Fortune* stated, women 'are capable of making the offices a more pleasant, peaceful, and homelike place.'[3] Taking on this kind of work, which has changed little in half a century, deepens women's wage labor identity as secondary and peripheral, for it patterns a gendered subjectivity already deeply etched into their day-to-day existence.

The objective structuring of these asymmetrical roles, of male leading roles and female serving roles, was already so much taken for granted by the students that they were unable to even perceive it. One young graduate told me that during high school 'everyone wants to be a cheerleader.' She naturally presumed that in this

context I would know 'everyone' meant 'every girl,' so that she did not have to make it explicit.

In much the same way, the students took the sexual division of labor they found in their offices for granted. During an interview of a graduate who had worked in the same department of the same large corporation for almost two years, I asked her to mention the types of jobs that were filled by men, by women, or by both men and women. After reflecting for a few moments, she said,

'All of the big bosses are men. I've never noticed that before, but that's the way it is. And all the secretaries are females . . . and all the key punch operators are ladies. I've never thought of that before.'

At another workplace, a student made daily mail runs, picking up and delivering mail to every office in the building. On the desk of each employee was a name plate. The typical nameplate for a female employee read, 'Beth,' 'Jo,' 'Susie,' or 'Pat,' The typical male employee's nameplate was 'Mr. Mott,' 'Mr. Gleeson,' or 'Mr. J. L. Stone.' When I brought the distinction to the student's attention, her response suggested she had never noticed the difference. She said, almost in passing, 'I don't think there is anything behind the difference. I think it's just a matter of preference.' The nameplates were a natural, congruent part of her social environment.

The relation of the woman office worker's status to that of the male worker was objectified in the structure of the workplaces as well as in how the workers were addressed. Men often had offices that were private or closed off, in contrast to the public work areas of the women.[4] Even if women had their own desks, they were generally grouped together in a large, open space. About eight or nine of the places at which students worked were fairly large bureaucracies housed on more than one building level. Inevitably, when this was the case, status differentials were structured into the floor on which one's office was located. So when referring to bosses, workers would naturally employ expressions like: 'I don't know if there are any ladies up there – up at the very top.' 'One of the big bosses who sits upstairs is over him.' These linguistic expressions reinforce notions of superiority and inferiority which are so naturally linked with the English language concepts of up/down, high/low, over/under, and top/bottom.

While the students often watched upper-level, male employees taking work home, having their work lives spill over into their home lives, so to speak, they usually saw the converse in the lives of the women with whom they worked. These women often worked only part-time so they could see their children off to school in the mornings and be home before the school day ended. They often brought in candy or cookies to sell for their children's scout troop or hung home-made skeletons they had constructed in their role as den mother. Sometimes they had to take a temporary maternity leave or had to quit work altogether because they were no longer able to juggle working and child care, even though the family needed the money. One of the students vividly recalled how her mother was fired from her clerical job years before because she and her siblings kept walking over to her office (located just blocks from their home) to visit, ask questions, or get permissions.

In many ways, then, the identity of women office workers seems to be closely linked with their identity and work in the home. This was underscored for the students at the appreciation banquet. The two main speeches were given by the teacher and by a retiring supervisor, Mrs Carter, who was held in high esteem by co-workers, the teacher, and the numerous students whom she had supervised over the years. In both speeches, reference was made to the woman worker as mother. Mrs Carter told the group: 'My first family was all raised and scattered around the country. I thought my parenting days were over. Then, six years ago, I began a second family. And in six years I've had forty-two offspring.' Mrs Lewis's speech was filled primarily with appreciative remarks to those at the banquet who had contributed to the success of the program. A special note of thanks was addressed to Mrs Carter. 'They gained so much from being in your office. You became the mother at work that I was in school.' I find it difficult to imagine male supervisors or teachers so naturally using paternal imagery in speaking about their work relationship to male apprentices.

Mrs Lewis also underscored her own identity as mother by knitting baby clothes during class time and using traditional notions about sex-appropriate behavior by advising the students not to express emotionalism if they wanted to rise up the corporate ladder, and not to shout since 'it's not ladylike.' One of their texts

warned them not to 'chit-chat' during the workday since it wasted their employer's dollars.

Another teaching aid, a filmstrip, similarly reinforced traditional notions of the sexual division of labor. Titled 'Telephone Impressions', the filmstrip was geared to teaching students good phone techniques: courtesy, clear speaking, and promptness. Mrs Lewis made a point of telling the class that although the filmstrip was excellent at demonstrating good phone usage, the school system could not purchase it because it was sexist. All the examples of the wrong way to answer the phone, she elaborated, were delivered by a male voice; all the correct examples were delivered by a female voice. Therefore, the filmstrip had an antimale bias. It should have portrayed mistakes being made equally by the man and the woman.

There was, however, a deeper, more subtle sexism at play in the filmstrip. The incorrect phone manner was not just a male voice, it was an authoritative, busy, important-sounding male voice, one that was irritated that it had to be bothered by answering the phone. The female voice, on the other hand, sounded trained for the job: that was her proper work and the task for which she was perfectly suited. Far from being antimale, the filmstrip reinforced that age-old notion that men have more important things to do than answer the phone. Since women are not doing anything of value, they are the ones who should be constantly interrupted to screen and direct messages.

At some of the workplaces, however, women workers were beginning to resist this traditional telephone role, requesting the installation of a de-centralized phone system where each person would have to take his or her own messages. Mrs Carter was one supervisor who was adamant about this. Shortly after she was hired as an executive secretary she told her boss to take the phones away or she would leave the job. She resented the burden of answering her boss's phone, claiming that if women were relieved of that kind of task they would be freer to do 'the administrative work that men won't let women do.'

Office workers were also starting to resist the secretary's traditional task of serving coffee. Maureen, for example, was startled when a boss asked if she had offered coffee for the men who had arrived for a business meeting. She responded in surprise, 'No, was I supposed to?' Her boss replied, 'You bet you are, and

do it with a smile, too!' Maureen characterized this attitude as chauvinistic, but when she checked with other office workers and was told the directive was appropriate she was reluctant to say anything because she feared it would turn people against her, and affect the way she felt about working there. So even though she thought she would 'raise a ruckus' if she were an older worker, employed full-time, and if the practice were habitual, because of her structural relationship to the job she ended up complying with the directive.

But, all in all, just as the students partially accept sexuality as a criterion of themselves as office workers, so do they tend to accept being defined as man's helper, as his office wife. Some students saw this as a natural division of labor, some as a social division, and some seemed unable to distinguish between the two.

'Office work is mostly for women because it's typing and a lot of guys don't like to type. Filing and receptionist, that's more for girls too, because that's secretary work and girls are secretaries, you know.'

'Women shouldn't do construction work. Men are stronger and it's just the way it should be. Secretary jobs are probably for women mostly. That's just the way things are.'

'Boys don't take the class because boys aren't secretaries. They're more into manual labor. That's just today's society. Men don't sit and push pencils. Being a secretary is a girl's job.'

'A guy should be the boss. I can't see a lady telling a guy what to do. He'd probably be bigger than her. . . . I'm not used to a lady boss. I mean, you don't see it on television. There a man is always the boss. And that's just the way I think it should be. Sure, there could be a lady doing Robert's job, but that wouldn't be right.'

What 'is' often became equated with what 'should be' and, surprisingly enough, as late as 1981 many of these eighteen- to twenty-year-olds had not seriously considered alternatives. In fact, the ideology of the sexual division of labor remained so strong that many of the students continued to advance arguments that their

everyday experiences clearly contradicted (for example, seeing men who pushed pencils, having women as bosses).

When students elaborated on the reasons why men did not or should not do women's work and why women did not or should not do men's work, a striking contrast could be heard. Generally using euphemistic language, they explained that men who ventured into what was traditionally regarded as women's work would be considered homosexual.

'I really can't picture a man doing a woman's job. My uncle is a nurse, but he's like this (she made a limp wrist). That's why it would be hard for guys to have a woman's job. Because it's considered delicate and people might think they're gay.'

'Guys aren't cheerleaders because they think it's too faggy.'

'I guess guys don't take something like the cooperative office class because they don't think it's right for them. They think they'd be laughed at – wow, what a weirdo!'

'It's only in big cities that guys are secretaries; because they're able to get lost or hide more there.'

Doris went on to confirm my interpretation of her statement; if men did office work it meant they were gay; and if they were gay they would naturally want to hide their identity.

On the other hand, the young women who thought that the sexual division of labor should be maintained explained that women who were after men's jobs were trying to be like men or trying to prove their (mistaken) equality. As described in Chapter 4, they said things like women were trying to prove a point, or were trying to prove they were equal to men when they applied for jobs traditionally defined as male.

According to these students, then, when men do women's work, they are denying or rejecting their masculinity, their natural claim to superiority. They are becoming effeminate. When women try to do men's work, they are not accepting their natural limitations and subordination, but are trying to be as good as men, when in fact they are not.

Just as most of these students had a hard time imagining men and women doing the same wage labor jobs, so too did they find it hard to imagine men and women filling the same domestic labor

roles. For them, the notion of women's work automatically meant the primary role in domestic labor. In one way or another, they made it clear that men were the primary breadwinners and they, the women, the primary homemakers and childcarers.

'If I were to marry, I would still want to work part time. Otherwise I'd get bored. But I wouldn't want to work full time if my husband were bringing in a good income. There's a lot to do already with housekeeping and kids.'

'If I had kids I would sit around the house with them. I wouldn't work. You can tell kids who have been raised by a baby sitter. I don't know if I would let John stay home with them or not. It's not what guys are supposed to do.'

'I would like not to be working sometimes. It's hard to come home every evening and just start to do what every housewife has to do. And I'm the one who always has to get the baby off to the sitter.'

While they might have been able to imagine themselves having full-time, interesting or important careers when they were younger or if they were to stay single, the central force directing the students' sense of a work identity was the expectation of eventual marriage and family.

The kind of training the students received for office work served to further marginalize their work identities since this identity was presented as secondary to or synonymous with a sexual/home/family identity. The conceptions the young women held about themselves as subordinate workers were, thus, reinforced by the ideological messages in the classroom and at the work site, and by their structured experiences as office workers; their beliefs became an even more take for granted part of their everyday existence. While in some minimal ways the women may have rejected the ideology of male supremacy, at a more fundamental and persistent level, they affirmed it, granting superiority and legitimacy to the dominance of men in a way that appeared spontaneous and natural.

Conclusion

As the three chapters in this section have demonstrated, labor process theory is not sufficient to explain the transformation of students into workers, because it disregards the potential effect cultural orientations and experiences outside the workplace can have on the way in which work identity is created. The only aspect of culture considered important is that which is created within the labor process itself. My data clearly reveal this is not the case.

Ideological reproduction theories (of which correspondence theory is one type) are inadequate to explain social process at two levels: at the level of actors and at the level of structures. In terms of actors, these theories fail because they do not analyze consciousness as an active, interacting medium of identity formation. For them, consciousness functions more like a mirror, passively receiving and reflecting the structures or messages around it. In terms of structures, these theories fail because they gloss over the many ways in which schools are 'semi-autonomous' organizations, having needs, rules, practices and structures that schooling brings about itself, without recourse to its relation to the economic sector. They miss the real messages that are conveyed because they strip practices from context, rendering adequate interpretations problematic.

In fact, as Bernstein (1977: 174–200) has indicated, the boundaries between the institutions of school and work can be fairly solid. When this is the case, practices which to all appearances are quite similar, when embedded in strongly bounded institutions will convey quite different meanings (Cohen: 1969). Teachers and supervisors are not the same kind of authority figures; grades and paychecks are not the same kind of rewards; school work and office work are not the same kind of tasks (Bills, 1981).

But even when their school experiences did not strongly promote their development as obedient, productive workers, elements within the labor process and their cultural backgrounds promoted the ongoing production of these orientations. In terms of the labor process, for instance, the students were encouraged to be productive by the need to overcome boredom, the desire to offer service to the customer, and by their relationships with their co-workers and supervisors. Their cultural orientation supported this inclination toward productivity since it stressed personal

181

relationships and pride in personal achievements. These young female workers were quite prepared to transform and accept the transformation of what are essentially exchange relationships into personal relationships because family, community and service were highly salient to them. Immediate, surface, apparent relationships (which are nonetheless real relationships) serve to hide the structural relations that govern them. Workers willingly consent to work hard because they experience it as working for their supervisors (whom they like) or for the consumer (whom they identify with). They do not experience their productivity as cooperation in their own exploitation (except in the extreme instances I have noted).

But these strong pulls to be cooperative, loyal and productive workers do not mean that the social relations of labor are reproduced unproblematically. Tensions and conflicts are built into both capitalist and patriarchal relations, so that even over an issue like pay, for instance, where students' knowledge of pay scales (and the relations between worker pay and company profits) was highly constrained, room for questioning, insight and bargaining was definitely present. The young women I observed and interviewed did not necessarily accept the legitimacy of company policies, demands or intrusions into their personal life. They rejected the right of bosses to demand coffee, for instance, or to tell them what they could do or talk about with co-workers outside of the office. At times, by teaching them how to be assertive with customers, bosses unwittingly taught the student-workers how to be assertive with them as well.

Yet, all in all, the structure of relationships in which the workers found themselves embedded interacted in such a way as to confirm a basically conformist and subordinate work identity. Partially because work identity was secondary to a home identity, quitting work or working part-time was more natural for them than was engaging in struggles over the quality of work life. By denying wage labor primacy over domestic labor, they inadvertently consented to and confirmed their own subordination, preparing themselves 'for both unskilled, low paid work and unpaid domestic service.'[5]

PART FIVE
Conclusion

10
Correspondences and contradictions

Through the use of cultural reproduction theory and ethnographic methodology I have analyzed the processes through which a group of high school girls construct their identities as office workers. At a higher level of abstraction, this transition from school to work can be viewed within three fundamental relationships between educational and economic sectors of the social structure.

Part Two analyzed the reproduction of the division of labor: the movement of young women from school to particular types of slots in the job market, taking into account their choice of intensive vocational training in office work at the high school level. The analysis revealed that traditional socialization and allocation theories were not fully adequate to explain selection mechanisms within Woodrow High School's Cooperative Office Education Program. Socialization theories do not adequately explain selection mechanisms because they are often developed in a manner that detaches notions like aspirations and role identification from culture and social structural constraints, giving them the appearance, in the analysis, of being properties that arise from the individual.

Allocation theories of selection mechanisms fall short on several counts. They are based on the premise of scarcity of openings, which did not apply to this particular situation; they impute status-seeking behavior, not characteristic of Woodrow's COOP students; and they imply that students in vocational courses have passively accepted the institution's definition of them as failures. Allocation theories do, on the other hand, usefully point to the possibility of external selection processes being based on non-meritocratic criteria. My analysis indicated that decisions about

job placements were at times made on the basis of a young woman's appearance rather than her skill.

Furthermore, the analysis in Chapter 3 suggests that an adequate explanation of students' vocational preparation in office skills is quite dependent on notions of cultural reproduction and the structure of job availability. Students received training for office work because they perceived it as a sensible option, as an appropriate choice for a woman. Occupational selection is determined not by aspirations, but by common-sense notions of culturally acceptable employment. These notions are based on class definitions and, to a far greater extent, on gender definitions.

Part Three analyzed what the COOP students learned about technical aspects of the labor process in office occupations. I argued that an understanding of the reproduction of the technical relations in production would be enhanced by a more refined description of office jobs than the categories of service occupations and automated jobs used by proletarianization and embourgeoisement theorists. In place of those categories I utilized Kusterer's (1978) definitions of routinization and specialization to analyze the skill requirements of office jobs, the corresponding training the students received for those jobs, and how students felt about performing particular types of office functions.

My data indicated that many of the jobs the students filled were so routinized and specialized that they were already overqualified for them before they completed high school. That lack of correspondence between skill level and job requirements created a feeling of dissatisfaction that resulted in low-quality work, requests for changes, and/or a marginalization of wage labor identity. While a social efficiency perspective might suggest lowering educational expectations, a human development perspective would encourage concerted work on skill development so that young workers have the competence and confidence to protect job boundaries.

Part Four focused on three aspects of the social and sexual divisions of labor in order to analyze the way in which the social relations in offices are reproduced. By analyzing the relationship between the ideological dimensions of the school, the impact of the labor process itself, and the cultural orientations and productions of the young office workers, the chapter was able to

explain the mechanisms and processes through which young women become productive, loyal and subordinate employees.

An analysis of exchange relations revealed that the COOP students were not productive workers because they had internalized the school's messages about a fair day's pay for a fair day's work or because they were closely supervised. Rather, productivity (in terms of both quality and quantity of work) stemmed from more intrinsic, cultural orientations of work pride, customer service, and worker cooperation. Productivity was also a means office workers used to overcome boredom, a basic problem of routine wage labor.

The analysis of authority relations suggested that although the school attempted to impart a 'proper' respect for authority, the COOP students related to upper-level managers and floor supervisors in fundamentally different ways. While the supervisor's role as helper and teacher functioned to incorporate the young worker into the company, the image managers projected as status-seeking and non-productive made the students skeptical of the authority held by persons in those positions. Moreover, despite the COOP teachers' attempts to deflect criticism from authority figures, the students persisted in what they considered to be justified complaints. The students never questioned the legitimacy of a *position* of authority, only the failure of *individual* agents to live up to their standards.

The final chapter of Part Four, which focused on gender relations, indicated a strong convergence of the messages students received from both school and work about their role as women workers and the work identities they had begun to acquire from prior relationships and experiences. In one way or another, these messages basically supported the notion that women's primary identity is in the home. By internalizing the main aspects of this ideology the students produced a culture of femininity that did serve to help them resist the impositions of employment, but also tended to lock them into subordinate positions in both wage and domestic labor.

The conclusions drawn from the preceding analysis can best be summarized by relating the various contradictions and correspondences within and between sectors of the structured totality to the culture the COOP students drew upon to produce their work identities, consciousness and subjectivity. As a result of these

187

social structural discrepancies and incongruities, subjectivity itself should be expected to contain some contradictory elements (although they may appear in incipient forms) and/or should be expected to be in relative conflict with some dimensions of the social structure. These multiple levels of actual or potential conflict are the weak links in the social structure through which change and transformation are most likely to occur.

In regard to the allocation of students to positions in the work force and to the reproduction of the technical and social relations in production, then, what areas of contradiction and correspondence have been explicated or implied by the foregoing analysis? How, in other words, do the various needs and characteristics of the economic sector converge or diverge with the needs and characteristics of the other sites of social and cultural reproduction to affect the formation of clerical worker identity and consciousness? A useful way to answer these questions is to relate the cultural, ideological, and labor processes which I have explored to the three primary characteristics of the economic sector outlined in Chapter 1: the sexual division of labor, the need for workplace efficiency, and the need for worker control.

The sexual division of labor: correspondences and contradictions

The ethnographic data presented in Chapters 2–9 clearly reveal the processes through which the sexual division of labor is reproduced in terms of both the movement of women into specific gender-related positions within wage labor and the manner in which women learn to relate to wage and domestic labor in ways quite different from men.

From their families, the COOP students first gleaned social constructions of masculine and feminine. Since these constructions pervade other domains besides the family (schools, workplaces, media, peer groups) some of the students perceived and spoke of them as natural categories, conflating or confusing biological sex differences with sociological gender differences. In fact, contrasting masculine/feminine constructions were so pervasive that COOP students often went about their daily activities without noticing them.

Cultural, ideological, and labor processes all tended to converge

in identifying women's place in wage labor as secondary to her place in domestic labor. The masculine code was, of course, just the opposite. Mothers, as noted earlier, often held part-time office jobs and most had their wage labor histories interrupted by family responsibilities; fathers, on the other hand, worked full-time until retirement – an event that did little to alter their basic relation to domestic labor. Even when fathers performed the same household tasks as did mothers, the practices signified fundamentally different relationships to domestic labor. The fathers were clearly 'helping out' in an alien domain or displaying (when inspired) a latent talent.

At the peer-group level, cultural patterns also reflected this dominant code of gendered subjectivity. These were patterns the students not only witnessed, but actively reconstructed. Each time a COOP student participated in ritual activities like homecoming courts or cheerleading, each time she chose school classes that were sex-linked, each time she displayed traditional feminine characteristics (darning boyfriends' clothing, deliberately losing a contest), she reproduced cultural codes that identified her as either a sex-object or as someone's future wife, with all its implications of possession, subservience and domesticity.

Given the high degree of salience and legitimacy this dominant gender code played in the students' lives prior to their initiation into the COOP program, there should be little surprise at the ease with which they made the transition to office work, a domain which reflected the same sexual division of labor and the same characteristics of masculine and feminine as did the other domains in which the students constructed their lives. Being implicitly or explicitly told to be sexually pleasing to perceive but not sexually distracting, and being expected to perform the housekeeping tasks of the office were practices quite congruent with their prior experiences. The students barely noted their gender-specific nature.

The picture of the unconscious internalization of specific forms of gendered subjectivity I am drawing here is highly reminiscent of the work of both Bourdieu and feminists I criticized in Chapter 1. While I admit the profound impact homologous structures and practices make on the social construction of identity, my data indicate that a primary mechanism in the reproduction of any cultural form, even a subordinate culture, is the benefit the group derives from reproducing it. The culture is neither irrational nor

the immutable form of a naturally inferior group, as others have suggested. Rather, it is an adaptation or accommodation (albeit unconscious) to the perceived structural limitations of their lives; it is a choice of the best alternative thought to be available.

Given the scarcity of professional-level or interesting career-type jobs and the difficulty of handling such a job along with home/family responsibilities, the emphasis the COOP students placed on a traditional feminine code exhibited a certain amount of good sense. Reproducing a traditional culture of femininity can be interpreted as a way of escaping the tedious demands of wage labor and of denying it power over the self. It can even be seen as an unconscious resistance to capitalist domination. The irony, of course, is that this culture both reproduces patriarchal domination and fails to alter capitalist exploitation which is quite amenable to a segment of the skilled labor force having a tangential relation to it.

All was not simply correspondence and reproduction in relation to the sexual division of labor, however. At the ideological level, the students heard some gender-related messages that questioned or opposed the dominant code: disagreements raised in families and classrooms about responsibilities in the home; statements made by Mrs Lewis and other teachers about specific forms of sex discrimination. Although these messages were few and far between, and although their impact was weakened by the students' participation in events that structured into daily experience the differences between men and women, by raising cultural patterns to the conscious level, ideology has the capacity to alter dominant codes. This interpretation is given credibility by reactions some of the students and alumnae had to interview queries about the sexual division of labor in their offices, responses such as 'I never noticed that before' or 'I never thought of that before.' If awareness of cultural patterns lies just below the conscious level, easily raised to consciousness through ideological discourse, at the very least ideology may help to distinguish natural constructions from social constructions and open the possibility for change.

At the level of practice, the students also witnessed and participated in events that suggested a less than perfect internalization of the dominant gender code. They witnessed female supervisors negotiating job boundaries with their bosses, tested gender-related job expectations themselves, distributed jokes that attacked the

sexual and work identity of male bosses, and adopted a dress code that resisted definitions of themselves as merely workers or as merely sex-objects. Within their families they sometimes attempted to negotiate or resist a division of labor based on traditional gender categories and with their peers at school some of them expressed resentment at being labelled on sexual criteria or having their culture of romanticism disparaged.

Workplace efficiency: correspondences and contradictions

I have argued that the technical relations in production, whether in the private or the public sector, are characterized by the need for efficiency, the need to minimize operating costs and maximize output. Although this need may vary with the general economic climate or a company's specific market location, it is a basic constraint that structures the labor process. In what ways did this characteristic of the economic sector, and forces that were in correspondence or contradiction to it, affect office worker preparation and subjectivity?

Unlike the preceding section, in which the sexual division of labor was so clearly reproduced within each domain, the clearest mechanisms I found in the COOP students' experiences that prepared them for workplace efficiency were the skill training they received in school and the personal motivation they had to be productive in their work.

In terms of skill preparation, quite an exact correspondence existed between the skills that were taught in school and those utilized in the workplace. The critical point that would be missed, however, by merely correlating the production functions from the two areas is the disparity in the level of skill within each production function between the two areas. In other words, even though students were asked to use such knowledge as filing, typing, photocopying, and record-keeping on the jobs, in most cases, their degree of skill and knowledge exceeded the possibilities of the job and the students were left dissatisfied and unchallenged. Only in those areas least routinized and specialized, where more advanced typing, editing, word processing, or data- and account-keeping skills were utilized; where students were rotated among various production functions or forced to balance a number

of production functions simultaneously; or where they had extensive contact with the public were the students' degree or variety of skills tapped enough for them to like their work.

This tendency for workers to become bored and dissatisfied with routinized and specialized jobs would have little relation to a workplace's need for workers having sufficient skill to do their jobs efficiently if it were not for the ways in which these subjective experiences are acted out on the office floor. As the analysis in Chapter 5 suggested, this experience of boredom and dissatisfaction is expressed in three different types of behavior: low production standards, demands for change, and/or quitting the job. Each of these three modes of behavior is in potential contradiction with the need for offices to run smoothly and efficiently.

Although most workplaces can operate efficiently with a segment of the work force less than totally committed to wage employment, willing to move in and out of various forms of wage labor, a point can be reached where the refusal of workers to apply for or remain in specific jobs becomes dysfunctional to that operation. That this is indeed a problem is indicated by the persisting shortage of office workers and by companies like United Group who are willing to hire external consultants to make recommendations about the labor process because of their excessively high rates of worker turnover.

There are other ways in which the skill workers have acquired can become contradictory to a workplace's need for efficiency. Skilled workers develop a certain confidence in themselves. They lose their shyness, their hesitancy to demand or complain and begin to express what they consider to be their legitimate concerns: requests for more sophisticated equipment, refusal to let others encroach on their job territory, negotiation for better working conditions, or a re-evaluation of their job classification. So while the school services workplaces by providing them with skilled workers, this service always contains contradictory and problematic elements.

The other factor relevant to the COOP students becoming efficient workers was the motivation they had to be productive at their work. This motivation was brought about by the pride the students experienced when they produced high-quality work; the satisfaction they derived from serving customers, helping co-workers or putting in a 'good day's work;' and the dread they had

of time dragging if they were not busy, so that they could often volunteer to do more work than was expected of them. If these factors were not sufficient to guarantee the quality and quantity of work demanded by efficiency standards, more coercive mechanisms, ranging from informal reprimands to threats of firing, could be brought into play.

This analysis brings into serious question the theory that workers learn to be productive primarily through the corresponding structures of work tasks to school tasks, tasks to which students have become accustomed. If such a correspondence had the efficacy correspondence theorists claim, the COOP students would have found ways to avoid their office work, the same way they found the means to avoid their school work. But no such correspondence existed. Instead, students would skip class and neglect their school assignments; yet they seldom missed work and actively sought out extra work.

Worker control: correspondences and contradictions

As the preceding section has suggested, the social and technical relations in production are not totally separable processes. Efficient production is created not merely by technical know-how, but by workers 'properly disposed' to render the amount and quality of labor desired by the employer. Since these proper dispositions can never be guaranteed, are never instilled once and for all, workplaces institute various practices and policies to control workers who may perceive their interests to be in conflict with those of the company. Threat of job termination is only one such practice; more common practices seemed to be employing floor supervisors, instituting rules governing production and promotion, developing policies about co-worker relations, and consciously planning ways to promote company loyalty.

The use of supervisors to control the production of workers in a designated area appears to be a highly prevalent practice. Even in the smallest companies or offices a supervisor generally mediated and oversaw the work expectations of the owners or managers; in large organizations their roles involved the enforcement of company policies.

As Chapters 7 and 8 have demonstrated, the supervisors, by and

193

large, were quite successful at extracting labor from the COOP students. Apart from the students' other motivations to produce, the apprentice-type relation many of them developed with their supervisors served partially to transform impersonal, authority relations into personal, helping relations. COOP students experienced their production as a way of assisting supervisors, who so often helped the students with the complexities of their work. The supervisor was both helper and teacher, a personal link between the student and her place of work.

Only in the organization with the most developed system of bureaucratic control did the supervisor/apprentice relation fail to operate in this manner. But contrary to Edwards's (1979) claim that bureaucratic control deflects conflict from the immediate work area, hostility toward supervisors at United Group was far more intense than in any of the other workplaces. Students blamed supervisors for company rules they were enforcing, seldom realizing they were not the supervisor's own personally devised system of control.

Both modes of authority relations have elements within them that correspond to and contradict the organizations' needs for worker control. Personal authority relations control workers by mystifying the underlying contractual or exchange relation, binding the young worker to the company through the supervisor at an affective level. At one and the same time, however, they can serve as contradictory forces, giving the young worker a claim on the benevolence and good will of her supervisors, putting her in a position to demand more from the company than just a 'fair wage.'

Bureaucratized authority relations, on the other hand, focus worker complaints on the immediate floor supervisor and usually save the company from having to justify its policies regarding worker rights, promotions, production standards, etc. while still being able to appropriate extremely high rates of productivity. Such conflict, however, can at times disrupt the labor process, decreasing output, or result in worker complaints to higher authorities.

The overt and explicit training the COOP students received at school for the most part corresponded to the workplaces' attempts to control workers through their supervisors. Mrs Lewis attempted to instill proper deferential attitudes about authority figures,

leaving the impression that authority relations were natural and inevitable, that authority figures should not be criticized, and that any relational problem was personal, not structural, and should be handled privately.

These teacher messages about proper work dispositions did little to dissuade students who were experiencing 'boss problems' from complaining, however. Although the student sometimes mistakenly interpreted authority problems as residing at a personal rather than a structural level, they tended to trust their own experiences more than the school's rendition of their experience, refusing to be deterred from their complaints.

The limitations of the school's power to produce properly obedient and submissive workers was further indicated by the power the students themselves had, by the end of the year, in convincing Mrs Lewis of their right to criticize and evaluate their supervisors. Moreover, if Bowles and Gintis (1976) are correct in their assertion that one's proper place in the work hierarchy is learned from experiencing one's proper place in the school hierarchy, what these students learned was that roles and expectations are negotiated, not given.

Another way in which companies sought to exert control over employees was by telling them what types of relations they could and could not develop with their co-workers. Two types of relations generally regarded as off limits were discussions of wage relations and social relations outside work. Particularly in terms of wage relations, the school supported companies' 'no discussion' policies. Perhaps because of the helping and caring orientation so much a part of the students' feminine culture, the students did little to resist this restriction, accepting the explanation of not wanting to hurt anyone's feelings.

In this situation, the students' cultural orientation corresponded to the school's and workplaces' claim to have the right to determine what was the legitimate way of viewing exchange relations. The only times this legitimacy broke down were when a student discovered a higher wage could be given for comparable or lower-level work, when students saw more highly paid employees *not* working, and when their own parents went out on strike for higher pay.

Where the students' resistance to company policies seemed strongest was in the area of social and sexual relations. Without

exception, the young workers I spoke to objected to intrusion in what they considered to be matters outside the company's business. They complained privately, pursued their personal lives privately, and, as far as I know, did little to effect change in these types of policies. While this reproduction of the public/private distinction is probably useful to capital since it legitimates capitalism's terrain, it does serve to limit encroachment on workers' lives.

A third way in which control was exerted was through the cultivation of worker loyalty and identification with the company. This was attempted through such practices as organized birthday celebrations, Christmas parties, pot-luck luncheons, and social outings, all of which embody the company's concern for its employees. These sort of activities took place at the school level as well; Mrs Lewis, in fact, consciously sought to establish more personal relations with her COOP than with her other students because of her extensive work relation with them.

While the students certainly participated in these events, they did not necessarily internalize the family or community ideology the company was promoting in those activities. Their resistance seemed primarily prompted by their outlook on company managers or VIPs, an outlook which militated against feeling they were part of a big happy family.

In contrast to their relations with their floor supervisors the students had little direct contact with managers. They definitely did, however, form distinct impressions from their observations of them. These observations inclined the students to conclude that bosses were fundamentally status seekers and work avoiders who thought nothing of pushing off their work on them in an exploitative, demeaning manner. Even though the authority of the bosses was structured into the physical layout of the organization and was projected in various status symbols, the students saw these more as self-aggrandizing behaviors in conflict with their own interests as workers, and sometimes in conflict with the interests of the company or clients as well. Since these bosses were generally men, I presume this perception of the students had the power to transform the images they had of themselves as the subordinate sex.

Conclusion

What this analysis of the reproduction of the clerical labor force has revealed are those structural, ideological and cultural elements that serve to bind young women to secondary and subordinate positions in wage and domestic labor, and those they utilize to free themselves from relations they experience as oppressive. Unfortunately, however, many of these elements function to free and bind at one and the same time, making major transformations of social relations difficult tasks to accomplish, tasks generally beyond the desires or even the consciousness of most of these young women.

The students' helping or service orientation, for instance, part of their general feminine culture, did free them from experiencing their jobs as boring and tedious by infusing them with meaning, purpose and significance. But this transformation at the cultural or ideological level did little to transform the structural wage relation of exploitation beneath it. Similarly, the students' pride in their work and their qualifications served not only to give them more control over their labor process, but also to enable their employers to extract a higher rate of surplus value. And most fundamentally, by re-creating a culture that identifies them mainly as domestic laborers the women seek to free themselves from being full-time domestic servants and full-time wage laborers, but again, those fundamental relations of subordination are left in place.

Although the main process at work in these students' lives was one of social and cultural reproduction rather than transformation, their individual or collective actions did more than recreate oppressive structures and relations. As I have tried to emphasize throughout this work, the decisions and practices of these women made a great deal of sense given the constraints they were working within. Moreover, each act of negotiation or covert resistance, each attempt a subject makes to redefine her identity or structural location, has the power to become something more.

11
Recommendations for office education

Some strategies through which women's work can be improved have been alluded to in the analysis of this reproduction of the office labor force. This concluding chapter more systematically explicates what schools can do to benefit students on their way to becoming clerical workers. As such, its purpose is highly focused, dealing only with the question: what *should* the role of the school be in preparing students for the world of office work?

An assumption is, of course, contained within that question: namely, that vocational education is within the proper domain of the school. That assumption has long been debated by both right and left within the history of compulsory education in the United States, most recently in the form of the *Paideia Proposal* (Adler, 1982). Arguments against vocational education include its cost inefficiency, its irrelevance to the world of *real* work, the diminishment of a common, academic curriculum, and the perpetuation of a class society.

While sympathetic to many of these positions, I would argue that short of sweeping institutional and societal changes, the elimination of vocational education would cause more harm than good – at least for this stratum of young student workers. Ceasing to offer programs such as COOP would not necessarily mean that students would enroll in meaningful and intellectually stimulating academic courses. Unfortunately, those courses are more myth than reality (Sizer, 1984). Furthermore, in a basically untracked school such as Woodrow, vocational education does not have to be an alternative to an academic education. As the choices of many of the COOP students demonstrated, a high-school schedule *can* accommodate the two.

There are also vocational students, some of whom enroll in

programs like COOP, who see traditional high school offerings 'as simply marking time, jumping hoops, and getting by' (Gaskell, 1981: 70). For them, eliminating a vocational choice would do little more than heighten their alienation, encouraging them to drop out all together. As Gaskell says:

> business courses are redeemed by their relationship to work, and especially by the work experience built into them. Any hope of giving courses new life for a substantial number of students depends upon integrating this clear vocational and therefore real focus and experience with academic skills in language, math, social analysis, science, etc. This is admittedly a delicate balance – to please employers and teach what are often routine work procedures, and to introduce skepticism, analysis, and basic skills. It depends upon dedicated teachers and a school system committed to intellectual goals. However, it is a more useful direction for reform and pressure than eliminating work as a focus for curriculum altogether (1981: 70).

Gaskell's argument is particularly salient in a world where women's work is becoming increasingly synonymous with office work. Moreover, cooperative education programs, by structurally linking school and work experience, have the unique capacity for legitimating work experience 'as valid curriculum content' (Simon, 1982).

What I will propose in this chapter is that cooperative education programs must use this curricular space to *educate* rather than merely *train* students about work. These educative practices, I would argue, have the power to help student workers understand, question, challenge, and eventually participate in the transformation of those relations in production they experience as oppressive.

Training for office work

What, then, is the difference between education and training? In *A Place Called School*, Goodlad itemizes a set of goals that could serve educators as a 'guiding framework for curriculum planning

199

and teaching' (1984: 50). The category of vocational goals comprises the following:

- learn how to select an occupation that will be personally satisfying and suitable to one's skills and interests
- learn to make decisions based on an awareness and knowledge of career options
- develop salable skills and specialized knowledge that will prepare one to become economically independent
- develop habits and attitudes, such as pride in good workmanship, that will make one a productive participant in economic life
- develop positive attitudes toward work, including acceptance of the necessity of making a living and an appreciation of the social value and dignity of work (p. 52).

A similar list is offered by Woodrow High School's State Department of Public Instruction under the heading 'Advantages of COOP to the Student':

- provides a realistic learning setting in which the student may assess his or her true interests and abilities
- develops a good understanding of employment opportunities and responsibilities through direct on-job instruction
- develops work habits and attitudes necessary for individual maturity and job competence
- provides a laboratory for developing marketable skills
- provides the student with a feeling of accomplishment.

Embedded in these statements is a training orientation, the goal of which is technical and utilitarian – to teach young workers how to do jobs for which they are naturally suited. Behind the human development language of 'personally satisfying,' 'economically independent,' 'individual maturity,' and 'good workmanship' lies a more basic, unstated goal: training on behalf of economic efficiency.

In and of themselves, these goals aim at little more than adapting students to existing relations in production, perpetuating the myth that every job is a personally satisfying career when matched with a worker of suitable interest and ability. If students believe the myth, school has legitimated the 'world-as-is,' creating (for capital) a relatively non-problematic school-to-work tran-

sition, a fit between a new generation of workers and the needs of the labor market.

When translated from goals to classroom practice, training takes the form of rote learning, drill, and the type of pre-specified, closed, task-oriented curriculum described in Chapters 6–9. As Blichfeldt (1976: 334–5) argues, these closed learning structures 'encourage submissiveness, a lack of ability to raise problems and a disability to work out solutions to new problems that may turn up.' They discourage cooperation, open discussion, joint effort, the testing of hypotheses, and tend to produce, in one union representative's words, 'nice little secretaries who won't make waves.' This, I would argue, is a role schools must forcefully reject since it removes curricular knowledge from 'the sphere of democratic discourse and shared understandings,' reducing it to

the application of technical rules and procedures. The result of this, combined with the fact that serious conflict is usually absent from the curriculum itself, is that instrumental ideologies replace ethical and political awareness and debate (Apple and Weis, 1983: 6).

Education for office work

The goals of *education* are quite different from those of training. Goodlad again provides a useful beginning. Academic goals for schooling in the United States, he contends, should include those fostering intellectual development:

- the ability to think rationally, including problem-solving skills, application of principles of logic, and skill in using different modes of inquiry
- the ability to use and evaluate knowledge, i.e., critical and independent thinking that enables one to make judgments and decisions in a wide variety of life roles – citizens, consumer, worker, etc. – as well as in intellectual activities
- an understanding of change in society (1984: 51–2).

Rather than reifying and legitimating the social world, education helps students perceive the changeable nature of their surroundings, analyze the forces and relations that create and

perpetuate particular social arrangements, and understand possibilities and strategies for change.

In relation to COOP programs, education would enable students to explicate aspects of work experience that are part of their taken-for-granted frame of reference, part of their common-sense stock of knowledge. Vocational *education* would encourage students to critically reflect on (interpret and reinterpret) their work experience (Simon and Weiss, n.d.). It would 'embrace the students' interests and experiences as a relevant starting point for learning,' and 'encourage students to critically question, rather than passively accept, their relations with the social world' (Gleeson and Whitty, 1976: 101).

In the words of Giroux:

> This means teachers would have to take seriously those cultural experiences and meanings that students bring to the day-to-day process of schooling itself. Making knowledge problematic becomes meaningful only if students are allowed to explore such knowledge within their own mode of knowing and understanding. . . . Students must be given the opportunity to learn how to use and interpret their own experiences in a manner that reveals how the latter have been shaped and influenced by the dominant culture (1981: 123–4).

Rather than being characterized by drill, rote-learning, and closed task structures, *education* could only occur when critical consciousness is fostered through an open-discussion, problem-solving, inquiry approach to learning. The problems to be solved would be derived from the students' experiences of the sexual division of labor, and the technical and social relations in production. This educative approach would offer students skills and knowledge not just to *do* their jobs, but to *think* about their jobs: their nature, purpose, construction, and the relations they embody.

In the course of my research I found that students were eager to discuss work-related issues, often spontaneously mentioning in class a problem which had occurred at the workplace the day before. When interviewed, students reinforced this finding:

'What I wish we would have done is discuss the work situations

we were in: problems we were having at work, whether they
were personal or whatever; what we liked about the jobs,
what we didn't like.'

'There were some problems I would have brought up in class.
There were times when I was getting too much shit work.
I'd get all the piddly stuff other people could be doing too and
they were working less hard than I was. I would get mad
because they were paid so much more than me.'

Student accounts of their COOP experiences could easily provide
the starting place for critical reflection on their roles as office
workers; two accounts which readily come to mind were United
Group's time lapsing system (described in Chapter 7) and the
more universal practice of women office workers serving coffee.

The time lapsing system would provide a strikingly concrete
example of employers' concerns for efficiency and productivity.
Students could tentatively explore why such systems might exist,
why United Group was so concerned about measuring the amount
of work that was done, why workers aren't necessarily as
productive as employers want them to be, what other systems
or practices are used by companies to encourage high rates of
productivity, how these systems or practices affect workers, and
what alternatives might exist.

The coffee-serving example would provide a similar entree –
this time into the area of gender relations in the workplace.
Students need to consider what this practice symbolizes, what the
consequences of such actions are, what alternatives exist and what
other practices symbolize gender relations (titles, nameplates,
office locations and styles). Students should be asked why they
think boys aren't in classes like office COOP, and when 'natural
law' explanations surface should be exposed to the fact that, not
long ago, office workers were almost always men. Their accounts
of the sexual division of labor should also be elicited: what jobs
men and women hold at their workplaces, why classification along
gender lines is or is not pervasive, why men tend to hold the
higher positions, and what type of gender politics subsequently
occur.

Conclusion

Skill development

This argument for an educative approach in vocational courses should not be construed as an argument against skill development, however. As indicated in Chapter 6, a good working knowledge of the production functions which constitute office work can give students self-confidence and increase their assertiveness. If school does not train students, it gives the impression that there is nothing else to learn or to do at work, that what they know by the end of COOP and what they've done at the end of their work internship represent the limits of job-related knowledge. This is particularly the case if class-time is not devoted to developing and learning new and useful skills. As Willis argues, discipline and rigor are still essential in vocational education since the working class cannot develop without 'disciplined skills in expression and symbolic manipulation' (1977: 193).

A few of the alumnae I interviewed had taken secretarial courses at the junior college level and could articulate aspects of skill training the high school could provide:

'We were stressing selling candy bars for the banquet too much. We could have done a lot more typing. We did too much filing. You don't need that much. It's not that hard: we had it in middle school. Grammar, grammar, grammar needs to be stressed. I think the business department could be doing some of that.'

Setting priorities (a practical form of problem-solving) was another learning experience this graduate thought COOP students could benefit from. In this instructional activity, the classroom teacher simulates an office day by giving students a variety of tasks, telling them the boss will be leaving early that day, and having them determine and justify the order in which they would do the work.[1]

Job analysis

Skill, or work knowledge, should not merely be *developed* in vocational courses, however. It should also serve students as a central concept in analyzing their jobs, the division of labor, and

204

the effects of automation on the office. Teachers should not assume that places of work invariably want students with the highest skill development, but should explore with students the advantages and disadvantages to employers of having a work force characterized by certain qualities and quantities of skill.

The concept of skill could, for instance, help students evaluate jobs on the basis of their educative value. This is an important pursuit since, as the Education Group of the Center for Contemporary Cultural Studies states:

> Skills are reproduced, or developed or modified through their practice. Jobs may therefore be judged by educational criteria too: how do they contribute, by exercise and by repeated activities, to the 'education' of the laborer? Do they extend and develop mental capacities, stimulate curiosity and muscular energies, produce practical and theoretical understanding? . . : What opportunities . . . does the job provide for the development of interests, of knowledge and of self? (1981: 146).

Students should discuss what they like and dislike about the work they are assigned; what they have learned from their work; why they think tasks are divided the way they are; who decides how the workplace is organized and what the reasons might be for those decisions; and if they can think of any way they would prefer work to be performed or distributed.

Having students analyze their own places of work in relation to their educative value and other pre-specified criteria would also help them gain insight into variations in working conditions, change processes, and controversial issues around which women workers have begun to organize.

In past years, Mrs Lewis had required the COOP students to do such an analysis in the form of a 'Training and Procedures Manual.' The manual was to include a history of the company, company benefits, working conditions (breaks, facilities, etc.), a floor plan, job description (title, work performed, qualifications, salary, equipment), and promotional materials. The manuals were reviewed by supervisors and, since their simulated purpose was the training of new employees, the students necessarily had to assume the conservative position of company spokespersons.

Instead of this type of description, a more educative project

would be to have students analyze their work sites on policies regarding health and safety, automation, wages and benefits, and job rights.[2] Basic rights guaranteed by Title VII of the Civil Rights Act of 1964, the Equal Pay Act, the National Labor Relations Act, and state and local laws and ordinances could be discussed and used as evaluative criteria. 'The Bill of Rights for Women Office Workers,' distributed by the National Association of Working Women could also be explored for useful criteria.[3] The bill contains rights to:

- respect as women and as office workers
- comprehensive, written job descriptions
- compensations for overtime work and for work not included in job descriptions
- choose whether to do the personal work of employers
- defined and regular salary reviews and cost-of-living increases
- maternity benefits and having pregnancy and other gynecological conditions treated as temporary medical disabilities
- benefits equal to those of men in similar job categories
- equal access to promotion opportunities and on-the-job training programs
- choose one's lifestyle and to participate in on-the-job organizing or outside activities which do not detract from the execution of assigned tasks.

These statements could be examined for their relations to federal, state, and local laws, and their applicability to and implications for specific workplaces. Students should be encouraged to assess and discuss their desirability and what changes in the workplace their adoption has made or could make. The right to 'benefits equal to those of men in similar job categories,' for example, opens the possibility of examining point factor job evaluation plans, which attempt to assess jobs on the criteria of skill, effort, and responsibility. Other rights might evoke discussion of doing 'personal favors' for superordinates, experiences of sexual harassment, and opportunities for advancement.

Another topic that should be included in a workplace analysis is the problem of stress. In a 1975 study the National Institute of Occupational Safety and Health found that secretaries had the

second highest incidence of stress-related diseases of workers in 130 occupations. A later study (1979–80) found stress levels among women video display terminal operators

> the highest of any group of workers NIOSH had ever studied. . . . The chief causes of stress named in surveys were lack of promotions and raises, low pay, repetitive and monotonous work, and no input into decision making (*The Working Women Newsletter*, vol. 4, no. 3, May/June 1981).

Students should therefore be encouraged to report on those workplace factors associated with stress: the environment (noise, lighting, temperature, skin irritants, ventilation, furniture design, space); job design (work pace, control over time and work, specialization and routinization of tasks); employer/employee relations (level of respect, support of boss, number of bosses, grievance procedures); and socio-economic factors (pay, advancement opportunities, job security, incidents of discrimination, childcare facilities). Knowledge of these factors is an essential first step in empowering students to safeguard their physical and psychological wellbeing.

In addition to such pre-specified criteria should be criteria suggested by the students themselves. Following the lead of the National Association of Working Women, the COOP students could then rate employers on specific factors and identify what they regard as the best and worst policies of their employers.[4]

Work issues

Although, as I have indicated, a number of office-related issues were considered legitimate topics for discussion by Mrs Lewis, the content was often presented with a conservative bias and the curricular form generally precluded much thought, discussion or analysis. That need not be the case.

As just one example, magazine articles like 'Why Secretaries are Paid Unfairly' can be used as a basis from which to begin the process of demystifying the pay-productivity relationship and to legitimate exchange relations as issues in which workers have a right to be involved. As the ethnographic data indicated, issues on pay, equity and comparable worth were raised only peripher-

ally, were often avoided, or gave students the impression that their wages were indicative of employer generosity or a reflection of qualifications.

Rather than using slogans such as 'a fair day's pay for a fair day's work' as an ideological tool to train students to be docile, productive workers, it and other slogans could be used to stimulate inquiry about pay-related issues in which clerical workers are currently involved.[5] Students should be encouraged to consider such problems as:

- why unionized clericals earn more than non-unionized clericals
- why union organizers have found 'equal pay for work of equal value' to be a more adequate argument for increasing the pay of clerical workers than 'equal pay for equal work'
- why occupational segregation and wage disparity have increased since the passage of sex discrimination laws and regulations
- why a full-time woman worker averages 59c to every dollar a man earns
- why female clerics are paid only 63% of male pay even *within* the clerical category
- why factory workers earn more than office workers when, at the turn of the century, clericals earned twice the wages of production workers
- why VDT operators earn more than typists in some cities and less in others (even though their rate of production is higher).

Such questions would present pay as a public, not a private, matter and 'fair' as a socially determined, not a natural, concept. They could also serve as an introduction to the current debate on comparable worth.

Instructional tasks of the sort I have described here would serve to sharpen students' skills in observing and articulating the nature of their work, legitimate their right to discuss job conditions, and, in Willis's words, illuminate the *social* (rather than the individual) power of knowledge (1977: 190). By discussing workplace issues, by sharing problems, insights and ideas, students can begin to experience the potential of their collective strength.

Conclusion

Embracing the conception of vocational education I have presented in this chapter will be no easy task for COOP teachers since educational goals are not just supplementary to vocational goals but are, in many ways, in actual opposition to them, an opposition created by an economic system whose accumulation needs place value on 'capital resources at the expense of human resources' (Grubb and Lazerson, 1975: 472). Employers want trained workers, those who will acquiesce to workplace demands. Educated workers, those who have been taught to critically reflect on personal experience, are not always so willing to bend to productivity and efficiency demands. But since cooperative education programs are structurally linked to workplaces, COOP teachers are in a prime position to disclose and legitimate the proper educational relationship between school and the workplace.

Training COOP students to be docile, deferential and unquestioningly loyal workers is not the proper function of schooling and is of little service to prospective office workers who will soon have to cope with daily struggles as real workers. These young women have a right to expect the school to at least acknowledge that 'office trouble-makers' can be bosses, not just co-workers, and to help them learn how to strategize about their relations with them. They have a right to hear not only from career counselors who teach them how to use their sexuality *to get* jobs, but from union representatives who can help them learn how to use their skills *to negotiate* jobs and working conditions. They have a right to learn not only about the labor-saving features of new office technologies, but about some of the concerns and potential hazards that have been voiced about them as well.

Without access to the type of information and questions suggested here, students would remain mystified by their own limited experience (as evidenced by their discussions with me about pay and the sexual division of labor). Since employers often deliberately withhold certain types of information, the school must give students access to organizations, sources, and modes of thinking that empower them to gain control of their work lives. It must give them the tools they need to critique their work and working conditions. While this critical conception of school

Conclusion

knowledge cannot, of course, in and of itself transform either education or society, it is surely 'an essential first step' in generating more emancipatory practices (Apple and Weis, 1983: 18).

Methodological appendix

This appendix offers the reader interested in the intricacies and problems inherent to a field-work approach a more specific account of the procedures I employed as a researcher. The appendix describes the process of problem definition, the problem of entree to a field site, methods used to collect, record, analyze and report data, and research limitations.

Definition of the problem

In keeping with the ethnographic tradition of allowing questions for study to emerge and evolve in the field and of developing 'instruments, codes, schedules, questionnaires, agenda for interviews, and so forth' as the *result* of inquiry (Spindler, 1982: 6–7), I attempted to formulate the initial research proposal just coherently and thoroughly enough to guide me through the initial stages of the field work and to obtain official permission from school personnel to undertake the study.

Since my interest in vocational education stemmed partly from a concern with issues of equality of educational opportunity in a class society, the way I initially focused the research proposal was strongly influenced by the literature on the relationship between social class background, school and work (Bernstein, 1975; Bowles and Gintis, 1976; Kohn, 1969; Lazerson and Grubb, 1974). But my growing realization of the pervasiveness of the sexual division of labor and the continued stratification within schools along gender lines made it immediately evident that gender would prove to be an even more relevant dimension in explaining why and how women prepared themselves for office work (Davies, 1979;

Epstein, 1970; Kanter, 1977; McRobbie, 1978; Rubin, 1976; Sharpe, 1976; Smuts, 1959).

The specific manner in which I formulated my basic research question was undoubtedly influenced most by Paul Willis's research problem in *Learning to Labour*. He frames the problem in the following manner:

> the difficult thing to explain about how middle class kids get middle class jobs is why others let them. The difficult thing to explain about how working class kids get working class jobs is why they let themselves (1977: 1).

Although Willis's 'lads' were a group of British, working-class boys whose cultural orientation was in opposition to a conformist school culture and the students I would be studying were North American girls, mostly working class, whose cultural orientation was much more integrated into school culture, Willis's analysis was the clearest guide I had in formulating my research approach. He utilized the concept of social class in a cultural rather than an economistic manner and analyzed the influence of school on job choice by studying the interactions between ideology and culture. He even regarded gender relations, in the form of a masculine glorification of manual labor, as an essential element of his analysis.

With this literature as a backdrop to my own work, my initial research question became: 'why are particular high school women preparing themselves for secretarial positions, where entry-level jobs are widely reported as highly dissatisfying, rather than some other type of work?' The limitations of this question should have been immediately evident to me, but they were not. It was not until I was well into the field work that I began to appreciate the diversity of reasons with which the students approached office work preparation; I had expected the same cultural homogeneity reported in the lads. I also presumed that since I was aware of office workers' dissatisfaction with their jobs, that high school students would have that same awareness. Such was not the case. In fact, despite the reading I had done, (Aronowitz, 1973; Braverman, 1974; Beynon and Blackburn, 1972; Davies, 1979; Kanter, 1977; Kusterer, 1978; Langer, 1972; Mills, 1956; *Work in America*, 1973) my initial observations at the work-sites and the interviews

that followed made me aware of the limitations of my own understanding of office work and relations.[1]

But the greatest limitation to the question can be seen in the fact that it is basically dispensed with in Part II of this book. It too narrowly focuses on issues of access and entree, failing to address questions of worker consciousness and identity, failing to explore what type of workers the students become and why. So I had to broaden the question by asking not only why these students were in the program, but what they were learning from their experiences and relationships about the role of women at work, particularly clerical work, and what effect this learning had on their further occupational orientation. I assumed that the primary contexts in which they would learn about themselves as workers would be family, school and work. I did not presume, however, that the messages conveyed through these contexts would be consistent or non-problematic. I was prepared to look for ways in which messages about women workers confirmed or undermined one another and how the students dealt with these messages.

The questions I originally articulated for myself fell under four (what I then called) dimensions: family, gender, school and work. Under the family dimension I wanted to know, for instance, what parents conveyed to these students about their own work and marital experiences and how these messages influenced the students. Under the gender dimension, I was interested in discovering whether or not the students perceived clerical work as women's work, how they perceived sexual subordination, and whether or not they accepted such a world. Under the school dimension, I wanted information regarding tracking mechanisms, the students' participation in the formal and informal aspects of school life, and how school experiences corresponded or failed to correspond with work experience. And, lastly, under the work dimension, I was interested in finding out if the students viewed work as temporary jobs or as careers, how they integrated work roles with roles as wives and mothers, and what work factors attracted or disillusioned them.

I knew that the best way to answer these questions was not always by directly asking them. As Bourdieu (1977: 167) has stated so succinctly, 'what is essential goes without saying. . . .' Subjects' awareness of themselves and their culture is often implicit or tacit (Spindler, 1982: 7). Or, as Willis says:

Direct and explicit consciousness may in some senses be our poorest and least rational guide. It may well reflect only the final stages of cultural processes and the mystified and contradictory forms which basic insights take as they are lived out. Furthermore, at different times it may represent the contradictory moments of the cultural conflicts and processes beneath it. In this, for instance, it is unsurprising that verbal questions produce verbal contradictions (Willis, 1977: 122).[2]

So to answer many of my evolving questions, I had to draw close enough to the day-to-day activities of the students to see how these various issues were played out in their lives. I had to be attentive, through observation, conversation, informal and (toward the later stages of the field work) formal questioning to matters of appearance, friendship patterns, language regarding school, work, and marriage, etc. In short, I wanted to understand the development of culture within particular structural and institutional arrangements, utilizing a methodology with a long and distinguished tradition in both sociology and anthropology.

This tradition, of course, implies a somewhat special or privileged perspective on the part of the ethnographer. Homans (1950: 6) captures the sense of this perspective when he states that it is the task of the social scientist 'to make the commonplace strange by showing it in new connections.' Gans (1967: xxvi) makes a similar claim: 'if sociology has discovered anything, it is that often people do not know all they are doing or what is happening to them. The observer always sees more than anyone else, if only because that is his job. . . .' Part of the observer's job, part of what makes the observer an ethnographer, is that *seeing* is informed and conditioned by 'knowledge of existing social theory' (Wilcox, 1982: 458). While this knowledge obviously functions to limit as well as to inform perception, the fact remains that it is intrinsic to the ethnographic process. Ethnographers do not merely describe cultures, they *construct* cultures out of what they (choose to) observe (Wolcott, 1982: 87). I have attempted, therefore, to be self-conscious about the research process, trying to account for the act of 'construction' within the analysis.

Entree

In the early stages of the research, I decided to limit my agenda to a case study. This decision was made for both pragmatic and theoretical reasons. On the practical side, an attempt to analyze more than one cooperative education program seemed foolhardy. Since an ethnography of a COOP program required observations not only in the classroom but at numerous work-sites, including more than one program would have severely limited my time at each site, diluting the quality of field relationships and data. As Spindler (1982: 8) has said:

> ethnographic inquiry by its nature focuses on single cases or at most on a limited setting of action. . . . Ethnographers also usually feel that it is better to have in-depth, accurate knowledge of one setting than superficial and possibly skewed or misleading information about isolated relationships in many settings.

On the theoretical side, as Burawoy (1979: xv) claims, the analysis of a single case study has the benefit of illuminating the relationship of 'mutually interdependent parts' of the social formation and thus producing a picture of the whole. Had I chosen to compare various cooperative office education programs in different schools I would have been able to distinguish systematic from idiosyncratic processes in the school more accurately, but I would not have had the opportunity to intensively analyze linkages between the school, the students' cultures and office labor processes. Moreover, being conscious of the research problem of 'generalizability,' I chose a school setting that would not be 'markedly dissimilar from the other relevant settings' (Spindler, 1982: 8).

Gaining access to a school proved to be no simple task. My primary criterion for selecting a school was that it be comprehensive in nature and service a broad socio-economic spectrum of students, since such a school would be most characteristic of American high schools in general. The school also, of course, had to offer a cooperative office education program. I had previously made some contacts in a school that satisfied these criteria and so decided to pursue official channels for research clearance.

Since I intended to conduct my research over a full academic

215

year, following seniors through their entire cooperative experience, I thought I had the summer months to contact the school office, meet with the teacher, gain some knowledge of the way in which cooperative education was implemented, etc. I discovered late in April, however, that to gain clearance for September I had to have a prospectus of my research proposal approved by a joint school district/academic committee at a meeting scheduled for early May. Since my research proposal was not yet written, I was forced to quickly formulate my ideas.

In the prospectus, I stated that I would be exploring questions related to school attitudes, job satisfaction and work productivity, noting that I expected not only individual attitudes and work orientations but the structure of jobs as well to play a significant role in the students' transition to work and that I might have recommendations to make with regards to both the type of education the students were receiving and the nature of their jobs. As such, my prospectus, which was approved without reservation, was honest and straightforward. But it was written specifically for an audience of school practitioners with the aim of gaining official approval. Totally missing from the prospectus was any sense of theoretical orientation. Since I did not expect this more abstract and theoretical aspect of my analysis to be relevant to the committee reviewing my research agenda, it seemed reasonable to eliminate it from consideration. My theoretical orientation did, however, eventually become an indirect problem in my relationship to Mrs Lewis.

A problem I was first to confront, however, was that of time. Once my prospectus was cleared, I was given the name of a school district official who would process my request. This individual proved to be not only difficult to contact, but, more critical to my work, unwilling to solicit Mrs Lewis until the fall semester actually began. Not wanting to jeopardize my relationship with the school district I decided to accept that timeline. While this delay did no irreparable harm to my research, it did prevent me from participating in an important aspect of the program, home visitations.

During the summer, Mrs Lewis visited the homes of the students to explain to their parents what the cooperative office education program was about and to obtain their approval of their daughters' participation in the program. Mrs Lewis told me in the fall she would have been happy for me to accompany her on these visits

had she been aware of my research interest at the time. These visitations would have helped me obtain information on Mrs Lewis's characterization of the program and on parents' reactions to it, and would have provided me with a natural introduction to the students' families. Lacking such an introduction, I was unable to gain systematic and direct access to families at any point during my field work. So, unlike my knowledge of school and workplaces, which came from first-hand observations and conversations, my information about families and family relations became totally dependent on what Mrs Lewis and the students told me.

Once I was permitted to introduce myself to Mrs Lewis, however, she proved to be an invaluable source and contact, much like William Foote Whyte's Doc of *Street Corner Society*. She introduced me to teachers, students and business people, allowed me to sit in on any of her classes, told me how to go about getting documents and permissions I needed, and brought me to meetings with supervisors who eventually gave me access to do field research in their offices. If Mrs Lewis had not established positive and trusting relations with these work supervisors herself, my research would have been severely curtailed.

Unbeknown to me, Mrs Lewis had received a copy of my research prospectus so she could decide whether or not she would participate in the field work. Something in that proposal, probably the focus on women in the work force, or in my mode of self-presentation, indicated to her that I was a feminist. Thus, within a week of our acquaintance, she had characterized the two of us as kindred spirits, as women who were both concerned about women's rights and equality in the workplace. She said that she herself was quite a vociferous spokesperson for the women's movement and that it was very interesting that a person like me managed to hook up with someone like her.

This identification seemed to establish the trust between us that ethnographers invariably indicate is an essential component of good field work (Gans, 1967; LeCompte and Goetz, 1982; Metz, 1981; Schatzman and Strauss, 1973, Whyte, 1943). But as Schatzman and Strauss warn, 'entree is a *continuous* process of establishing and developing relationships' (p. 22). Blunders and errors can strain relations and close off a field site, at which the researchers are guests only if they maintain friendly relations with

the hosts. I was to commit such an error of judgment with Mrs Lewis as the research progressed, an error I will briefly describe.

Although Mrs Lewis and I had some common meeting ground (I had also been a high school teacher and, like Mrs Lewis, thought of myself as a pro-union feminist), I did not always agree with her about social issues or educational procedures. Being conscious of my status as a research guest, whose invitation to study the cooperative program could easily be revoked, and being personally less assertive than Mrs Lewis, I began to develop an overly withdrawn presence as a way of coping with potential conflicts that could arise. This silence produced a growing sense of unease in Mrs Lewis who, at one point, in front of a supervisor and in a jesting tone announced that I had not shown her any of my field notes but that that was all right since she could sue me if she did not like what I wrote. After a time, once Mrs Lewis and I had re-established a more trusting relationship, she told me there had been a period during the year when she had questioned whether or not she had done the right thing in agreeing to the study, saying, 'I felt as though it was a very vulnerable position I had put myself in and there had been times in the past when I put myself in a similar position and had been hurt because of it.' Part of this feeling of vulnerability and distrust might have been avoided had I been more verbal and shown Mrs Lewis some of my writing as the year went on. I was, however, afraid to take that risk, knowing she had absolute control over the continuation of my research. My fear, of course, was that she would so strongly object to a theoretical orientation she perceived from the proposal or would object to what was a mere speculative statement, that she would tell me I was no longer welcome in the class. By avoiding the problem of revealing too much, I perhaps created the worse problem of revealing too little and endangering my position that way.

Despite this period of strain, Mrs Lewis gave me access to all the persons, places and documents I needed throughout the year. She allowed me to observe all of her classes, explained how to go about gaining entree to other teachers' classes, how to contact graduates of the program, and introduced me to the group of students and supervisors with whom I would be most directly involved.

On the first day of class, Mrs Lewis introduced me to the COOP

students as a guest from the university who would be spending most of the year with them and said that I would like to tell them why I was there. My explanation was informal and went something like this:

'I am doing a study about high school students in office education programs. Mrs Lewis has generously said that I could study the COOP program here at Woodrow High School. What I'm interested in finding more about is why you, the students in the program, have chosen this particular program, this occupational direction – what went into your decision and how you're thinking about your future – what you'll do once you're out of high school. So I would like to be able to talk to each of you from time to time and also be able to go around to your classes and your place of work with you to see what it's like.

'I have a form letter that I'd like to distribute. If you agree to be part of the study there's a place for you to sign at the bottom. Since most of you aren't 18 yet, there's a place for your parents to sign as well. I would appreciate it if you did sign these letters and return them; it would be very helpful to the study. And you don't need to feel that once you've signed this you're totally committed. You can participate as much or as little as you want to. If you don't feel like talking to me one day or any more at all you don't have to, or you can tell me if you don't want me to go to your workplace with you. If you have any questions you can ask them now or as they come up. And if you're not sure if you want to sign the letter now you can always do it later in the semester.'

Not surprisingly, there were no questions at that time. Although a few students turned in their permission slips the next day, most took several reminders and two students never turned one in at all. Moreover, it was apparent from questions they asked, even towards the end of the year, that my introductory explanation indicated very little to them about what I was doing there. Personal conversations proved to be far more effective in establishing the relationships necessary to obtain information. Still, this introduction by Mrs Lewis and my orienting remarks about 'doing research' were necessary to legitimate my presence in the class-

room and my questioning the students. These steps were also essential in my research relationship with the supervisors and in gaining access to workplaces.

This utilization of authority figures for purposes of access to organizations and subordinates is a matter of some debate among field researchers, however. Schatzman and Strauss (1973: 20), for instance, claim that working through official channels is essential

> to negotiate entry into the farthest reaches of the organization. To do otherwise is to invite angry challenge at a later point, and ejection from the site. Even if the chief is not in general favor, all persons in the organization will understand that the researcher could not otherwise have gained authorization. Once authorization is gained, the researcher symbolically disengages himself from the leadership in order to establish his independence.

Kusterer (1978), on the other hand, questions whether it is possible for researchers to 'symbolically disengage' from authority figures and recommends unobtrusive or underground research techniques to gain access to subordinates and to protect informants from potentially harmful consequences of their participation in the research. As Kusterer concludes, this research approach might be more necessary for social scientists 'who take a conflict perspective of the way organizations are run' than for those who operate out of a consensus model (p. 18).

From my limited experience in the field I am inclined to agree with Schatzman and Strauss that official permission should be obtained if possible. Without it, freedom of movement within organizations is greatly curtailed. Kusterer, for instance, was forced to base his analysis primarily on extended interviews rather than on a combination of observation, casual conversation and interviewing. Moreover, it does seem possible to disengage oneself from authority figures. While this feat requires a certain amount of skill in human relations on the part of the field researcher, it is generally accomplished in two ways: by balancing the amount of time spent with the various subjects in the study, and by expressing genuine concern in hearing all sides to the story.

Kusterer's concern about protecting subjects can generally be accomplished by guaranteeing confidentiality and anonymity, and by carefully filtering the way in which information is given back

to authority figures. My own conflicts with Mrs Lewis and my struggles in deciding how to write the final account of the study have made me appreciate Kusterer's ethical concerns. One way I have partially resolved this dilemma is in giving a very generalized account of particular events when, in my judgment, more specific information could prove harmful to the persons involved. I have also, of course, utilized the convention of pseudonyms and have deliberately obscured specific identities when they were irrelevant to the analysis.

Collecting the data

Depending on the opportunities and research needs at the time, my research style was variously situated on the continuum between non-participant observer and participant observer.[3] At times I sat in the back of the classroom and merely took notes on my observations; at times I talked with a student or a small group of students; at other times I attempted to do the same classroom activity they were given, or took notes on the curricular materials. At the work-site I would more often than not merely observe what tasks composed the students' work role and ask clarifying questions about the nature of the work. If I understood the work before the end of the observation period and if it were opportune I asked broader questions about the organizational structure, social relations, supervisory style, the student's work attitudes, etc. If it was not opportune I waited for a more formal and secluded interview time.

During the fall semester, Mrs Lewis taught two sections of Office Procedures, the junior prerequisite to the Cooperative Office Education class. I observed the section during the third period of the day in hopes of learning three things: what the teacher perceived to be the cognitive and non-cognitive skills office workers should have; the office skills and knowledge the current COOP cohort should have since, other than a year of typing, this was the only required business class for entrance to the class; and the range of jobs within the general category of office work. My primary interest, then, was in the class content so that I could develop a broader understanding of the program. I made no attempt to interview the students in this class.

By contrast, I observed the senior-level Cooperative Office Education class not only to analyze the nature of office preparation in relation to the demands of the workplace, but to establish rapport with the students in the class as well. Consequently, I was much more actively engaged in conversations in this class than in the junior level class. But since I did not want to disrupt the normal activities of the class I still often sat in the back of the room, taking notes on the curriculum as it was presented and on how students were spending class time.

This arrangement proved to be satisfactory from a research point of view. Although some of the students apparently viewed me as a student teacher or some sort of teacher surrogate since they would ask for help on an assignment or for permission to go to the bathroom, for the most part, they took my presence for granted. I say this with a certain amount of confidence because my 'adult' presence in the room did not deter activities students engaged in like cheating, yelling, complaining, sneaking out of the class early or flinging textbooks around when Mrs Lewis was out of the room.

In addition to the observations in these two classes, as the year went on and the students and I got to know each other better, I asked four of them if I could spend a week going to all of their classes and activities with each of them. This gave me an opportunity to see the COOP program in relation to the broader context of the school program, to establish better and more extended rapport with the students, and to understand more fully the students' relationship to the formal and informal structures of the school. I was careful to select students from various sub-groups who had different structural relationships to the school. I was, however, somewhat limited in my selection since not many of the students felt comfortable with such a close and extended research relationship. Although I spent most of my out-of-class time with these four students, I did have lunch (either in or out of school) with most of the other students and went to extra-curricular activities, meetings and assemblies with some of them. In short, I tried to be around as much as possible without making myself a nuisance.

This was not an easy task, since I did not look like a high school student. Although I tried to affect an image mid-way between teacher and student (never wearing skirts but seldom wearing

scruffy jeans), my greying hair was an immediate give-away. Since, as Metz describes in *Classrooms and Corridors*, certain school areas, such as bathrooms, lunchrooms, and lockerrooms, are clearly designated for adults or students only, my presence in these areas often drew attention to the students I accompanied. Because this was sometimes awkward for them, I often chose not to accompany them certain places. It was much more acceptable to have lunch with Mrs Lewis in the teacher's lounge, for instance, than to eat with a student in the cafeteria.[4]

My direct observations of the students at their workplaces were limited to one afternoon apiece at most of the sites. With some students, however, I was able to spend between two to five days at work. This was helpful, since some of the work was too complicated or too varied for me to obtain a full understanding after one visit. Some of the students were also rotated in their department or company during the course of the year and I was able to follow this job rotation.

In addition to these direct observations I had occasion to indirectly observe at each of the work-sites four more times through the year since I accompanied Mrs Lewis to her evaluation meetings with each of the student's work supervisors. These meetings gave me information about Mrs Lewis's and the supervisors' perceptions of the students, the workplaces, and the COOP program.

The people I formally interviewed during the course of the year were Mrs Lewis, the present cohort of COOP students, and select alumnae of the program. From Mrs Lewis I was able to learn something of the history of Cooperative Office Education in general and its specific implementation at Woodrow High School. She told me about her own professional development and interest in teaching the cooperative program, the way she taught the class and why, and her perceptions of the various students and workplaces. Since Mrs Lewis was the person with whom I spent most of my time, the conversations extended throughout the year. Besides answering my questions, Mrs Lewis often volunteered information she thought I might be interested in but would have no way of knowing about if she did not initiate the dialogue.

Early in the field work, I made the decision not to limit my association to any one sub-group of students and not to become overly identified with either the teacher or any particular student.

Methodological appendix

I made this decision because, first of all, there was only one major sub-group in the class, the 'socies.' They were the popular group or 'in-crowd': the cheerleaders, student government leaders, the attractive girls. Since there were divisions even among the six of them, I doubted that acceptance by one or two would mean acceptance by the group. More centrally, I feared it would cut me off from rapport with the rest of the class. Besides, I doubt that the group would have accepted me: I was too much of an adult. They were into boyfriends, popularity and social activities; I definitely would have cramped their style.

Nor did establishing too close a relationship with one student (or a twosome or threesome) early in the year seem wise. The limited amount of interaction among the students made me suspect they either did not know each other very well, did not associate with one another, or did not like each other. Close association with any one person or group could well have made access to another quite difficult. This was a chain of events I wanted to be sure to avoid, since there was a great deal of variation in the room in terms of students' interests, backgrounds, work, and future orientations. I decided to focus on breadth instead of depth, gathering information from as many of the students as possible at first and then returning for additional information if necessary.

This turned out to be a fruitful approach. Every student in the room allowed me to observe them at their work-site and to attend the four evaluation meetings with their supervisors. Fourteen of the sixteen agreed to formal interviews and fourteen agreed to let me go through their files.[5] Two students did not turn in their parental permission forms and, although both students spoke at length with me and I think would have agreed to let me see their files, I simply stopped asking. The information was not critical to the study and, after having reminded them several times, I did not feel justified in pursuing the matter.

In addition to the sixteen students, I interviewed seventeen alumnae: ten from the previous graduating class, two from 1979, two from 1977, and one each from 1976, 1975, and 1972. I attempted to get somewhat of a representative sample of 'types' of COOP students and when I showed my list to Mrs Lewis she assured me that I had succeeded. Before I started to contact the graduates Mrs Lewis had gone over names with me and told me

224

a bit about as many of the students as she could so I would have something to base my selection on.

Since part of my selection rationale was to elicit a reaction to the experience of going through a co-operative education program I wanted to interview former students whose recollections would be quite fresh: hence the ten 1980 graduates. The remaining seven were from 1972–79 because I also wanted to gather some data on women who had been working for a while, particularly those who were married and had children. These women were particularly hard to locate since married women generally change their last name and temporarily drop out of the work force in order to raise families. Only three of the alumnae I interviewed were married (two others were engaged) and only two had children. I stopped at seventeen alumnae interviewees because I began to hear the same type of information. To interview more women would have elaborated the research findings, but would not have altered them in any significant way. From the information I collected during these interviews I was assured that my presence in the classroom did not significantly alter what I observed going on there.

My formal interviews with both the students and the alumnae focused on four general areas: their family backgrounds, their experiences in and impressions of their school experience and their work experience. The interviews often began with the question, 'How did you happen to take the COOP program?' Although the interview format was quite open-ended and I consciously followed the leads of the interviewees in terms of pursuing those areas which were obviously salient to them, I had the same types of questions in mind for all the interviewees and almost always was able to elicit information from them. The most important questions were:

What have you been doing since graduation?
How did you feel about working at. . . ?
What did you most like or dislike about it?
How did you feel about the classtime part of the COOP
 program?
Did you learn what you expected to learn?
If you had the chance to do your senior year, or your high
 school years over again, would you do them the same?
Why do you think there were no boys in the class?

225

Is there any type of work you can not imagine doing?
What type of work would you most like to do?
Would you work if you had children?
What do your parents (older brothers/sisters) do?

The last research technique I utilized during the field work was the collection of relevant documents. As I mentioned, most of the students had given me permission to peruse their student files. From them I obtained information on family background, the results of IQ and standardized achievement tests, and information from report cards as far back as kindergarten (i.e. grades, teacher comments, absences). I also collected forms that were used in conjunction with the COOP program (such as the student's formal contract with her place of work) and examples of any curricular materials that were handed out in class. Whenever feasible I also availed myself of items like student newspapers, parent newsletters, or programs from extracurricular events.

Recording the data

Ethnographers often find themselves plagued with the question of what to do with their hundreds and sometimes thousands of pages of field notes. If tape recorders are used during the interviews the problem is compounded. Although mechanical devices are often recommended by field methodologists as a means of rendering the most comprehensive account of an observation or interview and, thus, of enhancing the internal reliability of the analysis, they generally acknowledge the inescapable dilemmas of collecting massive amounts of uncoded data that are themselves selections and abstractions from the actual event (LeCompte and Goetz, 1982: 42–3).

I used a tape recorder for only four interviews. While I did find the technique beneficial in capturing the richness of the interviewees' spoken word and in preserving the exact way in which I formulated a question, the drawbacks far outweighed these benefits, and by and large I abandoned this procedure. First of all, despite certain ethnographer's claims, I did not find that interviewees were comfortable with a tape recorder. The machine gave a formality to the event that I felt jeopardized the establishment

of a comfortable and confidential atmosphere. A recorded voice is somehow much more public than a conversation during which one person happens to be taking notes. Moreover, I found that even without shorthand, I was able to record interviews almost verbatim without slowing down the natural rhythm of the conversation. When it was necessary for me to summarize statements or when I only had time to jot down key words I found that my memory was quite vivid and reliable.[6]

I was amazed, however, at how often I could take fairly comprehensive notes, even during periods that were primarily observational, without drawing the attention of the people in the room. I attribute this phenomenon to the fact that in most of the research settings (classrooms, evaluation meetings, offices) many of the people around me were also using paper and pencils to perform their tasks. My activities blended into the natural flow of events fairly well. When they did not, I was careful to put my recording devices away. I was also careful to flesh out sketchy observation notes prior to the next period of observation, and to type out interview material before another one took place. Had I not systematically followed this routine, my recollection of the events would have been much less precise.

My field notes fell into three main categories. On large note cards I recorded material that was primarily observational in nature. Observations of classroom activities were recorded chronologically and classified under the class name. Observations that were about particular students or Mrs Lewis were also kept chronologically, but were classified under the student's or teacher's name.

On loose-leaf size paper I kept typed accounts of each interview. These accounts were about ten pages in length, single spaced and were classified under the student's, graduate's or teacher's name. Most often I typed the interviewee's remarks in the first person and left out the questions that solicited the remark. I only deviated from this pattern when the question was out of the ordinary. Although this procedure of leaving out the interviewer's role in the conversation is not generally recommended by methodologists (since the way a question is phrased has direct bearing on the response) I found this procedure helpful in accurately reconstructing the interviewee's response. When I attempted to record the actual question/answer format of the interview, moving back

and forth between my voice and her voice, I was less able to reconstruct the language of the interviewee. So, for the most part, when typing the interview, I ignored my role so I could take on, so to speak, the role of my subjects. Had my interview schedule been less standardized, this might have been a problem, but since my questions were written down, and since I did note important deviations from the standard format, I believe I have an accurate account of my activities as interviewer.

In this folder of interviews, I also kept my records of supervisor meetings. My notes from these meetings, at which Mrs Lewis questioned the supervisors about the students' work performance, were taken directly on the evaluation form during the meeting and filled in later in the day. Since my role was largely passive at these times and since Mrs Lewis also took notes during the meetings, I was generally able to keep a running account of the dialogue.

The only other type of information I kept in my field notes was insights or inferences I was drawing as the result of the data I was collecting. These second-level constructs, in Schutz's language, were clearly marked off from the observational or interview data. If I were recording the event at the typewriter, I tended to both capitalize my interpretive comments and enclose them in parentheses. If the notes were hand-written, I again used the bracket technique and flagged the comment with a conspicuous star.

Analyzing the data

Although I was prepared for the research to be a dialectical process, with data and theory mutually informing and transforming one another, nothing I read quite prepared me for the complexity and uncertainty that accompanied every step of the analysis. I painstakingly reviewed my field notes on three separate occasions, taking notes from the field notes, and went through four or five major reorganizations before making a final organizational decision. First I thought issues of access and ideology would be the central organizing concepts. Then I briefly considered organizing the data around issues of differentiation and homogenization: what some students receive as contrasted with what they

all receive. But when I realized I could handle this issue under the first organization I abandoned the idea.

Then I became intrigued with the notion that there are ways or times in which gender issues are central to the labor process and times when they are peripheral, so I began thinking in terms of an organization that looked at education for raw labor power and education specifically for female workers. But when I found these categories too artificial a distinction to work with well, I went back to my original categories, carefully studying the notes I had taken from my field notes to look for dominant ideological categories and ended up writing a very rough, 150-page, ten-chapter draft in which there were basically five content chapters: selection and stratification mechanisms, stratification ideologies, ideology and femininity, ideology and individuality, and learning productivity. But this draft failed to meet my satisfaction for three reasons.

First of all, once again there was the problem of the data refusing to fall neatly into my categories. This was particularly evident as I wrote the chapter on individuality and found myself going on for pages about productivity. Secondly, for a long time, the notion of an as-yet-unwritten chapter had been floating around in my head. I tentatively called it 'Education and the Rationalization of Office Work' and it was to treat issues of skill development (which I juxtaposed with ideological preparation) in relation to organizational and technological changes that have been occurring in offices. And third, I felt my entire formulation of the problem was theoretically deficient, that I had become overly dependent on the data to control what I wrote and was underutilizing the relevant literature.

With this last realization I began re-reading the books and articles that had informed my progress thus far and discovered that implicit in what I had already written was the sense of schools as reproductive of labor power: a concept explicit in my proposal but abandoned in the initial stages of analysis because of its high level of abstraction. With that insight I further realized that the concepts of the allocation and reproduction of labor power would serve to organize my study in a manner that was both the most inclusive of my data and the most comprehensive of the extant theories. My chapter on selection and stratification mechanisms turned into the chapters on the reproduction of the division of

labor; the unwritten chapter became the reproduction of the technical relations in production; and the four separate chapters on ideological preparation became the reproduction of the social relations in production. And while I still found that none of these concepts were totally distinct from the others, the categories proved stable enough to function well as the study's organizational framework.

Reporting the data

In order to support the arguments I make in this ethnographic analysis and to enable the reader to judge the adequacy of these arguments, I have attempted to follow five basic methodological precepts in the final writing. First, heeding the advice of Homans (1950), I attempt to give a thorough and rigorous account of one event or idea at a time, resisting the temptation to wander off into other interesting but only semi-related ideas until the first has been systematically discussed and contextual relationships fully elaborated. In direct conjunction with that advice I explain my choice of concepts to describe particular phenomena and limit myself to those concepts. Otherwise, as Homans warns, 'in sociology we tend to wander all over our material; we never quite know what we are talking about at any particular moment' (1950: 44).

Secondly, I have attempted to indicate my own role as researcher in the data collection or interpretation. If a direct question of mine was significant in eliciting a particular response I try to report that as part of the data. If my interpretation of an event differed from a subject's account I offer both interpretations and suggest some reasons for the different points of view. Third, and related to this issue of interpretation, I have attempted to consider, wherever possible, competing explanations for any given set of phenomenon (Becker and Geer, 1960).

Fourth, I have tried to clearly describe not only the data, but the source of the data, and to indicate the reliability of the source. If, for example, statements are said in confidence during an interview or if the remark is made by several different types of individuals, it carries more weight in the analysis than a remark made

by only one person, or a statement written on an examination (Becker and Geer, 1960).

And fifth, I support generalizations made in the analysis with detail from observations or quotations from interviews. The only times I consciously deviate from this pattern are for ethical reasons of preserving the anonymity and reputation of the research participants. Instances that run counter to the overall pattern are also accounted for.

Research limitations

All research is constrained by both theoretical and empirical limitations. In a case such as mine, where ethnographic methodology is employed within a broad theoretical framework the problems are often exacerbated. By attempting to link micro-analysis to macro-analysis, by attempting to relate personal subjectivity to social processes of reproduction and transformation, assumptions, inferences and generalizations often fill in where theory or data is deficient. A few examples will illustrate what I consider to be the limitations of my own analysis and those aspects of cultural and social reproduction theory where advances need to be made.

First of all, some data limitations resulted purely from my own shortcomings as a field researcher and/or from objective obstacles I had no power to overcome. As mentioned elsewhere, these problems ranged from restrictions imposed upon me by school personnel prior to the start of the field work which prohibited me from gaining access to families, to my own reluctance to probe school and office personnel for more data for fear of jeopardizing my guest status. The quality of my data suffered as a result of these problems. Failure to have first-hand information from interviews with and observations of families creates the mistaken impression in my work that school and work-sites are necessarily more central to the construction of work identity than are families. A similar problem exists in relation to peer groups. Because I chose (for other reasons wisely) not to identify with a COOP subgroup, the power of the peer group also remains understated.

Data limitations also occurred because I was not able to or chose not to question my informants about particular issues. In the case of Mrs Lewis, for example, although I had the opportunities I

did not ask questions I thought she would perceive as critical. I did not ask, for instance, why she deflected discussion from authority relations (or if she was aware of doing so), why she did not discuss clerical unions with the students although she herself was an active union member, if she really believed pay was a private matter, or whether she realized she was conveying sex-stereotyped ideas even though she saw herself as a feminist.

In the case of the alumnae, my data suffers because I only contracted for one interview with each of them. Although I was able to gather the most significant aspects of the data I was seeking, I was not able to follow up on questions that occurred to me after I had transcribed and begun to analyze the interviews.

A similar problem occurred with the students. Even though I technically had access to them throughout the year, my position of non-alignment with any particular group or person meant that I almost never had the opportunity to directly and immediately question them about specific classroom practices and ideological content. These questions had to be left for the more formal interviews. At times I also was fortunate enough to overhear a conversation or accidentally meet a student when we both had time to talk. But the lack of a structured mechanism through which I could discuss with students each day's or week's events was clearly to my disadvantage. Moreover, I did not always realize how significant a particular event was until months after the field work was completed.

Perhaps because of this last reason and the fact that, despite our training, ethnographers can never absolutely transcend our own pre-conceptions, I am not always clear whether certain phenomena are the subjective experiences of my informants or my interpretations of these experiences. For example, I tend to use the word 'dissatisfaction' for a variety of complaints about the labor process. Because I did not at the time realize how central that construct would be to the analysis of the reproduction of technical relations I did not engage in enough systematic dialogue to precisely delineate the components of that construct or to know for certain whether subjects experienced work as dissatisfying. In other words, even though dissatisfaction was *my* logical concept to label their descriptions of their experiences, I am not certain it would have been their choice.

A similar and even more central problem exists in the analysis

of gender relations. Although I am convinced that the culture of femininity the students produced functioned to bind them to subordinate and inferior societal roles, I am not clear about whether this culture was perceived by them as inferior to masculine culture or just different from it. Because I so strongly perceived traditional feminine culture as working against women, I again failed to systematically explore the consciousness with which the students produced that culture. This, I think, is an important area for further research, as is the entire realm of class/gender relations.

Because my sample was devoid of men, restricted in class composition, and drawn from a politically progressive city, certain aspects of class and gender relations may have been muted. For instance, I may have discovered more striking social-class characteristics of the COOP students in a high school that was more predominantly middle class (such as Dewey or Bailey). Moreover, had I been able to analyze the social construction of work identity of students who fell into the four cells of female working and middle class, and male working and middle class, gender and class characteristics and relations would have been more evident. Even more importantly, such information would be critical to a thorough and coherent theory of cultural reproduction.

This last point highlights some of the empirical and theoretical lacunae within the general reproduction paradigm. More work needs to be done in three critical areas: the relationship between the social and sexual divisions of labor; the role of correspondences and contradictions in reproducing or transforming the social structure; and the relationship between material conditions, culture and subjectivity. More importantly, the connections among these three areas are also in need of specification.

The social and sexual divisions of labor are still, for instance, often regarded as totally separate social structural dimensions having their own separate causes and dynamics. When the two structures are analyzed relationally patriarchy is either viewed as a unified dynamic that supports capitalism or as a unified dynamic that undermines it. My work and Willis's work, for example, specify some of the ways in which patriarchal ideology and relations are a basis for capitalist control and the social division of labor. Barker and Downing (1980), on the other hand, give persuasive evidence of ways in which patriarchal relations are

antagonistic to capital's need for efficiency. Progress needs to be made in more systematically applying the notions of correspondences and contradictions to both the social and sexual divisions of labor in the various realms of the structured totality. Because these processes will differ according to groups and locations, ethnographic research is a necessary tool in the formulation of a comprehensive theory.

And lastly, a theory of the subject needs to be developed which integrates insights from social psychology and psychoanalysis with the insights of cultural anthropology. Without such an integration, subjectivity continues to be theorized apart from material structures or as the simple embodiment of particular structures or cultures. While this analysis and others offer ethnographic descriptions of the relation between materiality and subjectivity, the underlying theory is generally about culture, not about subjects. The relationship between biography and culture is perhaps the most taken-for-granted aspect of the whole cultural reproduction paradigm, and the one that must be further explored if theoretical advances are to be made.

Notes

Introduction

1 Lise Vogel, *Marxism and the Oppression of Women* (New Brunswick: Rutgers University Press, 1983), pp. 30–1.
2 Alice Kessler-Harris, *Out of Work: A History of Wage-Earning Women in the United States* (New York: Oxford University Press, 1982), p. 22.
3 Ibid., p. 59.
4 Ibid., pp. 147–8. See also Dan Clawson, *Bureaucracy and the Labor Process* (New York: Monthly Review Press, 1980).
5 Kessler-Harris, *Out to Work*, p. 148.
6 Ibid.
7 Ibid., p. 128.
8 See, for example, Samuel Bowles and Herbert Gintis, *Schooling in Capitalist America* (New York: Basic Books, 1976), Michael W. Apple, *Ideology and Curriculum* (Boston: Routledge & Kegan Paul, 1979), and Michael W. Apple, *Education and Power* (Boston: Routledge & Kegan Paul, 1982).
9 Heidi Hartmann, 'The Unhappy Marriage of Marxism and Feminism: Towards a More Progressive Union,' in Roger Dale et al., eds, *Education and the State*, Volume 2: *Politics, Patriarchy and Practice* (Barcombe, England: The Falmer Press, 1981), p. 191.
10 Some of the debates over these issues can be found in Michele Barrett, *Women's Oppression Today* (London: New Left Books, 1980), Vogel, *Marxism and the Oppression of Women*, and Apple, *Education and Power*.
11 These problems are discussed in considerably more detail in Michael W. Apple, ed., *Cultural and Economic Reproduction in Education: Essays on Class, Ideology and the State* (Boston: Routledge & Kegan Paul, 1982). See also, Apple, *Education and Power*.
12 Michael Burawoy, *Manufacturing Consent* (Chicago: University of Chicago Press, 1979).
13 Paul Willis, *Learning to Labor* (New York: Columbia University Press, 1981).

235

14 Angela McRobbie, 'Working Class Girls and the Culture of Femininity,' in Women's Studies Group, ed., *Women Take Issue* (London: Hutchinson, 1978), pp. 96–108.
15 Robert Everhart, *Reading, Writing and Resistance* (Boston: Routledge & Kegan Paul, 1983).
16 Lois Weis, *Between Two Worlds* (Boston: Routledge & Kegan Paul, 1985).
17 See Michael W. Apple and Lois Weis, eds, *Ideology and Practice in Schooling* (Philadelphia: Temple University Press, 1983).
18 For example, see Apple, *Education and Power*, Henry Giroux, *Theory and Resistance in Education* (South Hadly, MA: Bergin and Garvey, 1983), and Apple, ed., *Cultural and Economic Reproduction in Education*.

1 Theoretical overview

1 Although I presumed that most students in office education would be female, I did not realize how sex-segregated the area still was until I began the study. Most of the cooperative office education classes in schools in the surrounding area attracted only female students.
2 All references to persons and places are pseudonyms.
3 Poulantzas (1978) argues that clerical workers are unproductive workers and so cannot be analyzed within the dynamic of the capitalist labor process. This argument could obviously be extended to State workers. Wright (1978), however, takes issue with this formulation, arguing that (1) most workers are engaged in both productive and non-productive activities, (2) surplus-value can be generated in non-material production, (3) workers in both private and public sectors, engaged in mental or manual labor, have objective economic interests in common, and (4) each of these groups has 'unpaid labour extorted from them.' Since, from my observations in the field, I did not find that the labor process differed in any significant way between private and public sectors, I will analyze both within a common dynamic, pointing out differences as they occurred or where they were relevant. The phenomenon of State workers unionizing, gives weight to Wright's formulation of the problem. Indeed, there is often a greater distinction (particularly in regards to the wage packet) between union and non-union clericals than there is between private and public sector clericals.
4 Burawoy (1978) argues similarly that appropriation under capitalist relations always involves economic struggle since (1) the social relations of labor are not determined by law and (2) necessary and surplus labor time are not separated as they are in feudal relations but united in process, making the exact amount of surplus value invisible and uncertain.
5 For insights into this debate see Acker (1980), Barker and Downing

(1980), Gaskell (1983), Hartmann (1981), Kuhn and Wolpe (1978), and MacDonald (1979/80).

6 The use of the concept 'ideology' in this definition distinguishes culture in yet another way from socialization theory, which relies instead on the assumption of social consensus and normative behavior.

7 Gramsci says that 'common sense is an ambiguous, contradictory and multiform concept . . . to refer to common sense as a confirmation of truth is a nonsense' (1971: 423).

8 As Michael Olneck has pointed out to me, Bourdieu's concept of 'doxa' is also quite close to Althusser's 'theoretical ideologies.' Bourdieu defines doxa as the agent's 'sense of limits' or 'sense of reality.' Doxa are schemes of thought or perceptions that cause the 'world of tradition' to be 'experienced as a "natural world" and taken for granted' (1977: 164).

9 The emphasis on the material determination of culture and the 'rationality' of cultural formations given the limitations of material conditions frees the approach of the cultural Marxists from the cultural deprivation theory assumptions prevalent in American literature during the late 1960s. Cultural deprivation theory assumed the 'rightness' or superiority of middle-class culture and led to idealist solutions of making working-class culture more like middle-class culture. This theoretical orientation often rendered a blame-the-victim type of analysis, as though culture were detached from its roots. For a good critique see John Singleton, 'Implications of Education as Cultural Transmission,' (1974).

10 The artificiality of the analytic distinction between culture and ideology obviously and immediately breaks down here since families, schools and offices are obviously sites not only of ideology but of culture as well. If, however, the term ideology is reserved for the more formal and official aspects of those institutions and culture for the informal and unofficial aspects, the distinction remains useful.

11 I am indebted to Anyon's work for an introduction to *Roll, Jordan, Roll*.

12 Although Edwards (1979) and Apple (1981) seem to use the term contestation interchangeably with resistance, it seems to be more of a militant and aggressive form of negotiation since it implies a verbal confrontation the other term does not. Part of the overall difficulty in developing this type of typology is that many of the concepts remain under-conceptualized in the literature.

13 School personnel, of course, also have a cultural level and Willis's classification system suffers in this regard. By neglecting their cultural practices Willis tends to analyze teachers in terms of Parsons' 'role personality.' Still, the distinction of levels is useful in understanding and explaining what goes on in schools.

14 Burawoy uses the term 'expressive totality' to criticize the work of Braverman. In contrast to a structural totality, in an expressive

totality 'each part becomes the expression of a single dominant principle, that is of the whole' (1978: 274). For Braverman this principle is capital's universal tendency to fragment the labor process and deskill workers, first in wage labor and then in the family and the community. Such a concept allows no room for the 'mutual determination' of the structured totality since there is no relative autonomy among the parts of the whole. Because Bowles and Gintis implicitly employ a vision of an expressive totality in their formulation of the correspondence principle, Burawoy's criticisms apply to them as well.

2 Ethnographic overview

1 For the benefit of the uninitiated reader, a peppie dresses in the costume of the school's mascot to lead the cheering section at a sports event.

2 The restricted code enacted in the TWIRP and SENIOR AUDS becomes more apparent when compared to other role playing rituals. Schwartz and Merten (1974) describe a high school sorority initiation ritual wherein the initiates must wear, in exaggerated form, the garb of 'hoody' girls who are the antithesis of what the sorority girl strives to be. Bateson (1958) describes 'certain ceremonial behavior of the Iatmul people of New Guinea in which men dress as women and women dress as men' (p. 2). But this transvesticism is not symmetric. When men engage in this ritual behavior they usually wear 'the filthiest of female garments;' when women 'put on the garments of men,' they are 'the smartest of male attire' (p. 14). Bateson accounts for this asymmetrical sex-role reversal by claiming that the Iatmul women 'have no discernible contempt for the proud male ethos,' whereas the buffooning appearance of the male is an expression of obvious scorn and distaste for the female ethos (pp. 202–5). Schwartz and Merten offer a similar interpretation of the sorority ritual. Dressing as a hoody girl scorns the identity of that sub-culture. (The ritual is even called 'Mock.') The pledges are expressing or personifying a social identity they promise never to be, and in so doing rid themselves of that possibility. They become 'forever cleansed of any possible latent moral impurities, and their social identities as socies are publicly confirmed' (p. 173).

3 The school's selection processes

1 There are some exceptions in the literature to the notion that aspirations are stable at the high school level. Jencks et al. report, for instance, that 'many (perhaps most) young people have very little idea what they want to do, change their aspirations easily and

often, and follow the course of least resistance into whatever slots the economy makes available' (1972: 185). This conclusion, stressing the relative importance of 'empty slots' over personal aspirations, is supported by the interview data I collected.

2 Although socialization theorists might well assume that aspirations, perceptions, cultural orientations and socializing practices are all somehow determined by 'material conditions,' they often fail to make these connections explicit. This leaves their work open to the interpretation that aspirations are determined at the individual or cultural level. A significant exception to this problem is Melvin Kohn's *Class and Conformity*.

3 Office COOP seemed less well known than other programs or courses. Some courses, like grammar, algebra or typing seemed to belong to students' stock of general knowledge. Other courses, like distributive education's version of COOP, also seemed more well known because of club related activities (which office COOP did not have) and, as one student remarked, because of male participation. Programs and/or events that were male dominated seemed to attract more student awareness.

4 See, for example, Crozier, 1965; Glenn and Feldberg, 1979a; Lockwood, 1958; McNally, 1979, Garrison, 1979.

5 Figure I: Numbers of students enrolled in Cooperative Office Education at Woodrow High School by year

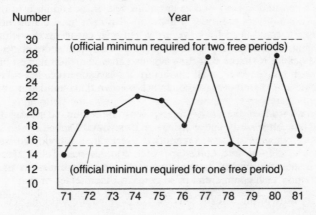

4 The students' selection processes

1 See, for example, Alexander, Cook and McDill, 1978; Davis and Haller, 1981; Garrison, 1979; Heyns, 1974; Kerckhoff and Campbell, 1977; Macke and Morgan, 1978; Rosen and Aneshensel, 1978.

2 See Frazier and Sadker, *Sexism in School and Society* (1973); Stacey et. al, *And Jill Came Tumbling After* (1974); Report of the Twentieth Fund Task Force on Women and Employment, *Exploitation from 9 to 5* (1975); Blaxall and Reagan, *Women and the Workplace* (1976); Sewell, Hauser and Wolf, 'Sex, Schooling and Occupational Status,' (1980).
3 The plausibility of both explanations is supported by other school studies. In *Classrooms and Corridors*, for example, Metz (1978: 221–2) describes an informal 'clustering' tendency on the part of black minority students at the Hamilton School.
4 See Alexander, Cook and McDill (1978) and Kerckhoff (1976).
5 Some of the stratification literature does indicate the limited influences of family background on work expectations for girls as compared to boys. Sewell, Hauser and Wolf (1978) find that 'women's aspirations are less responsive than those of men to several of the causal factors in the attainment process' (p. 575). Rosen and Aneshensel (1978) find that 'a girl whose father is a physician is as likely to expect to be a full-time housewife as is a daughter of a plumber' (p. 180). They also find, however, that the higher the status of the mother's occupation, the more likely it is that the daughter will work.
6 This statement should not be misread as a claim that there is no association between ability, achievement and social class background, on the one hand, and school track and occupational destination, on the other. First of all, I do not have the baseline data I would need from Woodrow High School to make such a claim. Secondly, I believe such data would reveal some association. My claim is simply that the students enrolled in COOP were much less homogeneous on all characteristics except gender than the widespread stereotypes about track compositions had led me to anticipate.
7 In his study of the West-Enders, Gans (1962) found a similar concern about job security and worries about downward mobility.
8 Kathryn's remarks were reminiscent of Epstein's work, *Woman's Place: Options and Limits in Professional Careers*. The chapters on socialization and socialization processes and women's roles contain such comments as

'Many of the career limitations on women are self-imposed' (p. 51).

'For a woman, sex status is primary and pivotal and it inevitably determines much of the course of her life' (p. 92).

'Since the woman who works must deal with two conflicting priority systems . . . she may often find herself under strain to perform both roles adequately' (p. 100).

9 This neglect has, in recent years, been addressed by both a new generation of labor market sociologists and by some senior

sociologists who formerly worked within the traditional status
attainment model. (Compare Sorensen, 1977, to Sorensen and
Kalleberg, 1981.) Ivar Berg's *Sociological Perspectives on Labor
Markets* (1981), for example, contains a number of essays written in
explicit opposition to the same human capital and status attainment
assumptions I am criticizing. These essays attempt 'to add demand-
related specifications to the favored theorists' model with its supply-
related specifications and its truncated character' (p. 4). Baron and
Bielby (1980) also describe structural explanations of stratification
and inequality as a 'recent shift' and, by incorporating a specification
of work organization within firms into their explanatory model,
attempt to relate analyses of positional inequality to analyses of
individual inequality.

10 Bourdieu and Passeron (1977) offer a similar criticism of
stratification theorists:

> It is no accident that so many sociologists, victims of the
> ideological effects of the school, are inclined to isolate
> dispositions and predispositions towards education – 'hopes,'
> 'aspirations,' 'motivations,' 'will-power' – from their social
> conditions of production: forgetting that object conditions
> determine both aspirations and the degree to which they can be
> satisfied.

11 For evidence of this assertion see the collections of articles on the
sexual division of labor compiled by Blaxall and Reagan (1976),
Kuhn and Wolpe (1978), and West (1982).

12 This is pure speculation on my part and I can conceive of at least
one counter-example. Women who work in factories, for instance,
although known to 'drink, smoke and swear like men' also take
pains to maintain long, painted fingernails, apply heavy layers of
facial make-up, and wear an abundance of flashy jewelry. Working
in 'men's' jobs seems to force women to elaborate a culture that
emphasizes their sexuality. Similarly, if men are forced to seek office
employment, they might feel the need to stress the 'macho' elements
of their identity lest anyone think them effeminate. More on this
point in Chapter 9.

5 A service economy and automated offices

1 Drawing upon Adam Smith's account of capitalist efficiency
(separating the labor process into its individual components,
limiting the job scope of workers to specific components, and
utilizing machines to facilitate the work) Braverman states:

> The worker may break the process down, but he never voluntarily
> converts himself into a lifelong detail worker. This is the
> contribution of the capitalist, who sees no reason why, if so much

is to be gained from the first step – analysis – and something more gained from the second – breakdown among workers – he should not take the second step as well as the first. That the first step breaks up only the process, while the second dismembers the worker as well, means nothing to the capitalist, and all the less since, in destroying the craft as a process under the control of the worker, he reconstitutes it as a process under his own control. He can now count his gains in a double sense, not only in productivity but in management control, since that which mortally injures the worker is in this case advantageous to him (1974: 78).

2 This embourgeoisement perspective is present in many of the recent commissioned reports on education. See, for example, The National Commission on Excellence in Education, *A Nation at Risk* (1983); Task Force of the Business-Higher Education Forum, *America's Competitive Challenge* (1983); and The Twentieth Century Fund Task Force on Federal Elementary and Secondary Education Policy, *Making the Grade* (1983).

3 I do not mean to imply that no analyses have taken into consideration variations in work organizations and job types. Blauner's *Alienation and Freedom* and Crozier's *The World of the Office Worker* are excellent analyses of the different effects varying organizations of the labor process can have on workers and worker consciousness. These types of studies, however, are seldom drawn upon in the 'upgrading/degrading' debates which is why I place so much emphasis on job types on this chapter.

4 All office jobs would be automatically classified as service occupations since, even though the offices might be located within an organization whose primary function is to manufacture goods (e.g. cars, dog food, deodorant), the office jobs themselves do not directly contribute to the production of that item, but rather contribute to the organization's accounting of its own production and distribution. The *Dictionary of Occupational Titles* defines clerical occupations as those 'concerned with preparing, transcribing, systematizing, and preserving written communications and records; distributing information; and collecting accounts' (1977: 153). Although the *DOT* includes everything from accountants to cashiers within office occupations, generally office workers are considered to be secretaries and various types of clerks, those who compose the bulk of the office work force. This is the segment of office occupations that I am considering.

5 Kusterer (1978: 179) deliberately replaces the concept of skill with that of working knowledge, claiming that skill categories (especially as defined and utilized by the Department of Labor) are grossly inaccurate and that they are based on the false notion of a mental/manual division of labor in which skill is associated with manual labor and knowledge with mental labor.

6 My observations of each student on her job verified the basic accuracy of their accounts. On a few occasions, students neglected to list tasks that were a regular part of their work. In these cases I took the liberty to include those tasks. Since I only had examination data on the 1981 graduates the N for Table IV is only seventeen students. The rest of the information in this chapter is based on the total sample: seventeen students and seventeen alumnae.

7 The term production function is quite vague since, as Marx indicates in *Capital* (Volume I: 342–3), virtually any function can be further sub-divided. I am using a broad definition of the term, making it synonymous with the common-sense notion of work task.

8 Since my information about work tasks within occupational categories and about occupational categories within employer types is based on such a small sample, the data could be presenting a distorted picture. Fortunately other studies which utilize larger samples confirm my findings. See, for example, Crozier (1965), Lockwood (1958), and McNally (1979).

9 When work was slow on a particular day, a typist might be sent to the filing department, mail room, or copy-center to help out, but this rarely happened.

10 As an indication of the extent to which these office jobs can be further sub-divided, some organizations now have positions where the sole function is proofreading.

11 Because I have never seen the electronic monitoring of production, I am not sure exactly how it would work. Braverman, however, says that stroke counters and 'automatic sequential numbering' devices can be attached to word processors (1974: 34).

12 Barker and Downing (1980: 92) quote Monotype, Wang and Dictaphone:

> From a secretarial station all work is productive and done on the spot. No waiting, walking and wondering (Monotype).

> . . . finally a built in reporting system helps you monitor your work flow. It automatically gives the author and typist's name, the document's number, the date and time of origin of last revision, and the required editing time, and the length of the document (Wang).

> They give all that a good supervisor would know – but electronically. You couldn't fail to get work on time (Dictaphone).

6 Schooling in office skills

1 Two major studies of high schools emphasize this theme. Boyer's *High School* (1983) points out the heavy teaching load of secondary teachers, their lack of preparation time, their non-professional responsibilities within the school, their low pay, and their lack of

recognition. Sizer's *A Study of High Schools* (1984) similarly calls attention to the large numbers of students secondary teachers must instruct each day, teachers' limited career ladder, and their non-competitive salaries and benefits.

7 Exchange relations

1 If the correspondence theory of Bowles and Gintis were accurate, students would learn to be productive at work because they *practiced* being productive at school. As I have just suggested, however, the students were seldom encouraged to work hard during their COOP classtime. In fact, classroom practices often conveyed the message than neither the quantity nor the quality of their school work mattered very much. Often, just 'being there' was what counted. Students rarely got in trouble for anything short of that and most of them consciously engaged in staging worker slowdowns on a regular, if not daily, basis. These slowdowns took various forms: coming late; leaving early; not coming at all; coming without classroom materials; asking to leave to go to the bathroom; complaining about hunger pains and asking to leave for lunch; chit-chatting with the teacher; sitting and daydreaming; or reading a novel. But although in the classroom the students tried to avoid as much work as possible, in their workplaces they frequently sought out different jobs to do. As the ensuing analysis will indicate, these tasks were regarded as real work that would keep them busy and make the time go fast, or help out co-workers, supervisors or customers. The only times students staged slowdowns at work were when they were bored by the routine, repetitive nature of the task, or when they felt 'used' by higher-level employees who pushed unpleasant tasks onto them.

2 Burawoy discovered similar ways in which workers consented to be productive at Allied Corporation. Because there, as at the offices in my sample, wages were largely independent of effort, the need for the pay check was not the primary motivation to be productive. Rather, in both studies, the reasons to produce were other than economic: overcoming boredom, work pride, and the 'need' to cooperate with co-workers. In the office situations I observed, however, I found nothing to approximate Allied workers cultural system of 'making out.' As Burawoy describes it, making out is 'a series of games in which operators attempt to achieve levels of production that earn incentive pay' (1979: 51). I can think of several reasons why the studies might differ in this respect, but I have no way of knowing which of these reasons really account for the differences. First, Allied workers were paid on the piece-rate system; all of the office workers in my sample, like most office workers, were paid by the hour. Second, the system of making out might be not only part of shop-floor culture, but part of masculine

culture, in which case it would not be found in places where mostly
women worked. Third, making out might have occurred in some of
the offices I observed without my being aware of it. This is a very
real possibility since Burawoy says that it took him 'some time to
understand the shop language, let alone the intricacies of making
out' (p. 64). I never spent longer than two weeks in any one
workplace and was never a paid employee in any one of them.
Lastly, even where systems of incentive pay existed (in the form of
evaluation for raises), the systems never seemed to offer real
possibilities for achievement, so the challenge and uncertain-
outcome aspects necessary to a game were missing. Mary, for
instance said, 'We're evaluated every six months, but you have to
have all ones and twos to get a raise there. Hardly anyone does.
I figure, no one's perfect; so it doesn't seem quite fair to grant raises
on that basis.' Another alumnae, at a different work-site, complained
that although her department had a system of merit raises 'they keep
reducing the time to put out the same amount of work for a merit
increase, so there's more pressure all the time. Workers have
complained but nothing is done – the time is still reduced.'

8 Authority relations

1 As in exchange relations, the correspondence theory of Bowles and
Gintis again breaks down in the image of teacher as boss. The
teacher does not have the same vested interest in having the students
work as does the supervisor. The supervisor might well lose her job
or be demoted if workers in her area do not put out the expected
work during the course of the day. On the other hand, the teacher
has an almost inverse relation to productivity. The harder and faster
the students work, the harder must she also work. Since most teachers'
work is isolated and their jobs protected by tenure, there is little
accountability in what students learn or produce. Once an ideology
of 'lack of student ability' is adopted (as Mrs Lewis said during a
supervisory meeting, 'When I get them as juniors and seniors it's
impossible,' and 'I think we do have to accept less. . . .'), there is
little need to stress productivity – except, of course, for professional
pride. So although at the most general level schools and work
organizations have the same hierarchical authority relations with
supervisors and teachers occupying approximately similar roles of
distributing, overseeing and evaluating work production and
performance, a closer analysis renders highly disparate images,
images quite apparent to the actors involved in these settings. As
one student said,

> 'In high school, if you don't get your work done it doesn't matter.
> At work it's not like that. Those poor habits don't carry over to
> work. Sometimes teachers didn't care if you got your work done
> or not. Bosses do; the report or whatever *has* to be done.'

9 Gender relations

1 This conclusion is also drawn by Madeleine MacDonald (1979/80).
2 Sheila Rowbotham, *Woman's Consciousness, Man's World* (1973: 89).
3 Margery Davies (1979: 257).
4 Although this is a basic authority relation that would probably exist irrespective of gender, because gender and authority are strongly correlated in office situations, hierarchical authority structures necessarily structure gender relations.
5 MacDonald (1979/80: 152).

11 Recommendations for office education

1 Although I argued in Chapter 6 that the specialized/routinized jobs COOP students are placed in serve as a disincentive for them to develop work-related skill, their cultural orientations of work pride and service function as a counterbalance. If skill development draws upon this culture and is presented within the context of struggles against job encroachment, I believe students would be inclined to apply themselves more rigorously than they did.
2 Pamphlets such as 'Race Against Time: Automation of the Office,' a report by the National Association of Office Workers, or the New York Committee for Occupational Safety and Health's (NYOSH) 'Health Protection for Operators of VDTs/CRTs' contain useful information. These pamphlets treat such topics as automation and employment, health, corporate interests, sex discrimination and the potential deskilling of jobs.
3 9 to 5, The National Association of Working Women (1224 Huron Rd., Cleveland, OH 44115) also publishes a newsletter and pamphlets like the 'Office Worker Survival Guide.'
4 In 1983, 9 to 5 conducted a first-time nation-wide survey 'to identify some of the best and worst employment policies in the United States' and hoped to use the results 'to inform public officials of working women's priorities and public policy expectations.' Survey categories were: equal job rights, wage gap, working family, older women workers, health and safety, and office automation. Respondents were invited to nominate employers for special mention ('outstandingly good or bad') in any of those categories.
5 A common slogan, widely disseminated as a bumper sticker is 'Free Enterprise is Working for You.' It was one of the first messages which greeted me from a hall bulletin board during my field work at Woodrow. No public school should allow itself to be the uncritical transmitter of a dominant ideology. Affixed to the same bulletin board should have been a sticker like the one I often saw on cars in my neighborhood: 'If Free Enterprise is Working, Why are So Many People Out of Work?'

Methodological appendix

1 I had begun the study, for instance, with Braverman's notion of the proletarianization of the office worker and the transformation of office work into factory-like work. Even though I was vaguely aware of Burawoy's contestation of this as a universal process, it was still the predominant model to which I held. So when the teacher of the program told me that most large typing pools and word processing centers had undergone a process of decentralization as a result of widespread dissatisfaction with that structure at all levels of organizational hierarchies, and that word processors were generally very happy with their jobs, I was prepared to disbelieve her. It was not until I interviewed word-processing operators myself that I was forced to modify my proletarianization scenario.

2 This methodological point emerges over and over again in the literature. Murdock and McCron (1975: 203) state that 'consciousness can be read not only in verbalization but in the way it is objectified and expressed through other forms of social and cultural action.' Kitwood, a social pychologist, says that something may be significant, but so much part of the 'taken for granted' world that it is never mentioned in the course of an interview (1980: 116).

3 In the Appendix to *Urban Villagers* Gans characterizes what I consider to be a continuum as three discrete types of research approaches: researcher as observer, researcher as research participant, and researcher as total participant. These categories have become fairly conventional in discussions of ethnographic methodology (see Sharp and Green, 1975, for example). Since, as Gans himself admits, however, these categories merely describe the main rather than the sole function of the researcher, I find the notion of continuum to be more precise. Where one's methodological approach falls at any point in time along this continuum depends both on the opportunities that present themselves and the information the researcher is seeking.

4 This factor probably prevented me from obtaining better and more extensive ethnographic data on feminine, youth culture. I do, however, believe the data I was able to gather is sufficient to argue the points I make in this analysis. Enough students became comfortable and spontaneous with me as the year went on to ensure non-distorted data.

5 I did not attempt to formally interview the student in the class who was classified as mentally retarded. Because of the special circumstances of this student there are times when I do not include her in the analysis. At other times, however, such as in Chapter 3, she plays a significant role.

6 Gans (1967: xxiv) says that memorizing interviews 'has long been standard practice for many sociologists.'

Bibliography

Acker, Joan R. (1980), 'Women and Stratification: A Review of Recent Literature,' *Contemporary Sociology* 9: 25–39.

Adler, Mortimer J. (1982), *The Paideia Proposal: An Educational Manifesto*, New York: Macmillan.

Alexander, Karl L., Martha Cook, and Edward L. McDill (1978), 'Curriculum Tracking and Educational Stratification: Some Further Evidence,' *American Sociological Review* 43: 47–66.

Althusser, Louis (1971), 'Ideology and Ideological State Apparatuses,' *Lenin and Philosophy and Other Essays*, trans. B. Brewster, London: New Left Books, pp. 127–86.

Althusser, Louis (1973), *Essays in Self-Criticism*, trans. Grahame Lock, London: New Left Books.

Anyon, Jean (1982), 'Intersections of Gender and Class: Accommodation and Resistance by Working-Class and Affluent Females to Contradictory Sex-Role Ideologies,' *Issues in Education: Schooling and the Reproduction of Class and Gender Inequalities*, ed. Lois Weis (Department of Educational Organization, Administration and Policy Studies and Comparative Education Center, Faculty of Educational Studies, State University of New York at Buffalo: Occasional Paper Number Ten): 46–79.

Apple, Michael W. (1979), *Ideology and Curriculum*, London: Routledge & Kegan Paul.

Apple, Michael W. (1980), 'The Other Side of the Hidden Curriculum: Correspondence Theories and the Labor Process,' *Interchange* 11: 5–22.

Apple, Michael W. (1981), 'Reproduction, Contestation, and Curriculum: An Essay in Self-Criticism,' *Interchange* 12, Nos 2–3: 27–47.

Apple, Michael W., ed. (1982), *Cultural and Economic Reproduction in Education*. Boston: Routledge & Kegan Paul.

Apple, Michael W., and Lois Weis, eds (1983), *Ideology and Practice in Schooling*. Philadelphia: Temple University Press.

Aronowitz, Stanley (1973), *False Promises: The Shaping of Working Class Consciousness*. New York: McGraw-Hill.

Barker, Jane, and Hazel Downing (1980), 'Word Processing and the Transformation of Patriarchal Relations of Control in the Office,' *Capital and Class* No. 10: 64–99.

Baron, James N., and William T. Bielby (1980), 'Bringing the Firms Back In,' *American Sociological Review* 45: 737–65.

Barrett, Michele (1980), *Women's Oppression Today: Problems in Marxist Feminist Analysis*, London: Verso Editions.

Barrett, Nancy S. (1984), 'Women as Workers,' Prepared for the National Conference on Women, the Economy and Public Policy. 'Washington DC, June.

Bateson, Gregory (1958), *Naven*, Stanford: Stanford University Press.

Becker, Howard S., and Blanche Geer (1960), 'Participant Observation: The Analysis of Qualitative Field Data,' *Human Organization Research*, ed. Richard N. Adams and Jack J. Preis, Homewood, Ill.: Dorsey Press, pp. 267–89.

Bem, Sandra, L., and Daryl J. Bem (1974), 'Training the Woman to Know Her Place: The Power of Nonconscious Ideology,' *Sexism and Youth*, ed. Diane Gersoni-Stavn, New York: R. R. Bowker, pp. 10–22.

Berg, Ivar, ed. (1981), *Sociological Perspectives on Labor Markets*, New York: Academic Press.

Bernstein, Basil (1977), *Class, Codes and Control* (1st edn, 1975), vol. III, London: Routledge & Kegan Paul.

Beynon, H., and R. M. Blackburn (1972), *Perceptions of Work: Variations within a Factory*, Cambridge: Cambridge University Press.

Bills, David (1981), 'Correspondence Theories of School and Work: Theoretical Critique and Empirical Assessment,' Unpublished Ph.D. Dissertation. University of Wisconsin-Madison.

Blau, Peter, and O. D. Duncan (1967), *The American Occupational Structure*, New York: John Wiley.

Blauner, Robert (1964), *Alienation and Freedom: The Factory Worker and His Industry*, Chicago: The University of Chicago Press.

Blaxall, Martha, and Barbara Reagan, eds (1976), *Women and the Workplace: The Implications of Occupational Segregation*, Chicago: The University of Chicago Press.

Blichfeldt, Jon Frode (1976), 'Relations Between School and the Place of Work,' *Acta Sociologica* 18, Nos 2–3: 330–43.

Bottoms, Gene (1982), 'Strengthening Technological Innovation,' *Voc Ed: Journal of the American Vocational Association*: 14–15.

Bourdieu, Pierre (1977), *Outline of a Theory of Practice*, Cambridge: Cambridge University Press.

Bourdieu, Pierre, and Jean-Claude Passeron (1977), *Reproduction in Education, Society and Culture*, London: Sage Publications.

Bowles, Samuel, and Herbert Gintis (1976), *Schooling in Capitalist America*, New York: Basic Books.

Boyer, Ernest (1983), *High School: A Report on Secondary Education in America*, Princeton, N.J.: Carnegie Foundation for the Advancement of Teaching.

Bibliography

Brake, Mike (1980), *The Sociology of Youth Culture and Youth Subcultures*, London: Routledge & Kegan Paul.

Braverman, Harry (1974), *Labor and Monopoly Capital: The Degradation of Work in the Twentieth Century*, New York: Monthly Review Press.

Burawoy, Michael (1978), 'Toward a Marxist Theory of the Labor Process: Braverman and Beyond,' *Politics and Society* 8, No. 4: 247–312.

Burawoy, Michael (1979), *Manufacturing Consent: Changes in the Labor Process under Monopoly Capital*, Chicago: The University of Chicago Press.

Clark, Burton R. (1960), 'The "Cooling-Out" Function in Higher Education,' *American Journal of Sociology* 65: 569–76.

Clarke, John, Stuart Hall, Tony Jefferson, and Brian Roberts (1975), 'Subcultures, Cultures and Class,' *Resistance Through Rituals: Youth Subcultures in Post-War Britain*, ed. Stuart Hall and Tony Jefferson, London: Hutchinson, pp. 9–79.

Clarke, John and Tony Jefferson (1976), 'Working Class Youth Cultures,' *Working Class Youth Cultures*, eds Geoff Mungham and Geoff Pearson, London: Routledge & Kegan Paul, pp. 138–58.

Cohen, Abner (1969), 'The Analysis of the Symbolism of Power Relations,' *Man* 4, No. 2: 215–35.

Collins, Randall (1975), *Conflict Sociology: Toward an Explanatory Science*, New York: Academic Press.

Critcher, C. (1975), 'Structures, Cultures, and Biographies,' *Resistance Through Rituals: Youth Subcultures in Post-war Britain*, ed. Stuart Hall and Tony Jefferson, London: Hutchinson, pp. 167–73.

Crozier, Michael (1965), *The World of the Office Worker*, trans. David Landau, Chicago: The University of Chicago Press.

Dager, Edward Z., ed. (1971), *Socialization: Process, Product, and Change*, Chicago: Markham.

Davies, Margery (1979), 'Woman's Place is at the Typewriter: The Feminization of the Clerical Labor Force,' *Capitalist Patriarchy and the Case for Socialist Feminism*, ed. Zillah R. Eisenstein, New York: Monthly Review Press, pp. 248–66.

Davis, Sharon A., and Emil J. Haller (1981), 'Tracking, Ability and SES: Further Evidence on the Revisionist-Meritocratic Debate,' *American Journal of Education* 89, No. 3: 283–304.

Dreeben, Robert (1968), *On What is Learned in School*. Reading, Mass.: Addison-Wesley.

Dreeben, Robert (1970), *The Nature of Teaching: Schools and the Work of Teachers*, Glenview, Ill.: Scott, Foresman.

Education Group, Center for Contemporary Cultural Studies (1981), *Unpopular Education: Schooling and Social Democracy in England Since 1944*, London: Hutchinson.

Edwards, Richard (1979), *Contested Terrain: The Transformation of the Workplace in the Twentieth Century*, New York: Basic Books.

Entwistle, Harold (1970), *Education, Work and Leisure*, London: Routledge & Kegan Paul.

Entwistle, Harold (1979), *Antonio Gramsci: Conservative Schooling for Radical Politics*, London: Routledge & Kegan Paul.

Epstein, Cynthia Fuchs (1970), *Woman's Place: Options and Limits in Professional Careers*, Berkeley: University of California Press.

Erickson, Frederick (1975), 'Gatekeeping and the Melting Pot: Interaction in Counseling Encounters,' *Harvard Educational Review* 45, No. 1: 44–70.

Exploitation from 9 to 5 (1975), Report of the Twentieth Century Fund Task Force on Women and Employment, New York: The Twentieth Century Fund.

Farman, Greg, Gary Natriello, and Sanford M. Dornbusch (1978), 'Social Studies and Motivation: High School Students' Perceptions of the Articulation of Social Studies to Work, Family and Community,' *Theory and Research in Social Education* VI, No. III: 27–39.

Featherman, David L., and Robert M. Hauser (1978), *Opportunity and Change*, New York: Academic Press.

Frazier, Nancy, and Myra Sadker (1973), *Sexism in School and Society*, New York: Harper & Row.

Freeman, Bonnie Cook (n.d.), 'Female Education in Patriarchal Power Systems,' Unpublished paper.

Freeman, Jo (1974), 'The Social Construction of the Second Sex,' *Sexism and Youth*, ed. Diane Gersoni-Stavn, New York: Bowker, pp. 10–22.

Gans, Herbert J. (1967), *The Levittowners*, New York: Vintage Books.

Gans, Herbert J. (1962), *The Urban Villagers*, New York: The Free Press.

Garrison, Howard H. (1979), 'Gender Differences in the Career Aspirations of Recent Cohorts of High School Seniors,' *Social Problems* 27, No. 2: 170–85.

Gaskell, Jane (1975), 'The Sex-Role Ideology of Working Class Girls,' *Canadian Review of Sociology and Anthropology* 12, No. 4, Part I: 453–60.

Gaskell, Jane (1981), 'Sex Inequalities in Education for Work: The Case of Business Education,' *Canadian Journal of Education* 6, No. 2: 54–72.

Gaskell, Jane (1983), 'The Reproduction of Family Life: Perspectives of Male and Female Adolescents,' *British Journal of Sociology of Education* 4, No. 1: 19–37.

Geertz, Clifford (1973), *The Interpretation of Cultures*, New York: Basic Books.

Genovese, Eugene D. (1974), *Roll, Jordan, Roll: The World the Slaves Made*. New York: Pantheon Books.

Giddens, Anthony (1979), *Central Problems in Social Theory: Action, Structure and Contradiction in Social Analysis*, Berkeley: University of California Press.

251

Bibliography

Gintis, Herbert (1971), 'Education, Technology, and the Characteristics of Worker Productivity,' *The American Economic Review* 61: 266–79.

Giroux, Henry A. (1981), *Ideology, Culture, and the Process of Schooling*. Philadelphia: Temple University Press.

Gleeson, Denis, and Geoff Whitty (1976), *Developments in Social Studies Teaching*, London: Open Books.

Gleeson, Denis, and George Mardle (1980), *Further Education or Training? A Case Study in the Theory and Practice of Day-Release Education*. London: Routledge & Kegan Paul.

Glenn, Evelyn Nakano, and Roslyn L. Feldberg (1979a), 'Clerical Work: The Female Occupation,' *Women: A Feminist Perspective*, ed. Jo Freeman. 2nd edn, Palo Alto: Mayfield, pp. 313–38.

Glenn, Evelyn Nakano, and Roslyn L. Feldberg (1979b), 'Proletarianizing Clerical Work: Technology and Organizational Control in the Office,' *Case Studies on the Labor Process*, ed. Andrew Zimbalist, New York: Monthly Review Press, pp. 51–72.

Goffman, Erving (1959), *The Presentation of Self in Everyday Life*, Garden City, N.Y.: Doubleday Anchor Books.

Goldstein, Bernard, and Jack Oldham (1979), *Children and Work: A Study of Socialization*, New Brunswick, N.J.: Transaction.

Goodlad, John I. (1984), *A Place Called School: Prospects for the Future*, New York: McGraw-Hill.

Goslin, David A. ed. (1969), *Handbook of Socialization Theory and Research*. Chicago: Rand McNally.

Gramsci, Antonio (1971), *Selections from the Prison Notebooks*, ed. and trans. Guintin Hoare and Geoffrey Nowell, New York: International Publishers.

Grubb, Norton, and Marvin Lazerson (1975), 'Rally Round the Workplace: Continuities and Fallacies in Career Education,' *Harvard Educational Review* 45, No. 4: 451–74.

Hall, Stuart, and Tony Jefferson, eds (1975), *Resistance Through Rituals: Youth Subcultures in Post-war Britain*, London: Hutchinson.

Hartmann, Heidi (1981), 'The Unhappy Marriage of Marxism and Feminism,' *Women and Revolution*, ed. Lydia Sargent, Boston: South End Press, pp. 1–41.

Heyns, Barbara (1974), 'Social Selection and Stratification within Schools,' *American Journal of Sociology* 79, No. 6: 1434–51.

Homans, George (1950), *The Human Group*, New York: Harcourt, Brace & World.

Inkeles, Alex (1966), 'Social Structure and the Socialization of Competence,' *Harvard Educational Review* 36, No. 3: 265–83.

Jencks, Christopher et al. (1972), *Inequality*, New York: Harper & Row.

Jencks, Christopher, et al. (1979), *Who Gets Ahead: The Determinants of Economic Success in America*, New York: Basic Books.

Johnson, Richard (1979), 'Three Problematics: Elements of a Theory of Working-Class Culture,' *Working-Class Culture: Studies in*

History and Theory, ed. J. Clarke, C. Critcher, and R. Johnson, New York: St Martins Press, pp. 201–37.

Kanter, Rosabeth Moss (1977), *Men and Women of the Corporation*, New York: Basic Books.

Karabel, Jerome (1972), 'Community Colleges and Social Stratification: Submerged Class Conflict in American Higher Education,' *Harvard Educational Review* 42: 521–62.

Kerckhoff, Alan C. (1972), *Socialization and Social Class*, Englewood Cliffs, New Jersey: Prentice-Hall.

Kerckhoff, Alan C. (1976), 'The Status Attainment Process: Socialization or Allocation,' *Social Forces* 55, No. 2: 368–81.

Kerckhoff, Alan C., and Richard T. Campbell (1977), 'Race and Social Status Differences in the Explanation of Educational Ambition,' *Social Forces*, 55, No. 3: 701–14.

Keyserling, Mary Dublin (1984), 'The Status and Contribution of American Women to the Economy: 1950–1983,' Paper prepared for the National Conference on Women, the Economy and Public Policy, Washington DC.

Kitwood, Tom (1980), *Disclosures to a Stranger: Adolescent Values in an Advanced Industrial Society*, London: Routledge & Kegan Paul.

Kohn, Melvin (1969), *Class and Conformity: A Study in Values*, Homewood, Ill.: Dorsey Press.

Kuhn, Annette, and AnnMarie Wolpe, eds (1978), *Feminism and Materialism: Women and Modes of Production*, London: Routledge & Kegan Paul.

Kusterer, Ken C. (1978), *Know How on the Job: The Important Working Knowledge of 'Unskilled' Workers*, Boulder: Westview Press.

Lacey, Colin (1977), *The Socialization of Teachers*, London: Methuen.

Langer, Elinor (1972), 'Inside the New York Telephone Company,' *Women at Work*, ed. William L. O'Neill, New York: Quadrangle/ The New York Times Book Co., pp. 307–60.

Lazerson, Marvin, and W. Norton Grubb, eds (1974), *American Education and Vocationalism: A Documentary History 1870–1970*, New York: Teachers College Press.

LeCompte, Margaret D., and Judith Preissle Goetz (1982), 'Problems of Reliability and Validity in Ethnographic Research,' *Review of Educational Research* 52, No. 1: 31–60.

Levin, Henry M. (n.d.), 'Workplace Democracy and Educational Planning,' unpublished.

Lockwood, David (1958), *The Blackcoated Worker: A Study in Class Consciousness*, London: George Allen & Unwin.

MacDonald, Madeleine (1979/80), 'Cultural Reproduction: The Pedagogy of Sexuality,' *Screen Education* No. 32/33 (Autumn/ Winter): 141–53.

McNally, Fiona (1979), *Women for Hire: A Study of the Female Office Worker*, London: Macmillan.

McRobbie, Angela (1978), 'Working Class Girls and the Culture of

Bibliography

Femininity,' *Women Take Issue: Aspects of Women's Subordination*, Women's Studies Group, Center for Contemporary Cultural Studies, University of Birmingham; London: Hutchinson.

Macke, Anne Statham, and William R. Morgan (1978), 'Maternal Employment, Race, and Work Orientation of High School Girls,' *Social Forces* 57, No. 1: 187–204.

Marx, Karl (1967), *Capital: A Critique of Political Economy*, vol I, ed. Frederick Engels, trans. Samuel Moore and Edward Avenling, New York: International Publishers.

Mechling, Jay (1981), 'Male Gender Display at a Boy Scout Camp,' *Children and Their Organizations*, eds R. Timothy Sieber and Andrew J. Gordon, Boston: G. K. Hall, pp. 138–50.

Metz, Mary Haywood (1978), *Classrooms and Corridors: The Crisis of Authority in Desegregated Secondary Schools*, Berkeley: University of California Press.

Metz, Mary Haywood (1981), 'The Impact of Ethnographers' Roles on the Research Process,' A paper presented at the Annual Meeting of the American Educational Research Association, April 13–17, in Los Angeles.

Mills, C. Wright (1956), *White Collar: The American Middle Class*, New York: Oxford University Press.

Murdock, Graham and Robin McCron (1975), 'Consciousness of Class and Consciousness of Generation,' *Resistance Through Rituals*, eds Stuart Hall and Tony Jefferson, London: Hutchinson, pp. 192–207.

National Commission on Excellence in Education (1983), *A Nation at Risk: The Imperative for Educational Reform*, Washington DC: U.S. Dept. of Education.

Parsons, Talcott (1959), 'The School Class as a Social System: Some of its Functions in American Society,' *Harvard Educational Review* 29, No. 4: 297–318.

Perl, Peter (1984), 'Monitoring by Computers Sparks Employee Concerns,' *Washington Post*, September 2.

Poulantzas, Nicos (1978), *Classes in Contemporary Capitalism*, trans. David Fernbach, London: Verso.

Reskin, Barbara F. (1984), 'Sex Segregation in the Workplace,' *Gender at Work*, Washington DC: Women's Research and Education Institute, pp. 1–11.

Race Against Time: Automation of the Office (1980), Report by Working Women, National Association of Office Workers, Cleveland.

Riley, Fran (1980), 'NSA Secretarial Stats,' *Secretary* 40, No. 1: 17–20.

Rosen, Bernard C., and Carol S. Aneshensel (1978), 'Sex Differences in the Educational-Occupational Expectation Process,' *Social Forces* 51, No. 1: 164–85.

Rosenbaum, James E. (1976), *Making Inequality*, New York: Wiley.

Rosenbaum, James E. (1978), 'The Structure of Opportunity in School,' *Social Forces* 57, No. 1: 236–56.

Rosenberg, Morris (1953), 'Perceptual Obstacles to Class Consciousness,' *Social Forces* 32, No. 1: 22–7.

Rosenfeld, Rachel (1978), 'Women's Intergenerational Occupational Mobility,' *American Sociological Review* 43: 36–46.

Rosenthal, Robert, and Lenore Jacobson (1968), *Pygmalion in the Classroom*. New York: Holt, Rinehart, & Winston.

Rowbotham, Sheila (1973), *Woman's Consciousness, Man's World*, Middlesex: Penguin Books.

Rubin, Lillian Breslow (1976), *Worlds of Pain*, New York: Basic Books.

Schatzman, Leonard, and Anslem L. Strauss (1973), *Field Research: Strategies for a Natural Sociology*, Englewood Cliffs, N.J.: Prentice-Hall.

Schutz, Alfred (1953), 'Common-Sense and Scientific Interpretation of Human Action,' *Philosophy and Phenomenological Research* XIV, No. 1: 1–37.

Schultz, Theodore W. (1977), 'Investment in Human Capital,' *Power and Ideology in Education*, ed. Jerome Karabel and A. H. Halsey, New York: Oxford University Press, pp. 313–24.

Schwartz, Audrey James (1975), *The Schools and Socialization*, New York: Harper & Row.

Schwartz, Gary, and Don Merten (1974), 'Social Identity and Expressive Symbols: The Meaning of an Initiation Ritual,' *Education and Cultural Process*, ed. George D. Spindler, New York: Holt Rinehart & Winston, pp. 154–75.

Seixas, Suzanne (1981), 'The Case of the Disappearing Secretary,' *Money Magazine*, pp. 84–5.

Serrin, William (1984), 'Electronic Office Conjuring Wonders, Loneliness and Tedium,' *New York Times*, March 28.

Sewell, William H., Robert M. Hauser, and Wendy C. Wolf (1980), 'Sex, Schooling, and Occupational Status,' *American Journal of Sociology* 86, No. 3: 551–83.

Sharp, Rachel, and Anthony Green (1975), *Education and Social Control: A Study in Progressive Primary Education*, London: Routledge & Kegan Paul.

Sharpe, Sue (1976), *'Just Like a Girl': How Girls Learn to be Women*, Middlesex: Penguin.

Simon, Roger I. (1982), 'The New Vocationalism: Adapting to the World of Work or Defining One's Work in the World,' A paper presented at the Annual Meeting of the American Educational Research Association, March 19–23, in New York City.

Simon, Roger I., and Joel Weiss (n.d.), 'Learning to Understand the World of Work in Relation to Self and Society,' A Research Proposal submitted to the Social Sciences and Humanities Research Council of Canada, unpublished.

Singleton, John (1974), 'Implications of Education as Cultural Transmission,' *Education and Cultural Process*, ed. George D. Spindler, New York: Holt, Rinehart & Winston, pp. 26–38.

Sizer, Theodore R. (1984), *Horace's Compromise: The Dilemma of the American High School*, Boston: Houghton Mifflin.

Bibliography

Smith, B. Othanel, and Donald E. Orlosky (1975), *Socialization and Schooling: Basics of Reform*, Bloomington: Phi Delta Kappa.

Smuts, Robert W. (1959), *Women and Work in America*, New York: Columbia University Press.

Sorensen, Aage B. (1977), 'The Structure of Inequality and the Process of Attainment,' *American Sociological Review* 42: 965–78.

Sorensen, Aage B., and Arne L. Kalleberg (1981), 'An Outline of a Theory of the Matching of Persons to Jobs,' *Sociological Perspectives on Labor Markets*, ed. Ivar Berg, New York: Academic Press, pp. 49–74.

Spindler, George D. (1963), *Education and Culture: Anthropological Approaches*, New York: Holt, Rinehart and Winston.

Spindler, George D., ed. (1974), *Education and Cultural Process: Toward an Anthropology of Education*, New York: Holt, Rinehart & Winston.

Spindler, George D., ed. (1982), *Doing the Ethnography of Schooling: Educational Anthropology in Action*, New York: Holt, Rinehart & Winston.

Spring, Joel (1978), *American Education*, New York: Longman.

Stacey, Judith, Susan Berlaud, and Joan Daniels, eds (1974), *And Jill Came Tumbling After: Sexism in American Education*, New York: Dell Publishing.

Stinchcombe, Arthur L. (1964), *Rebellion in a High School*, Chicago: Quadrangle Books.

Strauss, Anselm (1978), *Negotiations: Varieties, Contexts, Processes, and Social Order*, San Francisco: Jossey-Bass Publishers.

Task Force of the Business-Higher Education Forum (1983), *America's Competitive Challenge: The Need for a National Response*, Washington DC: Business-Higher Education Forum.

Therborn, Goran (1980), *The Ideology of Power and the Power of Ideology*, London: Verso Editions.

Treiman, Donald J., and Heidi I. Hartmann (eds) (1981), *Women, Work and Wages: Equal Pay for Jobs of Equal Value*, Committee on Occupational Classification and Analysis, National Research Council, Washington DC: National Academy Press.

The Twentieth Century Fund Task Force on Federal Elementary and Secondary Education Policy (1983), *Making the Grade*, New York: Twentieth Century Fund.

Tyler, Ralph Winfred (1976), 'The Competencies of Youth,' *From School to Work: Improving the Transition*, National Commission for Manpower Policy, Washington D.C.: U.S. Government Printing Office, pp. 89–115.

US Department of Labor: Employment and Training Administration (1977), *Dictionary of Occupational Titles*, 4th Edition, Washington D.C.: Government Printing Office.

West, Jackie, ed. (1982), *Work, Women, and the Labour Market*, London: Routledge & Kegan Paul.

White, Leslie A. (1972), 'The Concept of Culture,' *Culture and School*,

ed. Ronald Shinn, Scranton, PA: International Textbook Company, pp. 3–28.

Whyte, William Foote (1943), *Street Corner Society*, Chicago: The University of Chicago Press.

Wilcox, Kathleen (1982), 'Ethnography as a Methodology and its Application to the Study of Schooling: A Review,' *Doing the Ethnography of Schooling*, ed. George D. Spindler, New York: Holt, Rinehart & Winston, pp. 457–88.

Willis, Paul (1977), *Learning to Labour: How Working Class Kids Get Working Class Jobs*, Farnborough: Saxon House, Teakfield.

Willis, Paul (1981), 'Cultural Production is Different from Cultural Reproduction is Different from Social Reproduction is Different from Reproduction,' *Interchange* 12, Nos 2–3: 48–67.

Wolcott, Harry F. (1982), 'Mirrors, Models, and Monitors: Educators' Adaptations of the Ethnographic Innovation,' *Doing the Ethnography of Schooling*, ed. George D. Spindler, New York: Holt, Rinehart & Winston, pp. 69–95.

Wolpe, AnnMarie (1978), 'Education and the Sexual Division of Labour,' *Feminism and Materialism; Women and Modes of Production*, eds Annette Kuhn and AnnMarie Wolpe, London: Routledge & Kegan Paul, pp. 290–328.

Work in America (1973), Report of a Special Task Force to the Secretary of Health, Education and Welfare, Cambridge: MIT Press.

Wright, Erik Olin (1978), *Class, Crisis, and the State*, London: New Left Books.

Wrong, Dennis H. (1961), 'The Oversocialized Conception of Man in Modern Sociology,' *American Sociological Review* 26, No. 2: 183–93.

Index

Index